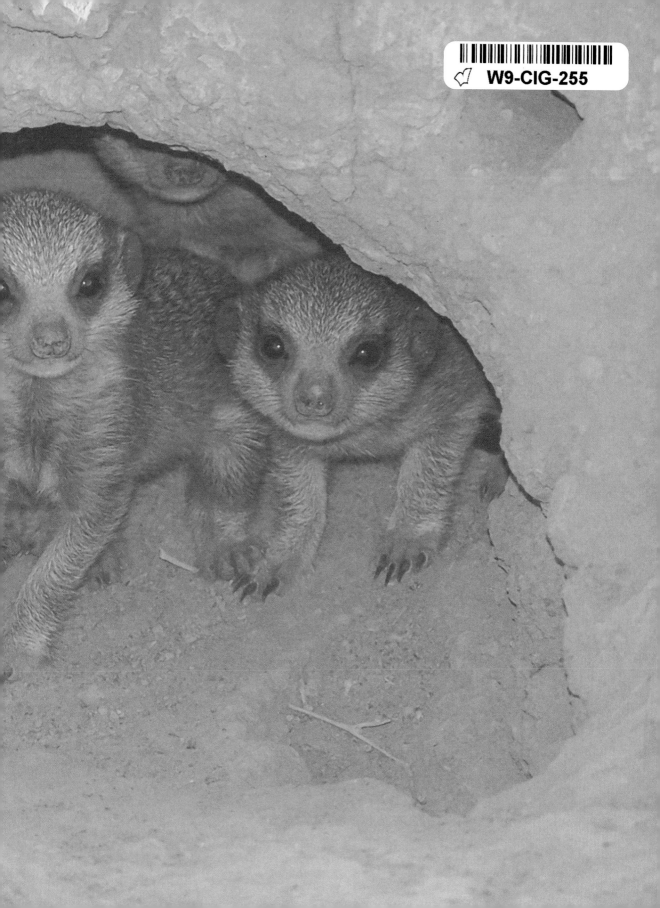

MEERKATS

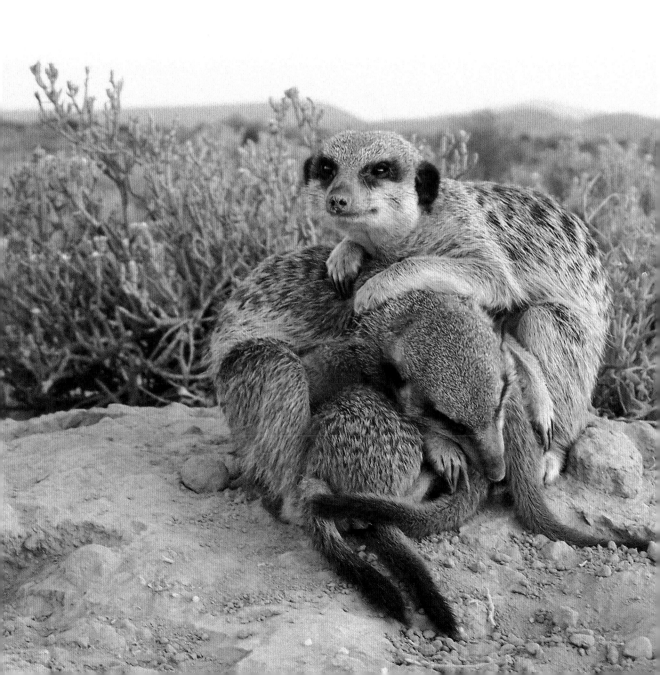

First published in 2016 by Reed New Holland Publishers Pty Ltd
London • Sydney • Auckland

The Chandlery, Unit 704, 50 Westminster Bridge Road,
London SE1 7QY, United Kingdom
1/66 Gibbes Street, Chatswood, NSW 2067, Australia
5/39 Woodside Avenue, Northcote, Auckland 0627, New Zealand

www.newhollandpublishers.com

A record of this book is held at the British Library and the National
Library of Australia.

ISBN 978 1 92151 765 5

Managing Director: Fiona Schultz
Publisher and Project Editor: Simon Papps
Designer: Thomas Casey
Production Director: Olga Dementiev
Printer: Toppan Leefung Printing Limited

10 9 8 7 6 5 4 3 2 1

Page 1: Meerkats curl around their tired babies to protect
them from the cold wind at the end of the day.
Pages 2–3: Meerkats sunning their dark grey undersides
just after sunrise.
Page 4: Co-operative thermoregulation. The youngest usually
manage to crawl to the centre of the warm huddle.

Keep up with New Holland Publishers on Facebook
www.facebook.com/NewHollandPublishers

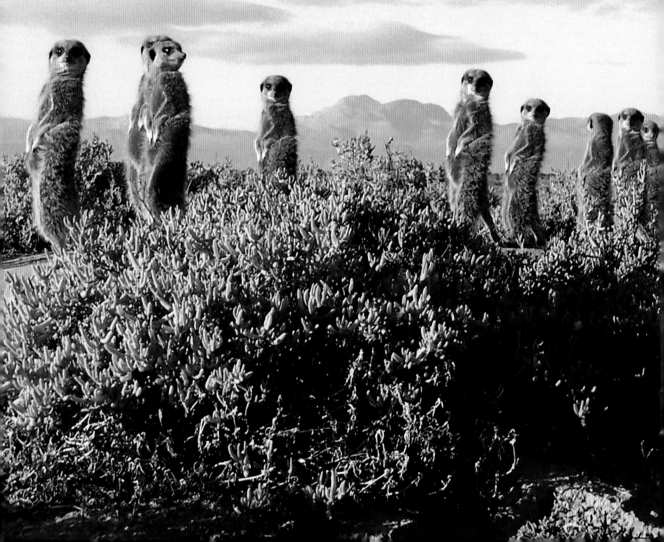

MEERKATS

GRANT M. Mc ILRATH – THE MEERKAT MAN

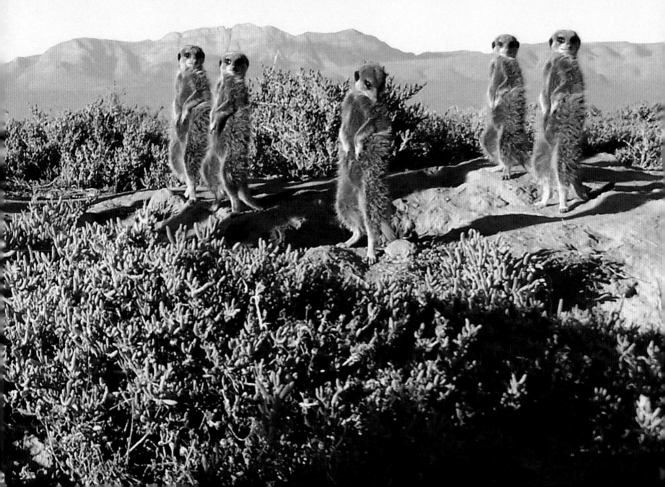

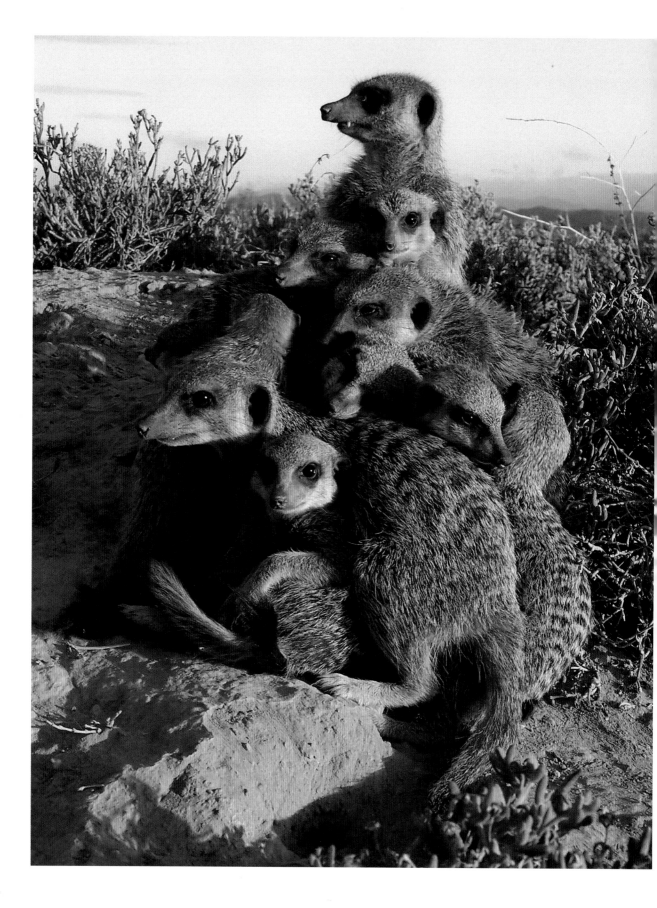

CONTENTS

Dedication

For the continued conservation of wild Meerkats and their diminishing natural habitat and the promotion of active Conservation Through Education with applied open source research.

Thank you to my precious family and friends for your love and support: Estelle, Michael, Craig, Kim, Hilary, Simon, Vanessa, Kelsey, Duncan, Hannah, Brooke, Amara, Freya and Kia.

Acknowledgements

Thank you to everybody around the world who has supported my conservation work over the decades and especially to the Ungulungu Meerkats from The Meerkat Magic Conservation Project in The Meerkat Magic Valley Reserve in the Little Karoo and to the Kalahari Desert Meerkats.

About the author

Grant M. Mc Ilrath – A.K.A. The Meerkat Man – is a professionally qualified nature conservation biologist and internationally published wildlife researcher and director and owner of The Meerkat Magic Conservation Project and The Meerkat Magic Valley Reserve. He has been directly involved with numerous Meerkat films with the BBC, National Geographic, Discovery Channel and others since 1993 and ongoing with over 20 years of fieldwork with two of the three recognised Meerkat subspecies.

Grant was born in Gauteng on 3 March 1973 and attended Parkview Primary and Senior Schools, followed by Greenside High School. He volunteered after school at Johannesburg Zoo for many years, becoming fascinated by the Meerkats. Grant then began his tertiary studies in professional nature conservation in Pretoria.

In 1993 he moved to the Kalahari Desert and completed seven years of professional wildlife field research studying the Kalahari Desert Meerkat subspecies. He was employed to assist the University of Pretoria MRI (Mammal Research Institute) in South Africa and Cambridge University LARG (Large Animal Research Group) in the United Kingdom.

This was followed by a spell at Witsand in the Western Cape to assist with research on the Yellow Mongoose with Stellenbosch University in South Africa and Oxford University in the United Kingdom.

Grant then moved to the Little Karoo and discovered an undocumented occurrence of the Meerkat in the area. This resulted in the creation of The Meerkat Magic Conservation Project and Meerkat Magic Moments. He subsequently purchased and began forming The Meerkat Magic Valley Reserve to protect the Little Karoo Meerkat subspecies and other naturally occurring fauna and flora and their threatened habitat.

PREFACE

THE PHOTOGRAPHIC ARCHIVES INCLUDED in this book are possible due to the highly selective tolerance gained from intimate observational patience with two of the three recognised Meerkat subspecies. The two subspecies illustrated are from distinctly different populations from the Kalahari Desert and the Little Karoo. This book encompasses the insights from over two decades and thousands of hours of professional field research and conservation into wild Meerkats from 1993 to 2015.

The journey began in the scorching shifting sands of the Kalahari Desert in 1993 and continued to the spectacular succulent saturated Little Karoo valley, which is hugged by snow-sprinkled mountains.

It is very easy and unethical to tame wildlife by touching and feeding individuals. The highly selective tolerance techniques used in Grant's unobtrusive observational research ensure that wild animals remain wild and true to their natural behaviours when observed in nature. A variety of tried and tested inter-species communication techniques have been adapted through the use of various sensory stimuli.

These unobtrusive wildlife observation techniques developed and used by Grant have been integral to numerous international Meerkat films and publications and have resulted in the nickname awarded to him of 'The Meerkat Man' as a translator of the staggering array of complex Meerkat calls and behaviours as they occur.

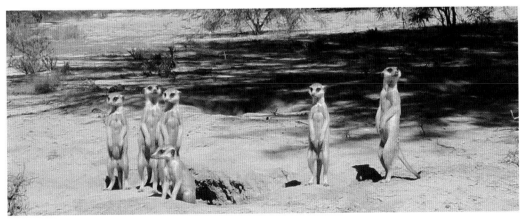

Meerkats of the Kalahari subspecies guard against predators from the safety of their river-bed burrow.

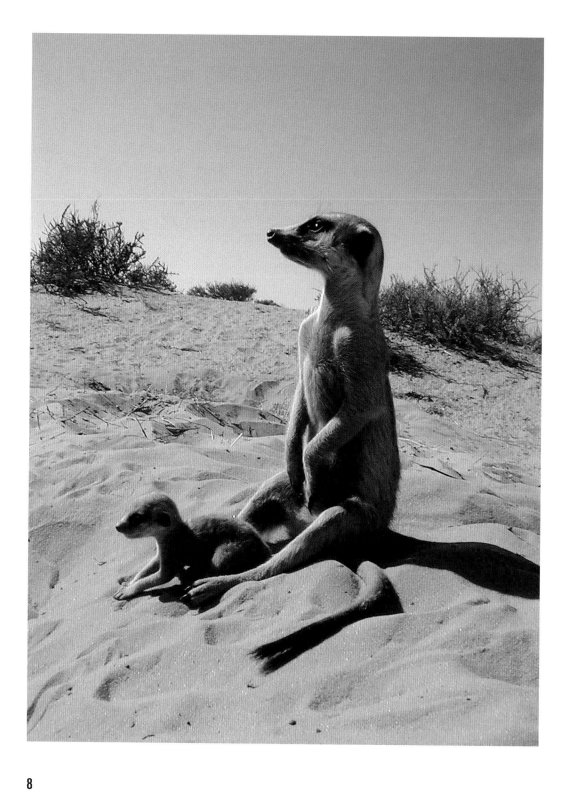

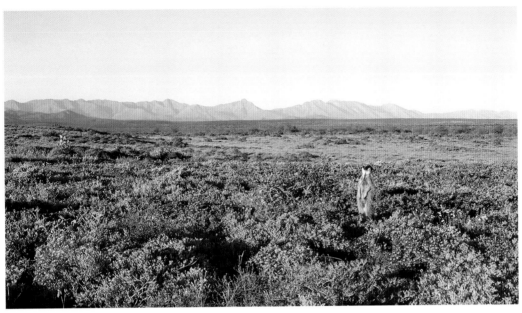

OPPOSITE: *A newly emerged baby Meerkat and its babysitter on guard among the shifting Kalahari sand dunes.*

ABOVE: *Little Karoo Meerkat standing guard by a burrow, surrounded by a tapestry of colourful succulents.*

This has allowed international observers an intimate view behind the scenes and science in the equivalent of an unedited wildlife documentary. All the images and information used are from Grant's personal archives and experiences.

There have been numerous challenges in locating wild Meerkats in different habitats. Searching for wild Meerkats is almost like searching for extremely well camouflaged needles in a gigantic haystack.

This species is fossorial, and with the slightest alarm will vanish into the security of burrows beneath the ground. This does not allow for aerial observation or standard statistical wildlife field surveys.

Anything that is not recognised by the Meerkat is perceived as a threat. This incredible alertness, combined with their burrowing habits, cryptic camouflage and astounding distance vision, are the reasons why their numbers in the wild will never be known as a fact.

What is a certainty, however, is that their natural habitat is being reduced at an alarming rate, without most people even knowing that there are burrowing creatures living in a world beneath our feet, concealed from the glances of casual observers.

It was believed that the vast barrier of mountains frequently covered in snow, and dividing the Great Karoo from the Little Karoo, formed a barrier for Meerkats which they could not cross to occupy the suitable habitat to the south of this imposing rocky wall. Many people imagine the vast expanses of the sandy dunes of the Kalahari Desert when thinking of

Meerkats, and certainly not snow-covered mountain ranges and a narrow valley of Meerkat habitat embraced between them, as is the case in the Little Karoo.

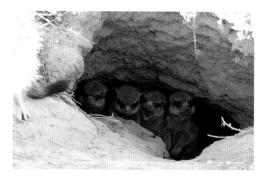

This lack of accurate information regarding Meerkat distribution was illustrated by the fact that in 2001 Grant discovered the subspecies *Suricata suricatta suricatta* in an area of the Little Karoo where it had not previously been recorded or documented.

He then established The Meerkat Magic Conservation Project and The Meerkat Magic Valley Reserve in an area of ancient riverbed, and in subsequent years set about studying and conserving this population of wild Meerkats and their habitat, together with other naturally occurring species of fauna and flora at the site.

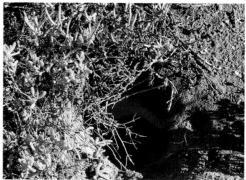

The happy surprise of discovering Meerkats here after months of searching in an area apparently devoid of this secretive species is what inspired the name Meerkat Magic and the subsequent conservation project and reserve. When Meerkats emerge from the ground preceded by dust billowing out of their burrows it seems impossible that a moment before there were no Meerkats and then as if by magic they appear.

RIGHT, TOP TO BOTTOM: *Baby Meerkat eyes checking out the adventures that await them beyond the safety of their underground home; a Meerkat tail is all the reveals this digging hunter in pursuit of a snack hidden deep in the sand; this is no deception! These Meerkats are surrounded by snowy mountains rather than sand dunes; snowy mountains form the backdrop of the Meerkat Magic Valley Reserve in the virbrant Little Karoo.*

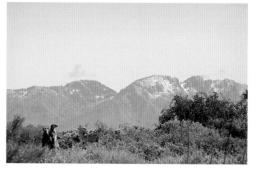

The compacted soil of the Little Karoo does not easily reveal the secretive tracks of the creatures living there, unlike the soft sandy surfaces of the Kalahari Desert which are a veritable feast of information for the wildlife tracker's eyes.

The Little Karoo burrow systems remain covered in vegetation throughout the year, making them invisible to a casual observer, unlike the Kalahari Desert burrows which remain unvegetated for the majority of the year and are easier to locate.

Researching the Little Karoo Meerkat subspecies, Grant has never fed or provisioned any study animals, never used any form of artificial marking, never handled or captured animals and never used radio transmitters for over a decade. Although very difficult to track, the daily following of the Meerkats allowed an intimate understanding of their movement patterns and burrow usage, enabling accurate predictions as to their location over the years. All the Meerkats were objectively recognised through the use of the uniquely identifiable patterns on their backs which are present from birth.

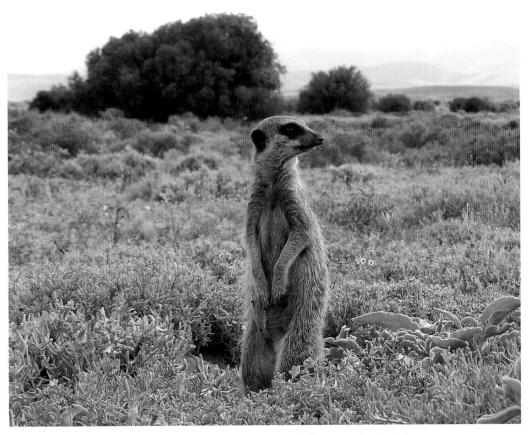

Little Karoo burrows are well hidden by vegetation and may only be revealed by an emerging Meerkat.

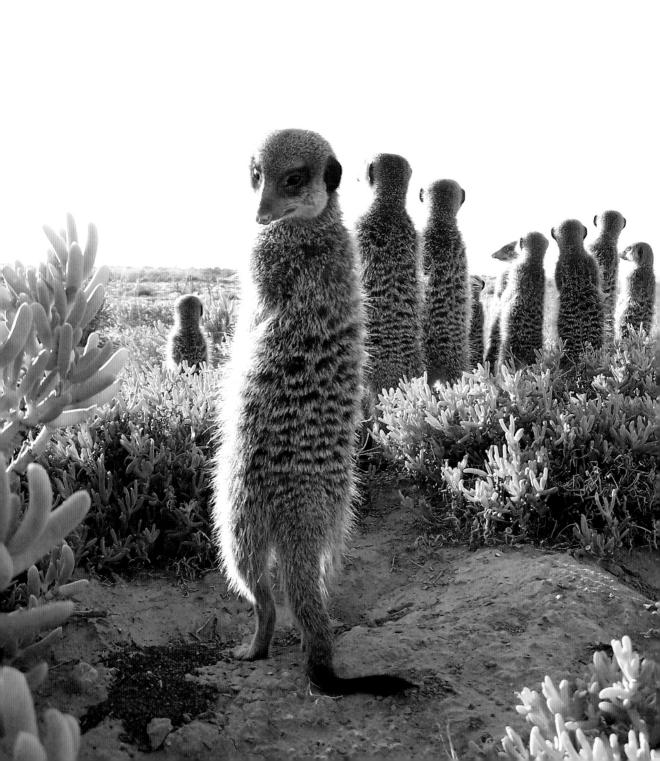

INTRODUCTION

COURTESY OF THE MEDIA the magnificent Meerkat has travelled all around the world from its limited distribution in the Southern African region. This intensely sociable species has fascinated millions of observers for decades. Few are aware of the lesser-known conservation challenges facing the very survival of the wild Meerkat and its diminishing habitat. Frequently the Meerkat is out of sight, hiding beneath the ground, or remains well concealed as it emerges from a burrow.

There are a number of collective terms for Meerkat families and they are sometimes referred to as mobs or gangs. I think, however, that these terms have a negative connotation for this species which does not shine a positive light on it for conservation. I prefer to use my own more positively biased description for these ecologically beneficial and highly sociable mammals and this is a Meerkat *co-operative*. This in my opinion best describes the essence of the meerkats' astounding survivalist teamwork. However, for this book have decided to use the widely understood description of a Meerkat group to avoid possible confusion of terms.

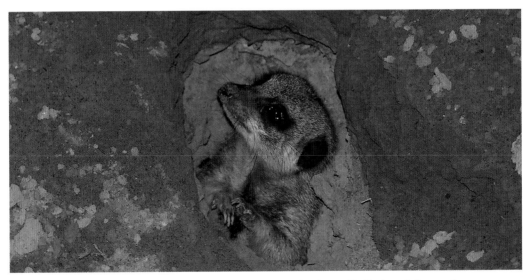

OPPOSITE: *Meerkats are mesmerised by early morning sunlight, pointing their solar-panel bellies towards the warmth.*

ABOVE: *A Meerkat emerges from a dark hole – there is a hidden world beneath our feet where many creatures take refuge.*

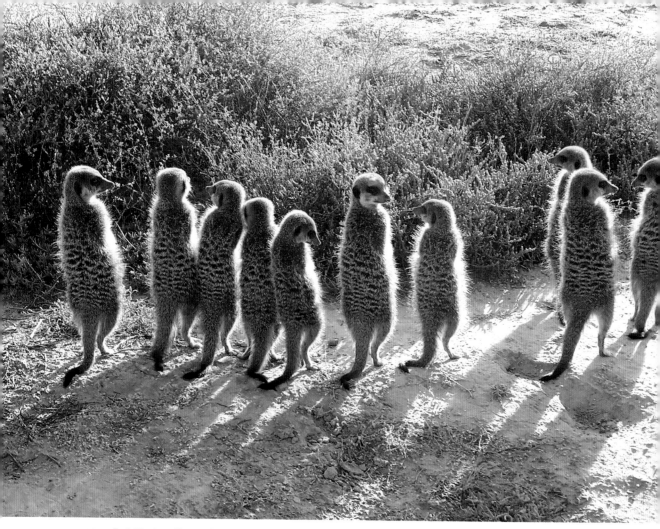

ABOVE: *Each Meerkat will try and avoid casting shadows on another as they shuffle around in the morning sun.*

OPPOSITE: *A Meerkat Magic Moment. Being tolerated by wild Meerkats is an incredible experience.*

Nature's classroom has motivated me into attempting to view the world through the untainted, timeless eyes of wildlife in order to perceive a reality that is unclouded by human civilization and one which transcends time.

Observing and being immersed in the realm of wildlife has resulted in a paradigm shifting from one of experiential awareness to another far more simple life without the daily stresses generated by humans in modern times.

When observing wild Meerkats I am transported into a world which is very focussed in the present reality, without the preoccupation with future events. Each moment is lived and experienced and dealt with as it happens and I find this to be the essence of Meerkat Magic.

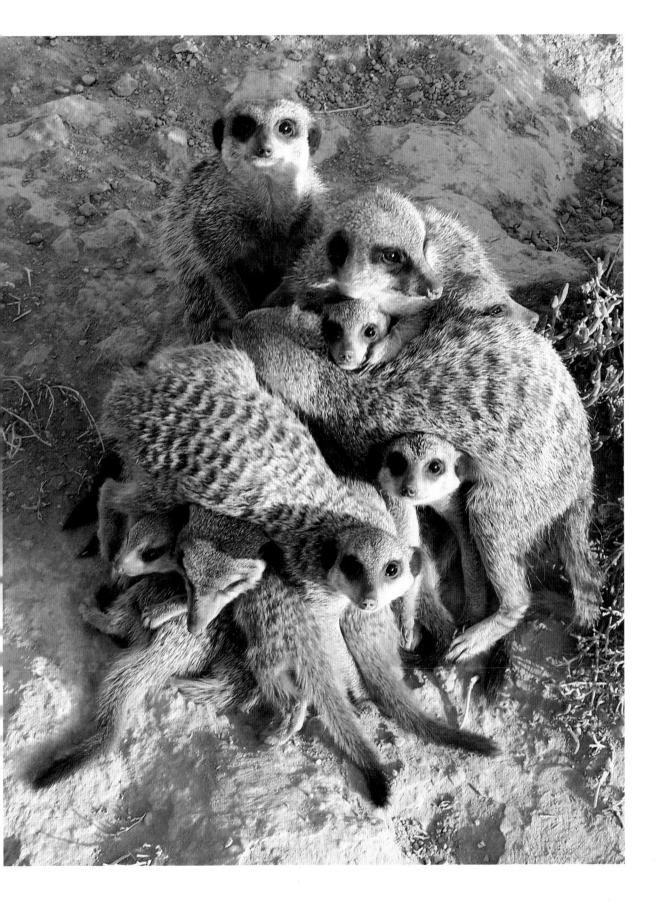

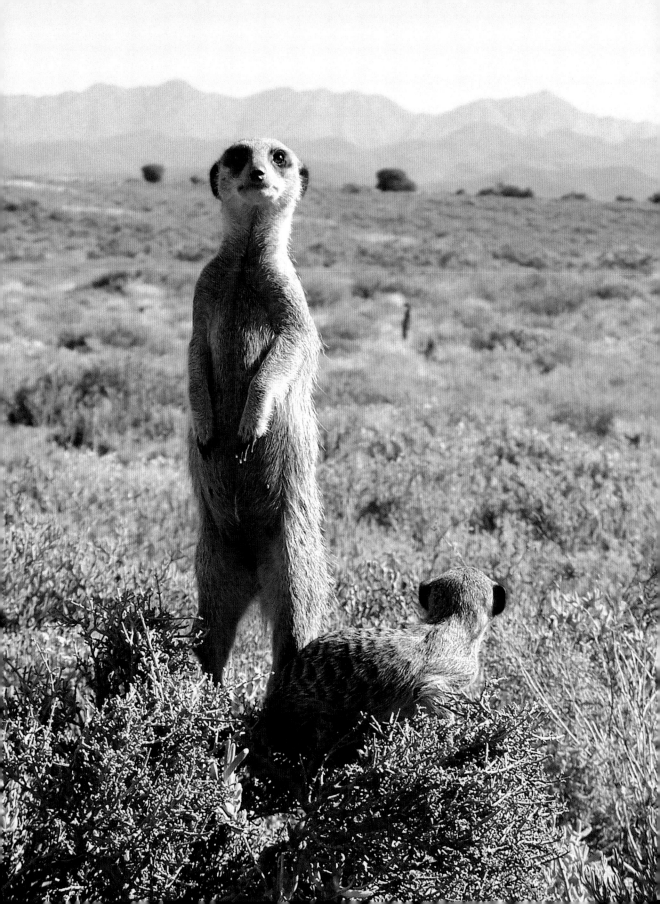

TAXONOMIC CLASSIFICATION

THE MEERKAT IS KNOWN by many different names, resulting in great confusion between it and its closest living relatives, the mongooses, genets and civets. This name confusion may not seem to be of much importance, but it does actually have a very negative impact on the conservation of wild Meerkats.

Although the Meerkat is commonly called a mongoose it is completely unique in many anatomical and physiological adaptations compared to those found in what others believe to be its closest living relatives. The fossil records suggest that relatives of the mongooses were apparently amongst the earliest forms of mammals to appear.

Tragically the confusion between the Meerkat and the typical wide variety of more cat-like mongooses in the world (of which there are over 30 species) has resulted in widespread persecution of Meerkats due to the ignorance of humans. Even the plural name mongooses is often confusing to some people who ask: 'why not mongeese or mongi?'!

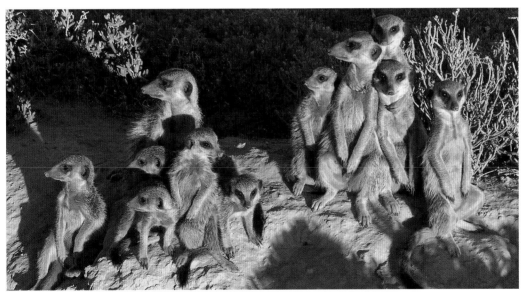

OPPOSITE: *Meerkat anatomy is more dog-like than cat-like and has many differences when compared to typical mongooses.*

ABOVE: *Sunset socialising maintains important survival bonds between members of the co-operative group.*

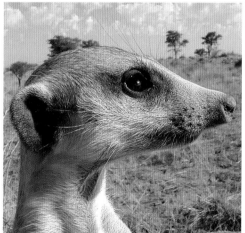

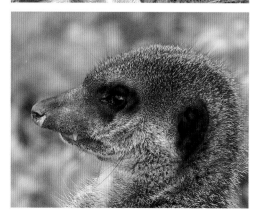

Another example is the Afrikaans name 'muishond', which when translated directly means 'mouse dog'; to add to the confusion this name is even used for species that are not actually mongooses, such as the stink muishond (literally 'stink mouse dog') or Striped Polecat (*Ictonyx striatus*) which, although superficially similar, actually belongs to the Mustellidae family and not the Viverridae.

I will mention the differences between the Meerkat and a typical member of the mongoose family, such as the Yellow Mongoose (*Cynictis penicillata*), in order to help alleviate the commonly occurring conservation disaster where Meerkats are killed by those believing that they are eating a mongoose diet or an unrelated captive Meerkat diet. Captive Meerkats often end up giving wild Meerkats a bad reputation due to this misunderstanding.

The name 'suricate', taken from the scientific name, is not commonly used. The name 'Meerkat' is the most commonly used English name for the species, and is believed to have been derived from the Dutch name meaning 'lake cat'. However this is not very appropriate as the Meerkat is more like a dog than a cat and does not often occur around water. The name may also have originated from the 'meer' being a reference to 'more' cat.

Meerkats have very flexible spines and can curl into a ball when grooming themselves (top). The Kalahari subspecies marjoriae *(centre) has lighter hair and a paler eye mask than the Little Karoo subspecies* suricatta *(below).*

Perhaps 'meerhond', literally translated as 'more dog', would be a better-suited name than Meerkat, since it is unlike a cat in many ways, for example: it has non-retractile nails; very coarse hair rather than the typical dense, fine fur of a cat; this hair does not fully cover the body, especially on the underside and feet; and often baby Meerkats are referred to as the dog-like 'pups' and not the cat-like 'kittens'.

The Meerkat has a round pupil and not a horizontally slitted pupil like the Yellow Mongoose. A very significant difference between the Meerkat and other mongooses is the specially adapted fleshy ear-valve that can swell up to seal the ear completely, compared to the thin paper-like ears of the Yellow Mongoose, which have long hairs and no valve to protect them.

Meerkats do not typically use a communal midden at their sleeping burrow, as is the case with the Yellow Mongoose, but rather scatter their dung around their territory. The exception is with overlapping ranges, where the Meerkats will all make shallow scrapes in close proximity and deposit their dung together – the dung is never buried. Yellow Mongooses do not make any scrapes for the dung at their middens, which they typically use daily when they emerge in the mornings. A typical cat buries its dung to hide the warning signs of a predator from prey, so the meerkat is again atypical of a cat in this habit.

Other common English names for Meerkat include 'Slender-tailed Meerkat', while Afrikaans names include: 'Stok stert' (meaning 'stick-tailed'); 'graaitjie' or 'grou meerkat' (a reference to the digging habit); 'erdman' (earth man); and 'erdmannetjies' (diminutive – little earth men). The list of names used for Meerkats is too extensive to fully list here.

In synopsis, I believe that scientific names are far less confusing as a single descriptive name is used for the identification of a species no matter where it is encountered in the world.

The scientific classification for the Meerkat is:
Kingdom: Animalia
Phylum: Chordata
Subphylum: Vertebrata
Class: Mammalia
Order: Carnivora
Family: Viverridae
Subfamily: Herpestinae
Genus: *Suricata*
Species: *suricatta*
Subspecies: *S.s.suricatta* (Little Karoo);
S.s.iona; *S.s.marjoriae* (Kalahari Desert)

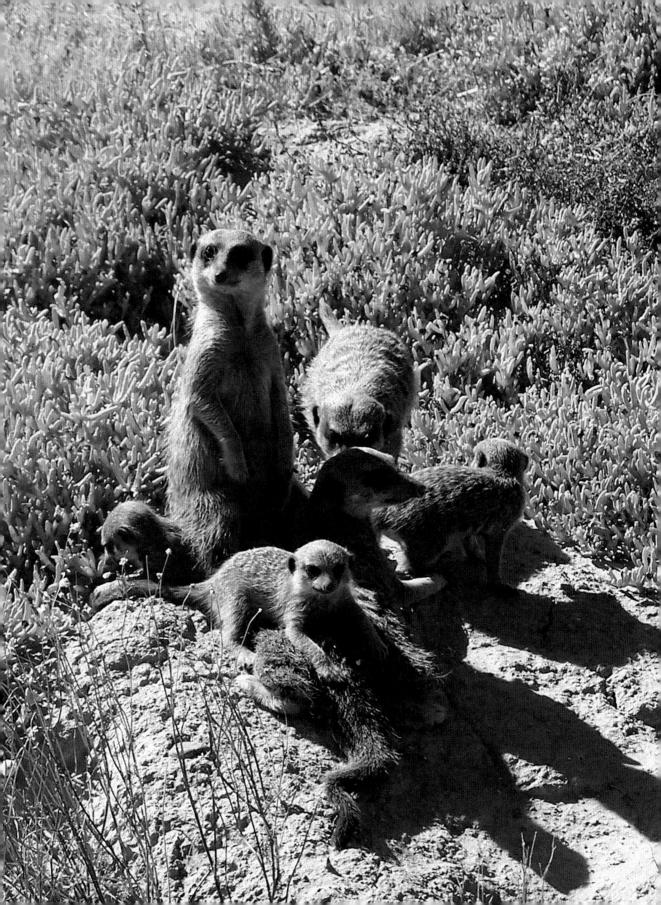

MORPHOMETRICS
BODY CHARACTERISTICS

Size

This is one of the most confused aspects regarding the Meerkat in the media in the world. The Meerkat is often believed to be much bigger or smaller than it actually is. An adult Meerkat standing upright on its back legs and using its supportive tail would be beneath the knee of most adult humans standing next to it.

The total body length for a Meerkat adult is on average 520–630mm. The tail length is shorter than the body at around 185–245mm.

Weight

Newborn babies weigh 14g (0.5oz), three-month-old juveniles 225g (8oz), six-month-old sub-adults 470g (16.5oz) and adults from eight-months-old to 15 years 680–960g (24–34oz).

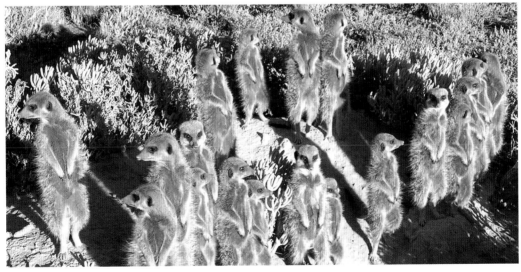

OPPOSITE: *Great care is taken over Meerkat pups – this one stretches out and climbs onto a babysitter.*

ABOVE: *A multitude of Meerkats warming themselves and watching out for any possible danger.*

 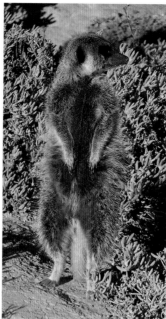 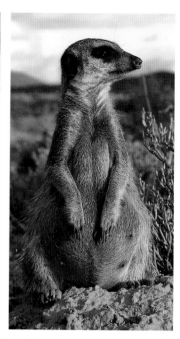

ABOVE, LEFT TO RIGHT: *The anatomy of a male Meerkat; the anatomy of a female Meerkat with suckle marks around her mammae; a heavily pregnant female is much larger then a male.*

Sexual dimorphism

Males and females are very similar in general appearance and weight with the exception of much heavier pregnant females. Older males tend to have more muscularity on their heads, which forms a distinctive ridge on the crest of the skull.

Appearance

The body of the Meerkat is often similar in colouration to that of the surrounding sand or vegetation in its natural habitat. Different subspecies have a lighter or much darker appearance according to variations in the habitats where they occur. The subspecies in Angola is very pale and almost silvery white, compared to the more yellowy, reddish-brown subspecies in the Kalahari Desert of Botswana and most of northern South Africa and the very dark brown subspecies of the Little Karoo and coastal areas of the lower regions of South Africa.

The hips of a Meerkat are very large compared to the narrow shoulders, allowing for good balance with the frequently assumed vertical postures. The narrow shoulders allow for very narrow foraging digs to be made while the back legs anchor the body. The very slender and flexible spinal column assist in this balance, and the body can be curled into a ball with the base of the head tucked down beneath the back feet.

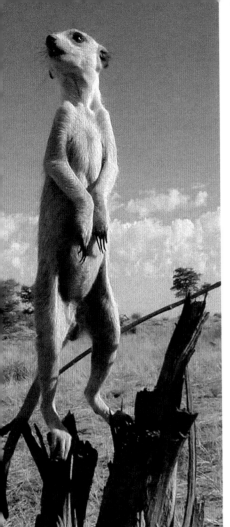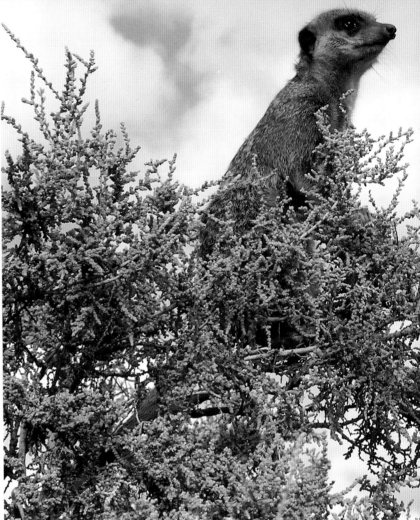

Meerkats on elevated guard, illustrating the light hair of the Kalahari subspecies (left) and the much darker hair of the Little Karoo subspecies (right).

The hair is very short on the head, neck and shoulders, and allows for sand to be easily shaken off after digging. There are long vibrissae on the nose and around the eyes which aid in tactile functions when beneath the ground; these whiskers are over 1cm (0.4in) long.

The hair on the back of the body is layered into transverse brown disruptive cryptic patterns which are unique to each Meerkat from birth and can be used for identification by human observers. Meerkats use scent to recognise each other and not these cryptic patterns.

When foraging beneath shrubs, the shadows cast from the vegetation make the bodies of the Meerkats very difficult to see from above. These markings break up the appearance of the Meerkats which helps to protect them from aerial attackers. If unable to get to the safety of escape burrows, Meerkats will lie flat on the ground, relying on their back patterns to avoid detection from above.

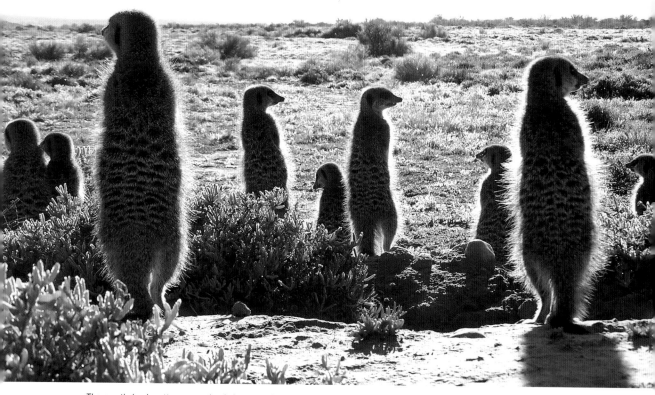

The cryptic back patterns can clearly be seen when Meerkats stand up to warm themselves. Each pattern is unique.

There is very short and sparse hair on the underside of the body, exposing the dark grey skin, which allows for essential rapid thermoregulation for heat loss and gain.

There is no hair on the feet of the Meerkat, unlike the fine, densely packed hair completely covering the feet of the closely related Yellow Mongoose. This lack of hair on the feet allows the Meerkat to cool down very quickly on hot surfaces, and the skin on their feet is thick.

The hair on the tail is very short and the top of the tail is much paler in appearance. The northern subspecies in the Kalahari Desert has a bright yellow underside of the tail and the southern subspecies in the Little Karoo has a bright orange underside. When raised the strikingly bright underside of the tail acts as a warning to others, who can easily follow this visual alarm. The tail has a distinctive black tip.

The tail is very slender and muscular but not prehensile. It is frequently used for supporting the body when in an upright vertical position. Generally when the Meerkat is foraging or relaxed the tail is dragged behind the body with the tip often leaving intermittent marks on the ground where it touches. When a predator or foreign scent is detected the tail is held rigidly and parallel to the ground.

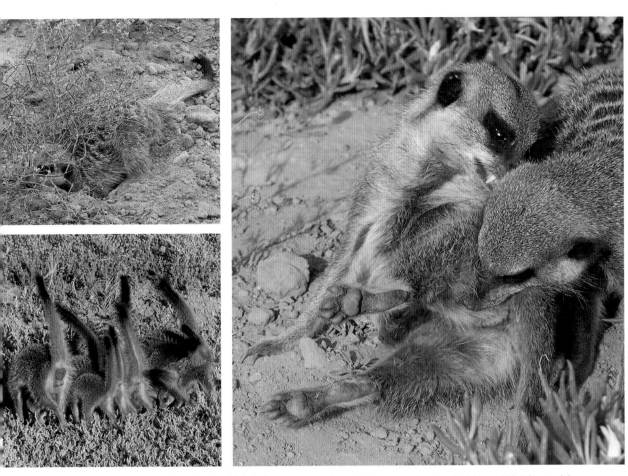

CLOCKWISE FROM TOP LEFT: *When foraging in mottled shadows, the camouflaged patterns on a Meerkat's back help to hide it from aerial predators; there is no hair on the thick rubber-like undersides of the Meerkats' feet; the bright underside of a puffed up vertically raised Meerkat tail is a clear sign of danger to the group!*

When the Meerkat is running the tail is held vertically with the bright underside used as a beacon to followers. The tail may also be briefly raised vertically and then very slowly lowered if the Meerkat is alarmed for a moment before it relaxes again, which is almost a 'warning flag' to others of potential danger. When stretching after resting the tail is bent and curved but the hair is not erected and the tail tip does not move around.

During agonistic displays such as the war dance or predator encounters, the hair is erected and the tail is bent over the back towards the head and often the tail tip is moved from side to side.

It is believed that the raised tail with the dark tip distracts attacking predators into focussing on the swaying and narrow tail-tip target. The head and usually puffed-up hair around the vulnerable body of the Meerkat are less of a focus for an attack. The piloerection of the longer guard coat of body hair may serve to intimidate predators with the sudden increase in the apparent size of the Meerkat.

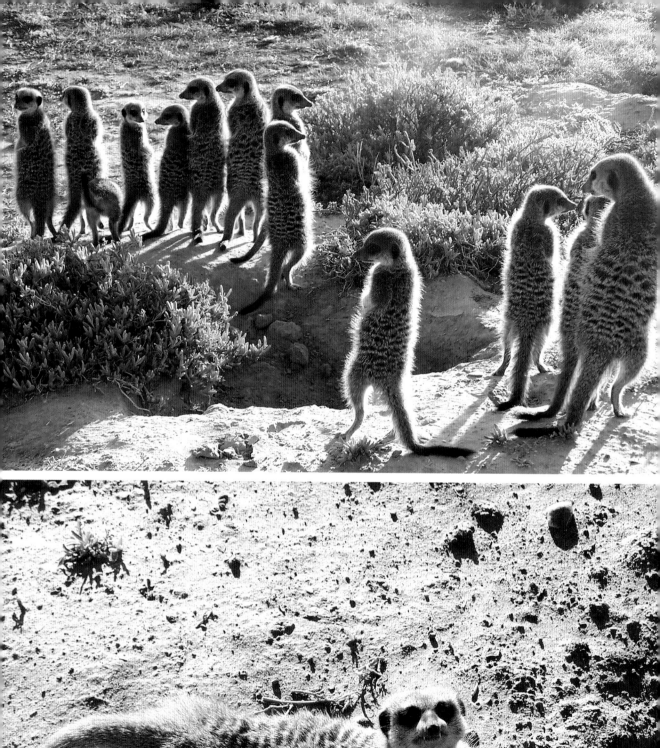
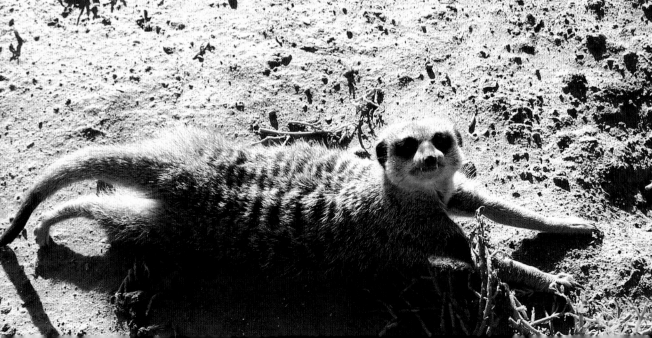

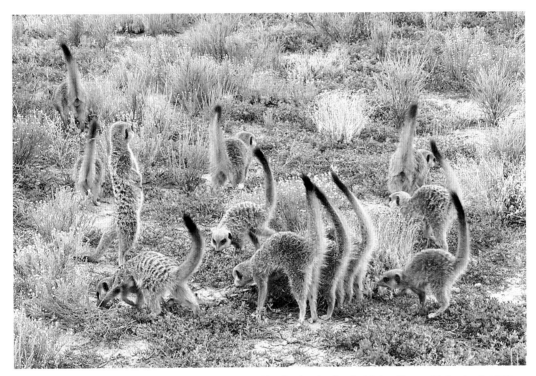

OPPOSITE, TOP TO BOTTOM: *Meerkats often bend their tails when stretching, but do not puff up their hair as they would when bending their tails during a visual alarm; Long golden hairs on the Meerkats' backs help to trap a layer of warm air around them, almost like a blanket.*

ABOVE: *Meerkats aggressively erect their hair to intimidate and confuse predators.*

When individual Meerkats move together they appear to blend into one much larger and more threatening opponent. The bristling bottlebrush appearance may also help to protect the most vital organs of the body so that predators that do attack the body are less likely to injure the Meerkat and rather bite the puffed out hair instead.

The hair on the back legs of Meerkats is much longer and has very long guard hairs which actively help to prevent attacks from various biting insects such as ants. This guard coat also extends in sporadic patches up the back of the Meerkat towards the shoulders. When sunning or huddling for warmth the Meerkat will piloerect these hairs to trap heat and channel it into the darker hair tips and into the skin.

Skull

The skull is very broad in width over the eye sockets and zygomatic arches, with greatly extended nasal bones and a highly developed pheromo nasal cavity. The top of the skull is relatively flat with no occipital crest, which prevents very large masseter muscles from developing and largely determines the dietary allowance of the Meerkat. Comparatively a Yellow Mongoose has a very narrow, almost slender, skull.

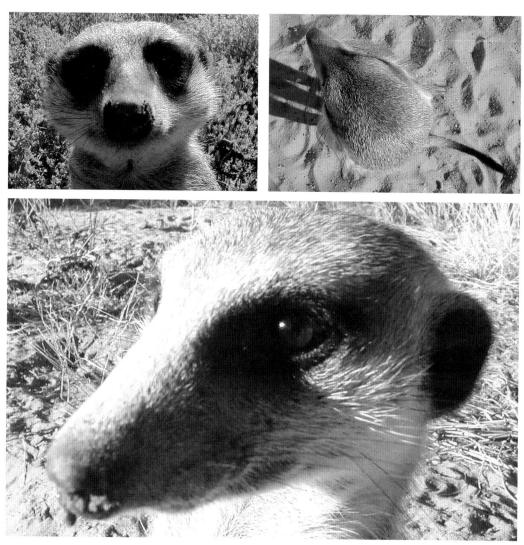

CLOCKWISE FROM TOP LEFT: *The Meerkat has a long almost proboscis-like nose; Meerkats have wide heads with their eyes to the sides and facing forwards, granting them a wide angle of view to hunt and watch out for danger simultaneously; the skull is flattened on top, broad around the large eye orbits and elongated for the sensitive nose.*

Eyes and vision

The eye is dark brown with a round pupil, and in contrast the Yellow Mongoose is again more cat-like with a horizontally slitted pupil and an orange eye.

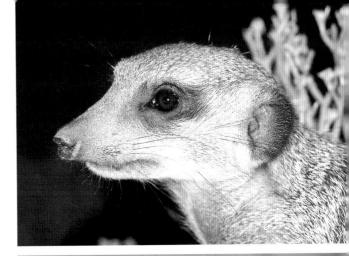

The Meerkat appears to have binocular vision with exceptional distance perception far greater than the human eyes' capabilities and the ability to differentiate between remote sightings of possible threats or harmless species.

The eyes are located on the side of the head and forward – this allows the Meerkat to watch out for approaching danger with lateral vision and focus on hunting directly in front too. Many predators have their eyes located forward in their heads for binocular vision and depth perception. Prey species often have their eyes located to the side of their heads to watch out for approaching danger, and will often turn their heads from side to side to get an indication of distance.

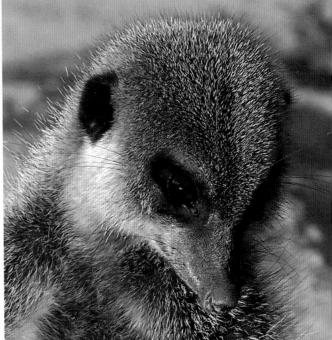

The Meerkat is the hunted hunter! It must watch out for danger approaching from around it as a prey species and simultaneously be able to hunt with depth perception from the forward-facing eyes.

The eyes are also situated high up on the head which allows the Meerkat to poke out only the top of the flattened skull and have the eyes with their light-absorbing dark masks level with the ground's reflective surface. This allows them to conceal their bodies, which remain protected within the burrow.

RIGHT: *The Meerkat has a dark brown eye with a round pupil rather than a vertically slitted pupil like a cat or a horizontally shaped pupil like a Yellow Mongoose.*

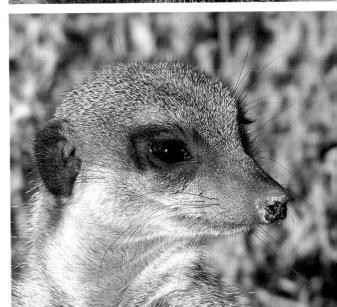

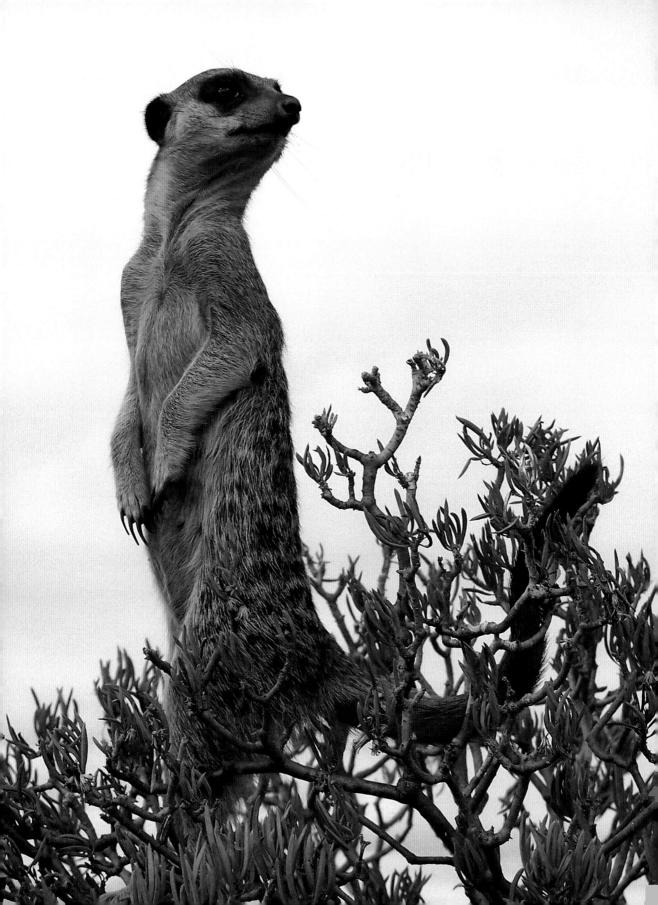

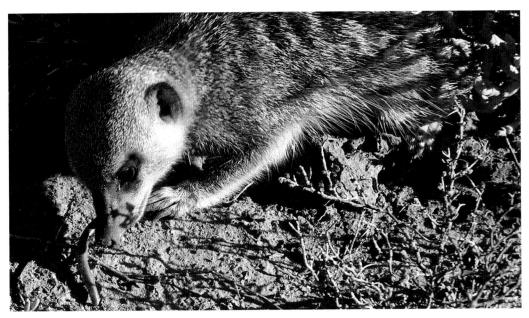

OPPOSITE: *It is very difficult for anything to approach a raised guarding Meerkat unobserved.*

ABOVE: *The very long nose of the Meerkat allows it to smell hidden food such as this reptile deep beneath the compacted Little Karoo soil.*

The eyes are able to see directly above the Meerkat due to the shape of the head. This allows it to have a very wide field of view around it to the sides, in front and above it. These incredible vigilance adaptations, combined with the Meerkats' highly sociable habits, make it very difficult to approach unobserved.

Frequently the Meerkat will bob its head up and down vertically to range-find or check the distance to an object, compared to the typical side-to-side movements of certain species of mongooses or owls.

Meerkats can differentiate between a threat or non-threat species when most humans fail to notice more than a tiny speck in the distance. This is evidenced by the predictable behavioural and vocalisation reaction given to a threat in the air such as an eagle, or a non-threat bird, and again to a threat on the ground such as a jackal and then a non-threat such as a small antelope. This is discussed in more detail in the section on predators and vocalisations.

The close-up vision appears to be fairly poor and a reliance on the senses of smell and touch are evident. Meerkats will commonly adopt an aggressive attack stance towards approaching group members which have been separated until they are close enough to be identified through smelling the groups' shared scent marks. Prey items that do not move are often overlooked until the Meerkat smells them rather than sees them.

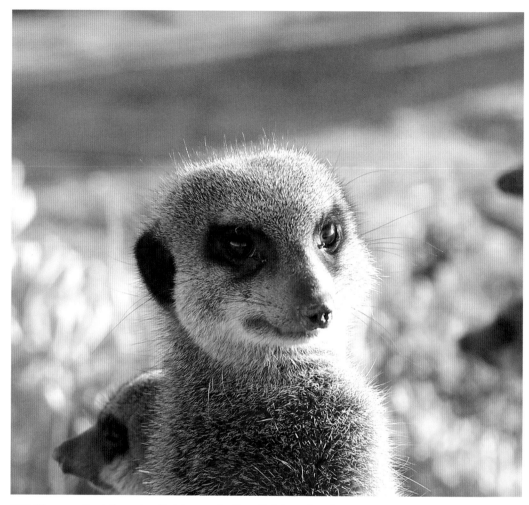

ABOVE: *Often many Meerkats guard and look in every direction with their excellent distance vision.*

OPPOSITE: *The dark eye mask is like built-in sunglasses; it is darker in the Little Karoo subspecies, lighter in the Kalahari subspecies.*

Eye masks

The dark eye masks surrounding each eye are the equivalent of inbuilt sunglasses that absorb reflective light and enhance vision in highly reflective surface areas or when looking directly into bright sunlight. Many aerial predators attack their prey from the direction of the sun, effectively rendering it blinded by the light. The Meerkat, however, can look directly into the bright light and detect these potential attackers. The Meerkat spends a great deal of its day focussed on the very reflective surfaces of the ground as it forages, so the masks again assist the Meerkats' vision by preventing blindness from the reflected albedo solar glare.

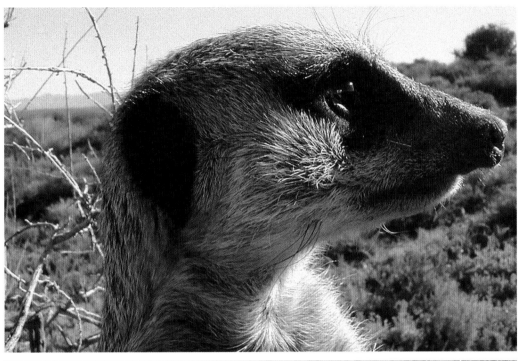

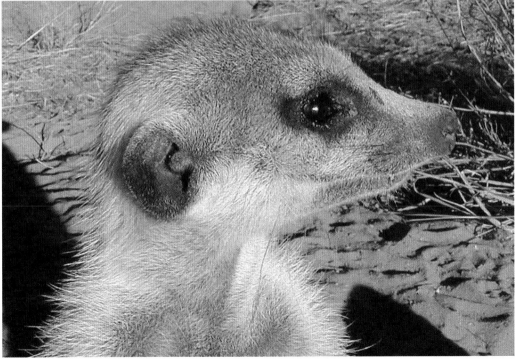

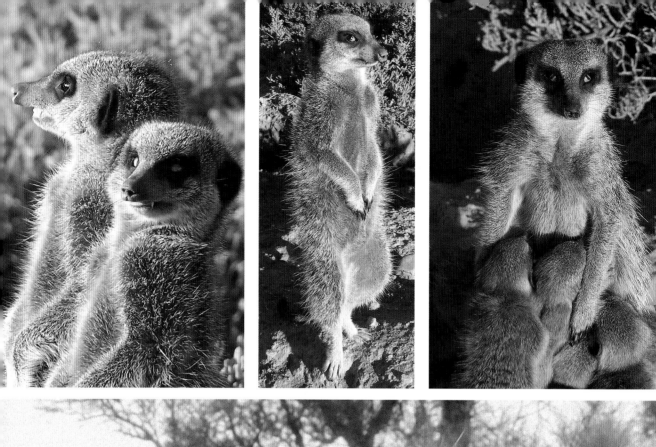

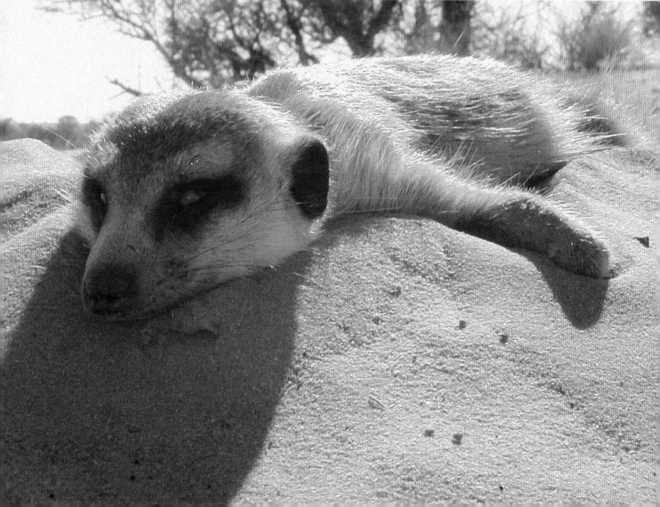

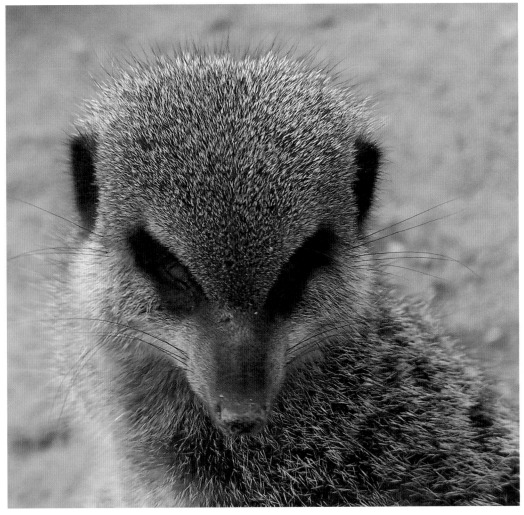

OPPOSITE AND ABOVE: *The nictitating membranes act as second eyelids which effectively protect the Meerkat's eyes from chemicals, dust and desiccation.*

Nictitating membranes

Each eye has a windscreen-wiper equivalent in the form of a membrane that prevents sand from damaging the eye and ensures the eyes remain moist. The membrane allows the Meerkat to effectively blink without the need to close its eyelids and expose itself to danger. The membranes cleanse the eyes into sandy tears that trickle down their dark velvety eye masks. The membranes also protect the Meerkat when it is attacking food with chemical defences that can be sprayed or exuded into the face, such as from defensive millipedes and predatory carabid beetles.

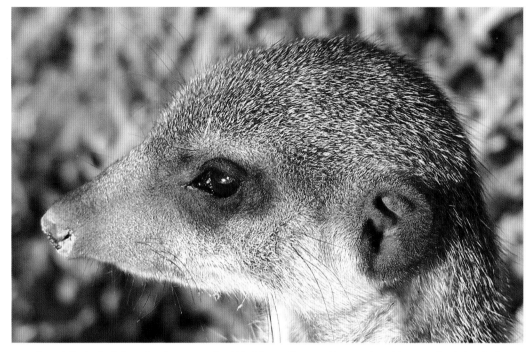

ABOVE: *A specialised valve in the external ear can seal and block the auditory canal to prevent sand from entering during digging.*

OPPOSITE: *The specialised 'windscreen-wiper' eye membranes can also be seen when Meerkats are simply tired, as with this dominant female who has had her babies drinking from her all night.*

Hearing

Each ear has a fleshy valve that can expand to seal the ear canal and prevent sand from entering it when the Meerkat is digging. Meerkats will frequently stop digging and often raise their heads and open their ear valves to listen for any possible danger or other communication from the group. The ears are very thick and fleshy and covered in soft fine dark hair. The thin paper-like ears are another feature which differs significantly from the Yellow Mongoose, which does not have a fleshy valve to seal the ear, but rather a dense covering of fine hair like that of a cat.

Olfactory

The nose is very flexible and proboscis-like and is jammed repeatedly into very compacted soil at times to discover hidden prey. The nose of a baby Meerkat is very rounded to allow for suckling without the nose getting in the way. The sense of smell of the babies is poor compared to that of the adults. As the nose grows longer, the depth that food items can be located beneath the ground increases from only a few millimetres when young to well below 1.5m (5ft) deep for adults.

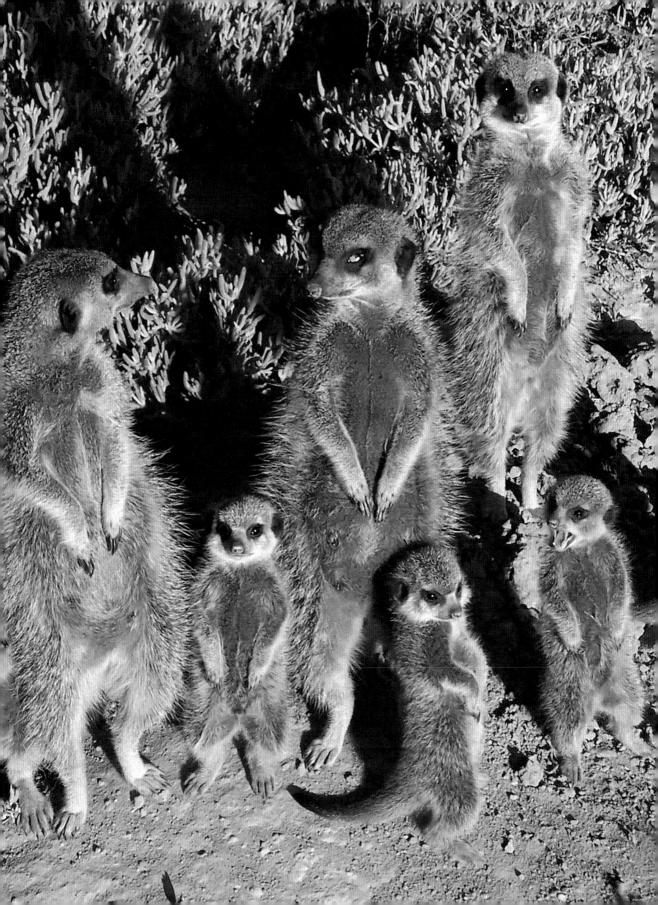

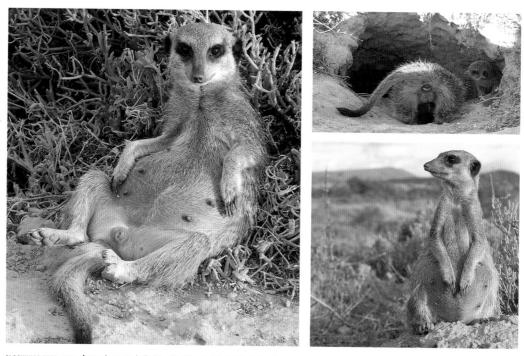

CLOCKWISE FROM LEFT: *A good way to help identify Meerkat individuals is also to count the number of mammae and to check their exact locations – this is easier to see when they are lying on their backs! Meerkat mammae are very large and produce milk before the pups are born. There are seldom more then six nipples in total; this is the Meerkats 'stamp of approval'. Male Meerkats have much larger paired scent glands then females, which they smear over everything that they recognise and trust, including each other and burrows.*

Mammae

There are usually six nipples, sometimes seven and even eight. Typically there are two pectoral, two abdominal and two inguinal pairs. Males' nipples are undeveloped compared to those of females.

Scent glands

There is a specialised paired anal scent gland beneath the tail, and this is very large and well developed in males. This thick skin is pushed outwards, enlarging in size when being used to mark and then being withdrawn again. The scent pouch contains transverse grooves which store a musky, greasy scent that is smeared onto the territory and onto Meerkats for olfactory identification. I refer to it as the 'stamp of approval' as only trusted or tolerated objects or individuals are marked. There also appears to be a cheek or salivary gland used for wiping scent in a similar way to the paired glands. Female Meerkats also occasionally urinate onto burrow entrances, lifting one leg to the side in a similar fashion to that of a dog.

Feet

The feet are naked with thick fleshy pads and dark grey skin. There is no hair on the underside of the paws at all, unlike the Yellow Mongoose which has very well-covered hairy paws. The front feet are much shorter than the very large vertical-stance-supporting back feet. There are usually four toes on each foot with additional toes being recorded on very rare occasions. The Yellow Mongoose has five toes on each front foot and four toes on each back foot.

The tracks of the Meerkat can easily be seen and identified in the soft sand of the Kalahari Desert due to their nail impressions and dragging tail.

Typically only footprints that are in wet soil will leave an impression in the compacted alluvial clay deposits of the Little Karoo.

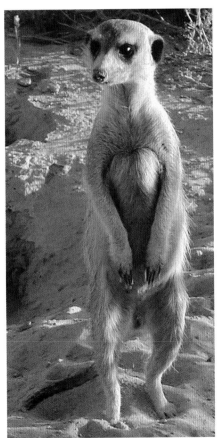
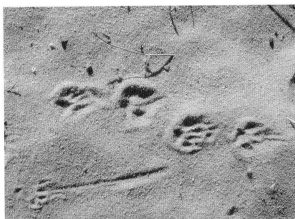
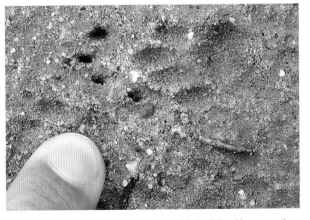

CLOCKWISE FROM LEFT: *There are four toes on each foot and their undersides are not covered in hair as with the Yellow Mongoose; the shifting Kalahari sand often reveals tracks. The Meerkats' distinctive four long nails on each foot and their drag marks are easily seen; the Little Karoo has very compacted soil and Meerkat tracks are seldom seen, except in the mud left after heavy rainfall.*

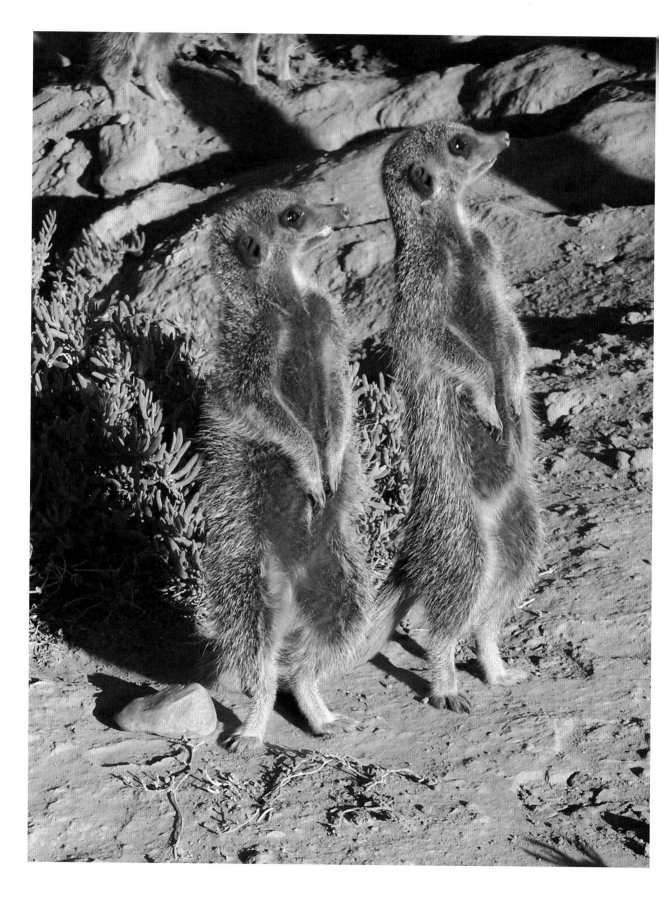

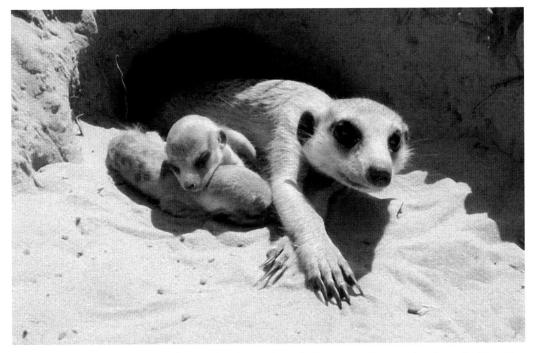

OPPOSITE: *The Yellow Mongoose has five nails on the front feet and four on the back – some Mongooses have five on the front and back feet – the Meerkat has four. Meerkat feet lack hair so the nail marks are easily seen.*

ABOVE: *Long nails on the front feet are used for digging, as weapons against aggressive prey and even as 'tooth picks'.*

Nail weaponry

There are four nails on each foot. The front nails are almost double the length of the four short nails on the back feet. The nails are non-retractile and if one is broken it appears that it will not regrow.

The front nails can be over 2cm (0.8in) long and are frequently used to grip prey and to assist in holding onto branches when climbing. The nails can also be held together to form a bucket shape in order to scoop sand more efficiently while digging or maintaining burrows.

The nails are more like those of a dog rather than the sharp claws of a cat, and are also used to impale food and protect the toes from injury. The nails may also be used almost like tooth picks to dislodge shells or debris from the teeth.

Nails often give the foraging Meerkat protection from the stings of scorpions and the bites of spiders, solifuges and other aggressive prey items. The nails prevent the skin of the feet from touching the prey. Nails are also used to drag and wipe away toxic chemical defences from certain food items such as millipedes and acid-spraying carabid beetles and ants. These prey items are vigorously rubbed and dragged along the ground, often with the Meerkat moving backwards while it does this.

Dentition

The dental formula is (36) with a distinct absence of carnassial teeth for the cutting and slicing of food. The sharp canines are used for puncturing and together with the bony ridged palate the crushing teeth dispatch softer prey or crush armoured exoskeleton shells. This contrasts with typical mongoose species such as the Yellow Mongoose, which has a dental formula of (40) and an extra two premolars in the upper and lower jaws that are adapted to cutting and slicing food. The tongue is abrasive with many backwards-facing hooks to help grip and rasp food and also to help in the cleaning of the teeth.

Life span

There is a high mortality rate for young Meerkats under one year. Adults may live to an average of four to ten years in the wild and around 15 years in captivity.

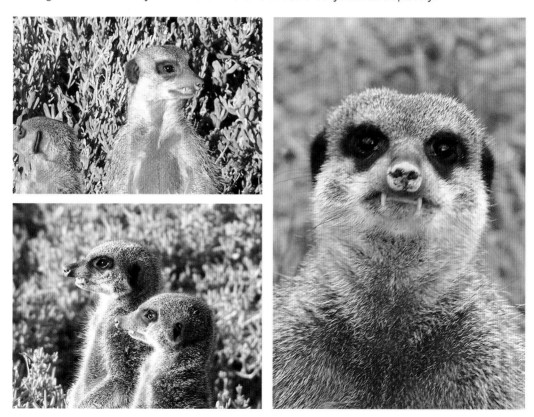

ABOVE, CLOCKWISE FROM TOP LEFT: *Long canines are used for defence, attack, and also for puncturing and holding food; occasionally during grooming, a Meerkat's nose will get pushed up and stuck behind the canines, creating an anthromporphised 'grin'; opening the mouth wide to make certain calls can cause the nose to become stuck behind the teeth, resulting in a 'smile'.*

OPPOSITE: *Meerkat littermates may form lifelong bonds. They will commonly hug each other as they grow up.*

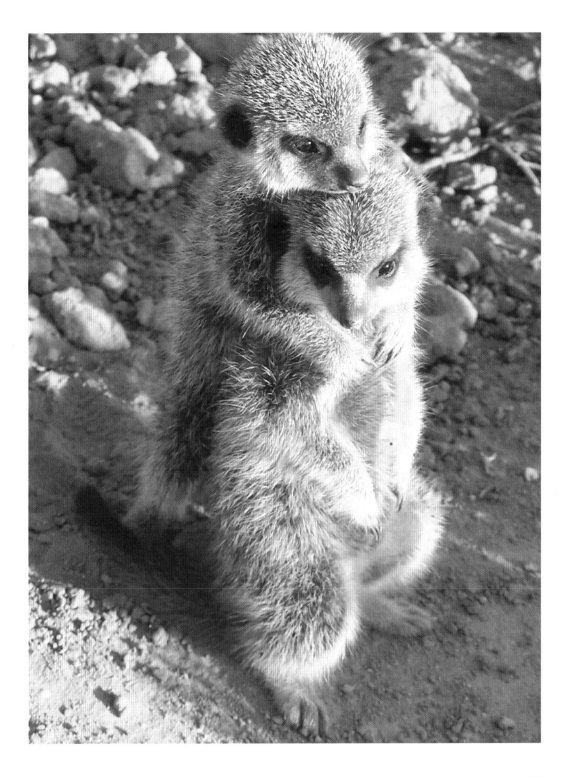

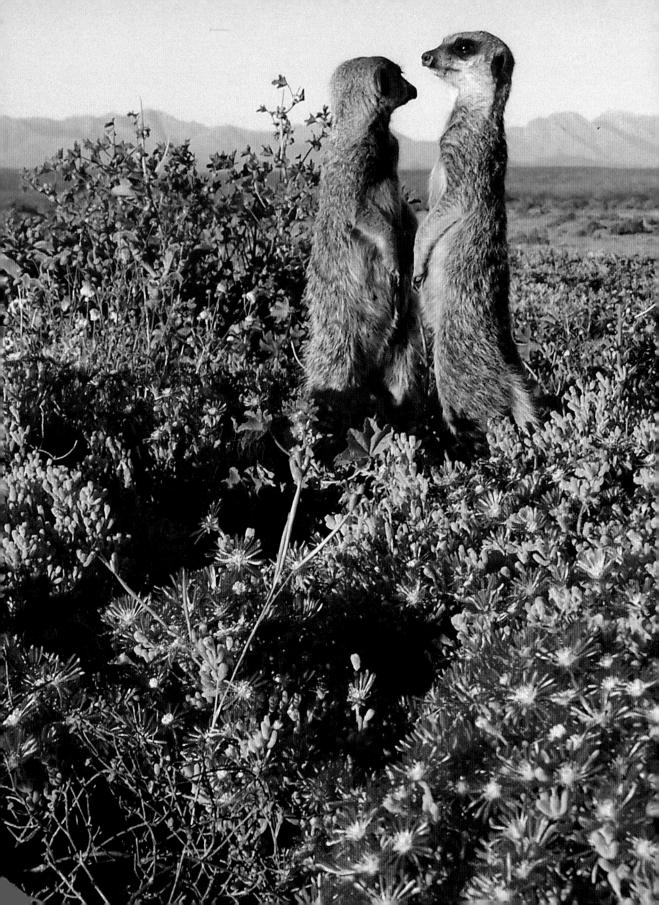

POPULATIONS AND DISTRIBUTION

THE TOTAL WILD MEERKAT population is unknown and can only be guessed at. Locating and counting wild Meerkats can be a very challenging process. Meerkats are very secretive and small and are covered in effective camouflage which enables them to avoid being easily seen. They use underground burrow systems to quickly escape from possible danger or disturbances. Together with their incredible alertness and complex social guarding characteristics, very few observers simply find Meerkats without actively searching for them.

Larger non-burrowing animals can easily and accurately be counted with ground or aerial surveys. These surveys are completely ineffective for monitoring wild Meerkat populations. From great distances, the Meerkats will quickly identify and hide from noisy aircraft or unknown human observers in an area.

In the Little Karoo the compacted clay-rich soil is covered in dense succulents, which effectively hide burrow systems. Meerkat tracks seldom make an impression on the sun-baked clay sand which makes information on activity difficult to ascertain.

Meerkats favour dry arid regions, usually without dense trees and with more open scrubland. These preferences are well catered for in ancient river beds and salt pans and valleys. The rainfall in the distribution areas varies from around a very low 9cm (3.5in) to around 58cm (23in) per annum.

Distribution records show confirmed Meerkat sightings in southern Angola, Namibia, Botswana and South Africa.

OPPOSITE: *Finding Meerkats in the Little Karoo can be challenging due to the vast area, dense plant-cover and compacted soil which does not easily reveal tracks.*

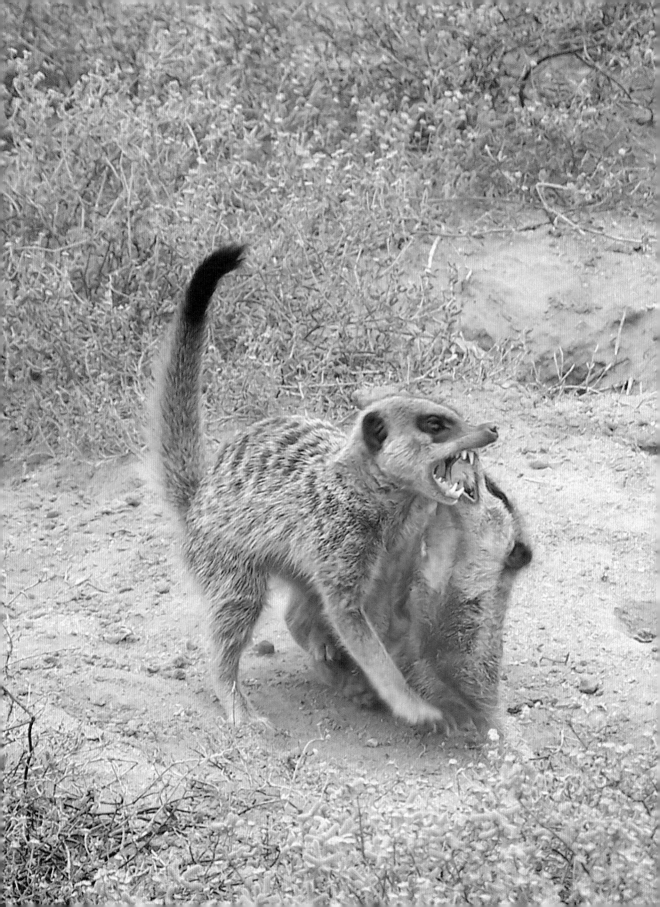

HABITS

BEING A DIURNAL SPECIES is a dangerous challenge to the noisy and highly sociable Meerkat. They are not stealthy and solitary foragers like some of their mongoose relatives. A great benefit in being sociable is that there are many alert eyes, ears and noses that contribute towards a collective vigilance for daytime survival.

Contrary to the popular view that Meerkats take turns in guarding and babysitting 'duties', it will be revealed how Meerkats are 'mammalian multi-tasking masters' who are not specialised into singular activities but are motivated primarily by their physical condition as to which behaviour they engage in.

The Kalahari Desert is primarily a summer rainfall area compared to the predominantly winter rainfall area of the Little Karoo, which impacts on the strictly diurnal behaviours of the Meerkat species.

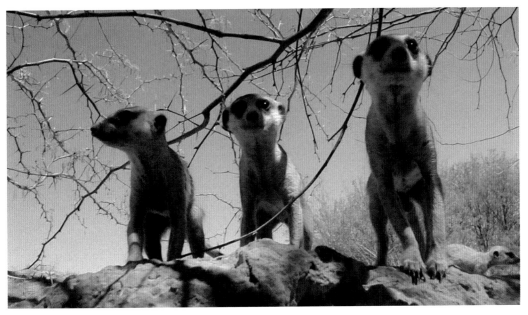

OPPOSITE: *Playing is an indicator of surplus energy and good condition. It is an essential social bonding behaviour between individuals and begins a few weeks after birth.*

ABOVE: *Meerkats are very curious and alert and will closely inspect anything for signs of danger.*

48

This is a brief introduction to some of the commonly encountered behaviours over the course of a typical Meerkat day. These will be elaborated on in more detail under their respective section headings.

In summer Meerkats will emerge from their burrow around sunrise, and in winter or on overcast days usually a few hours after sunrise when it is slightly warmer. Upon emerging Meerkats will usually engage in thermoregulatory behaviours such as sunning their bellies or huddling for warmth. Burrow maintenance may begin to occur, or in winter digging aerobics.

Sporadic play fighting may also occur, but this is usually seen later in the day when the Meerkats have eaten well, as playing is often triggered by good condition and surplus energy.

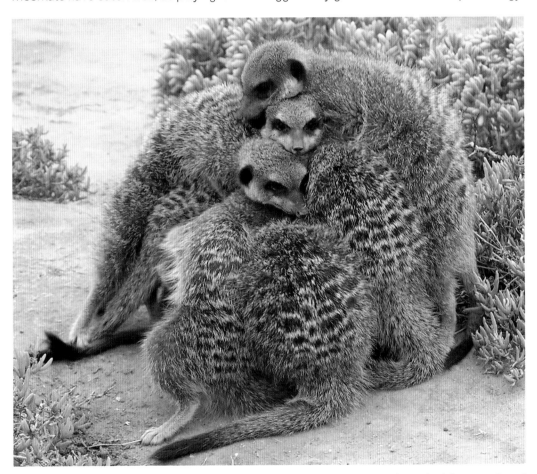

OPPOSITE, TOP TO BOTTOM: *Meerkats are strictly diurnal and will usually become active shortly before or after sunrise during warmer times of year; on colder winter days Meerkats will not rest during the day but will usually wake up long after sunrise and sleep before sunset.*

ABOVE: *Meerkats may congregate and press their sparsely haired undersides against each other in co-operative thermoregulation during colder weather.*

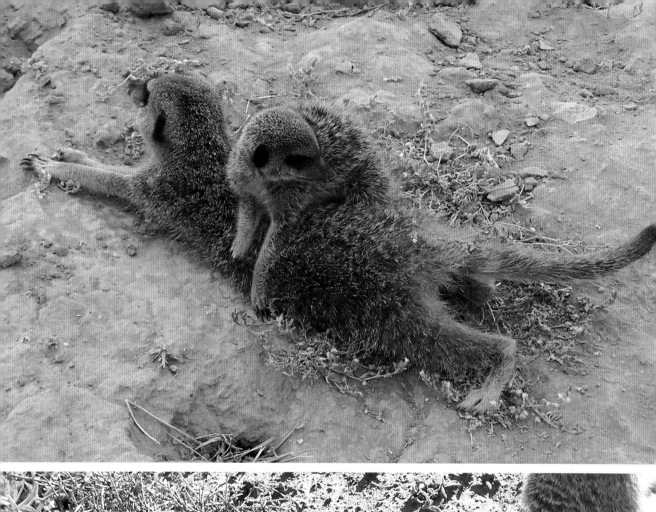

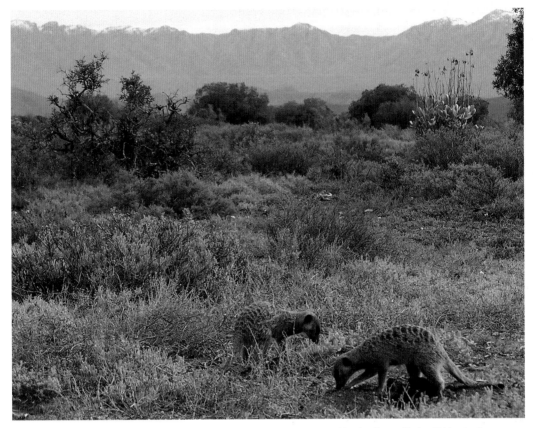

OPPOSITE, TOP TO BOTTOM: *There is a great deal of stretching and yawning at the start of the day. Pups will often hold onto others to warm up or play; after warming up Meerkats will often take a few moments to stretch out on their stomachs and often drag themselves along with their front nails while yawning and bending their tails.*

ABOVE: *Hungry foraging Meerkats spread out and dig for food.*

When all the Meerkats have warmed up enough through sunning, digging or playing they will begin to call and stretch and group in a specific direction of travel for the day. The dominant female is frequently the one to determine which direction will be chosen for the day, and will call loudly and move off with the others following, making a loud drawn-out humming call.

Some Meerkats will stand up at intervals and guard while others move along. This forms the equivalent of a reconnaissance with scouts, rear guards and those along the movement line, appearing as if performed with an almost militaristic practiced precision.

Once a foraging area has been selected, the Meerkats will slow their pace and begin to disperse and actively call out to each other as they search for food and look around while they move, watching for danger. They will also sit and stand on guard for brief periods while they pause between spells of foraging.

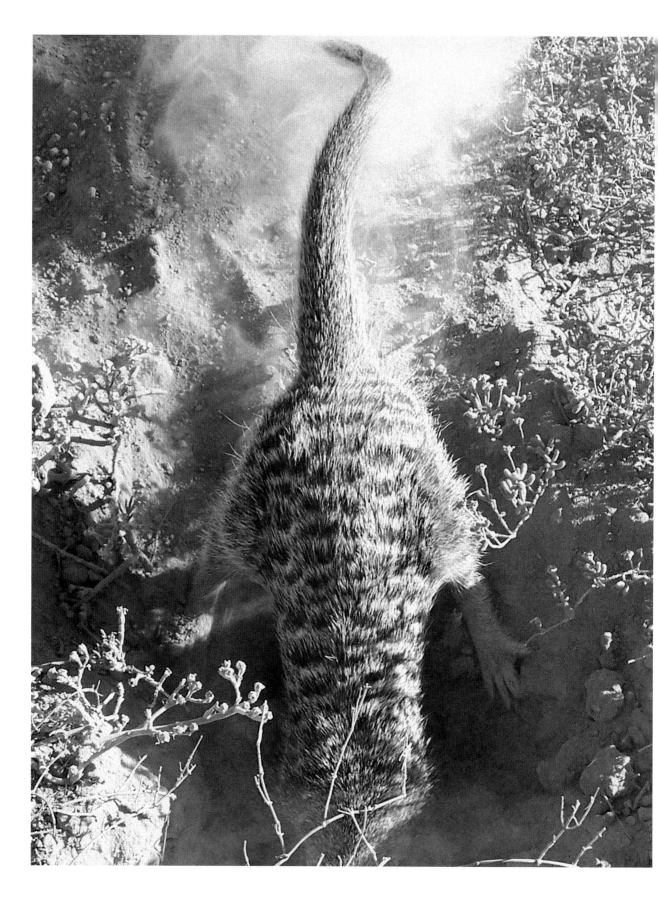

Older and more experienced Meerkats often find larger food items quickly and this allows them to begin guarding for longer periods at a time. They will commonly begin to climb onto objects and up into vegetation as raised guards. If the group remains in an area for a few hours, a raised guard who has eaten very well may climb to a height of over 8m (25ft) above the ground, using vegetation or other suitable objects.

They may remain there for a few hours broadcasting intermittent assurance messages, unless a threat is seen and then these vocalisations will transform into threat alert warning whimpers and may escalate and become piercingly loud shrill barking to warn of an imminent predatory attack.

The Meerkats will also investigate any escape tunnels they encounter over their morning meanderings. The dominant breeding pair will frequently scent mark the entrances of these safety sinkhole zones, and if the escape tunnels are in need of repairs various Meerkats will begin to renovate these before the group moves on.

OPPOSITE: *Burrow systems are often actively renovated to ensure that they can be used if danger approaches.*

ABOVE: *Elevated guarding commonly occurs when Meerkats remain in an area to forage. It may last over three hours.*

In summer the Meerkats will move into cooler shady areas over the course of the morning as the temperature becomes hotter. They generally gather much closer together in the shade and begin to call increasingly loudly as they forage. Often these relatively harmonious hunting periods may quickly break out into brief growling tussles due to close proximity and resource competition.

From a distance of many metres away from these industrious diggers, a research observer may find themselves wondering if they are hallucinating in the heat as the shadowy vibrating and shaking bushes around them emit all manner of growling and excited foraging, crunching, scratching and sand-snorting sounds.

As the day grows hotter the Meerkats will begin to actively cool off by lying on their backs, or against succulent plant 'chairs', making shallow scrapes in the soil, covering themselves with the cooler sand and pressing their sparsely haired undersides into these cooling scrapes.

They will also move into escape tunnels to get away from the heat.

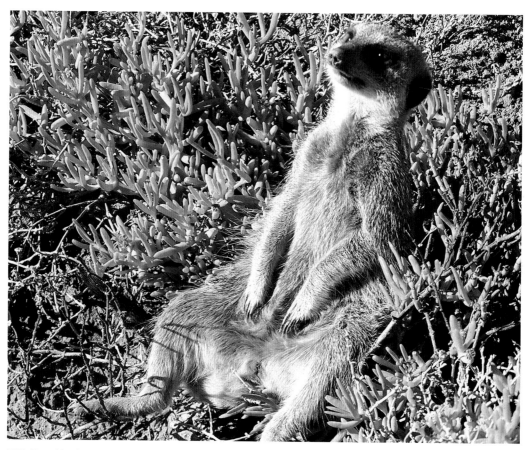

Little Karoo Meerkats will commonly lean against succulent plants that cool them down during the heat of the day.

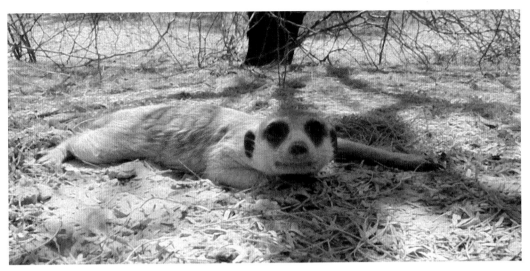

Kalahari Meerkats make shallow scrapes in sand and stretch their bare bellies into these cooling crevices.

In winter, Meerkats do not need to rest during the shorter days, and due to them waking up later, due to the later sunrise, they also have less time to forage for food.

After the resting and cooling down period in summer Meerkats continue their foraging and will then begin to move to a sleeping burrow for the night. The dominant female again ushers the group in a specific direction that she wishes to move in. The dominant female is the historic archival system heir of the territory that she inherited from her mother – the previous dominant female.

She knows the whereabouts of all the escape tunnels and sleeping burrows, where to locate the best food reserves, and which predators are the most dangerous. All the other Meerkats in the group follow her. The dominant male is not the one who leads the matriarchal Meerkats as some people believe, as he is inevitably a migrant from another territory and is unrelated to the dominant female. The dominant male never grew up in the area as she did, and this is why he will follow her lead. The dominant female and not the dominant male is the leader.

Anybody who does not follow the oldest and most experienced dominant female will be placing themselves at great risk, as nobody knows the territory as well as the dominant female does. This incidentally is a primary reason why the releasing of captive Meerkats into an area is highly unethical, as the released animals have no idea of the territorial challenges that would have been acquired over a lifetime of learning in the wild.

Size, weight and strength are not what primarily determine a wild Meerkat's leadership and survival skills, but rather age and experience. Big strong Meerkats that may be safe in captivity are helpless in the wild.

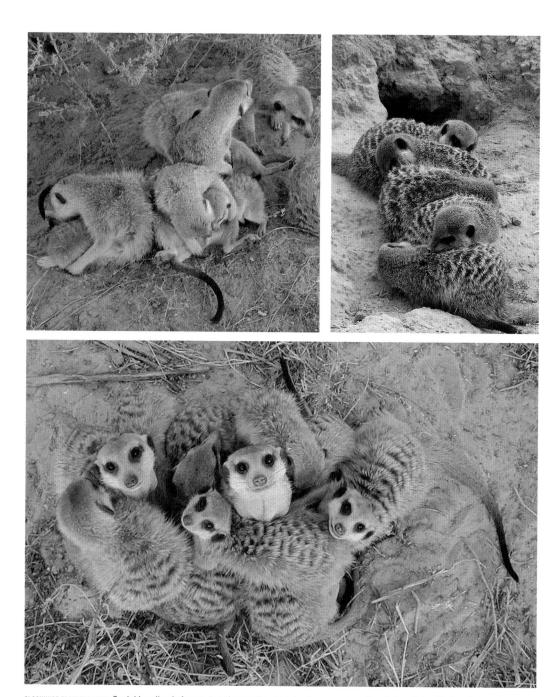

CLOCKWISE FROM TOP LEFT: *Social bonding is frequent at the evening sleeping burrow, where Meerkats will huddle together and groom; although babies are groomed extensively by the group, they do not groom other Meerkats; allogrooming is important behaviour in terms of parasite removal and social bonding.*

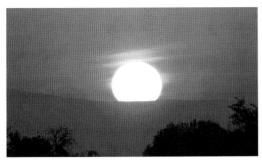
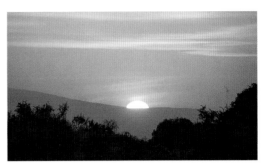

TOP LEFT AND RIGHT: *At sunset Meerkats to return to the closest sleeping burrow. They do a little burrow maintenance, social bonding and grooming before going to sleep.*

ABOVE: *Meerkats are sometimes active under bright moonlight. However, an unfamiliar sound will send them rushing for the safety of the burrow entrances and sometimes result in a body jam.*

When the Meerkats arrive at their evening sleeping burrow, they investigate the various entrances, and once the dominant male has scent marked the chosen sleeping area the group will often participate in burrow maintenance. They will clear the sleeping chamber and connecting tunnels.

Once they have cleaned the sleeping area they will usually groom each other and frequently huddle together and rest before they begin to move into the chosen burrow entrance for the night.

On warmer evenings Meerkats will sometimes remain awake and not retreat below ground into their burrow after sunset, especially with the presence of the full moon's light.

They may fall asleep, but the slightest evening sound could send them rushing into a burrow and even block the entrance with too many bodies trying to squeeze below at once. They risk predation from owl species in particular during these late investigations into the unfamiliar and dangerous nocturnal realm.

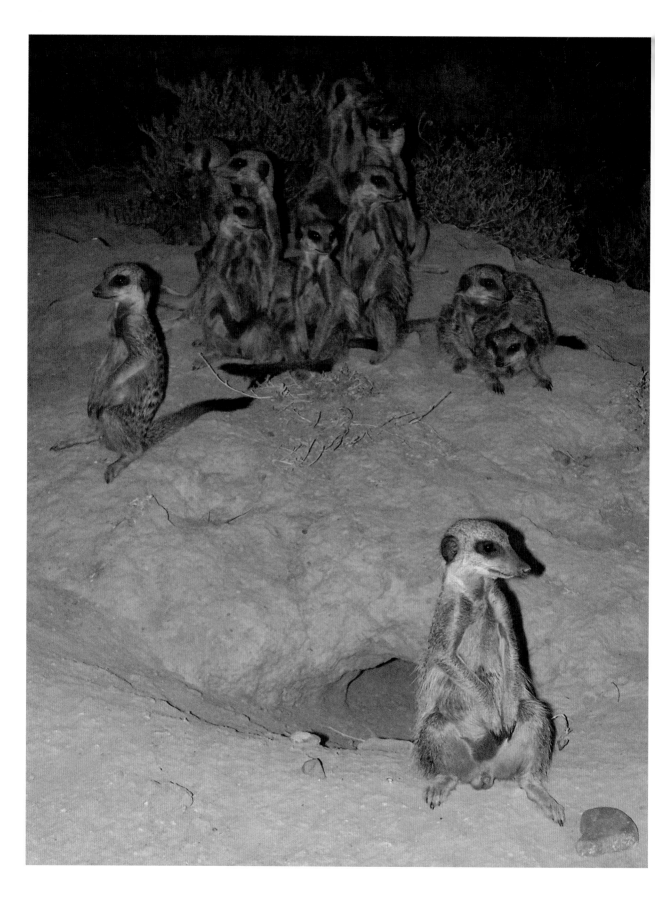

TERRITORIES AND
BURROW SYSTEMS

THERE IS A VERY CLEAR preference for compacted, alluvial and sedimentary soils and those containing calcrete deposits frequently located in ancient or fossilised river bed systems and dried up salt pans.

Very soft shifting sandy soils and very loose rocky soils are avoided due to the fact that they would compromise the burrows' structure and stability. In areas which have unsuitable geology, burrows will collapse and even trap and kill Meerkats. This specialist preference for certain geological habitats is an essential determining factor as to where Meerkats can naturally occur throughout their distribution.

Territory sizes vary from around 4 sq km (1.5 sq miles) to over 12 sq km (4.6 sq miles). Meerkats can travel more than 2–3km (1.2–1.8 miles) in a day in search of food before selecting a sleeping burrow for the night.

The daily activity times and distances travelled are influenced by various factors and include amongst others: the seasons of the year; group size; food availability; climatic conditions; neighbouring groups; scent marking territorial maintenance; predators; parasite infestations; breeding status; and the presence of young.

Extreme events such as fires and floods have a significant impact on the Meerkats' territory. Fires destroy dense vegetation but improve visibility and may open previously densely vegetated and dangerous poor visibility areas of the Meerkats' territory for safer foraging. Floods renew food resources and vegetation, but increase the incidence of intergroup aggression with the removal of scent marks in a territory.

Although rainfall brings an abundant feast for Meerkats, it also brings additional challenges with reduced visibility and guarding being compromised. Higher plants result in poor ground-level visibility which may seem to offer additional cover for foraging Meerkats from the ever-hungry predators that hunt them. However, the opposite is true and the denser vegetation also offers cover to predators, resulting in Meerkats being highly vigilant and frequently climbing above the surrounding vegetation for a better view.

OPPOSITE: *Meerkats make their burrows in compacted alluvial soils, avoiding very loose and rocky unstable ground that could collapse.*

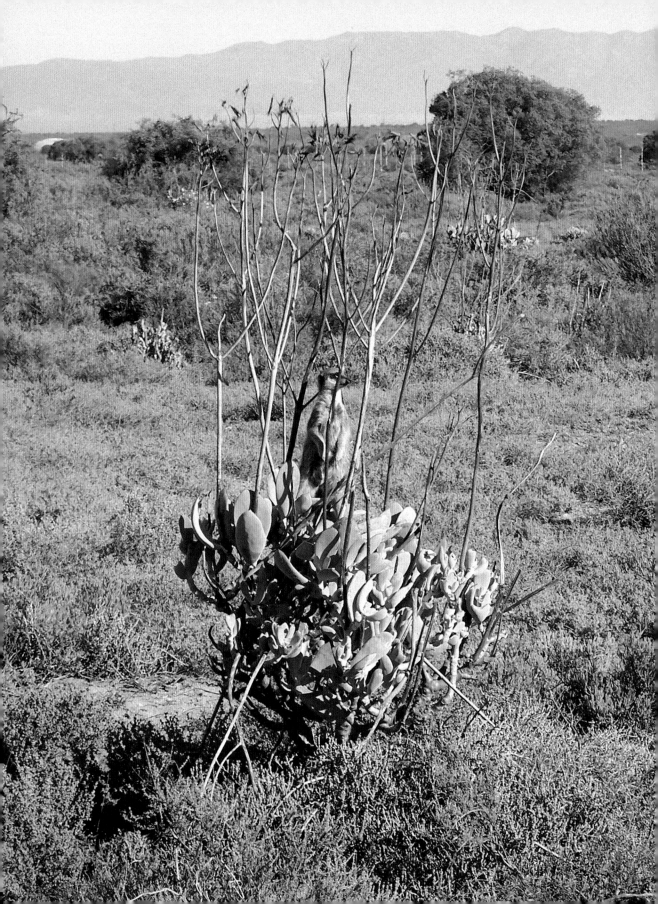

When Meerkats are trapped at a bolt hole and are unable to forage, or they are unable to return to any young at a breeding burrow, for any of the numerous reasons mentioned, this has a very negative impact on their survival. For each day that the babies remain at a burrow and are unable to forage with the group the risk escalates. Although Meerkat babies are often safer at a burrow system, unforeseen developments leading to the Meerkat group being trapped away from the babies, or divided, could be disastrous for a litter's survival chances.

There can be anything from four to forty or more main sleeping burrows in a territory. Each burrow can have from five to hundreds of entrances and exit tunnels. Sleeping burrows can be anywhere from a few hundred metres apart to a few kilometres apart. Usually, if no young are present, different sleeping burrows are chosen each night, often according to their proximity to the Meerkat groups' location at the end of the day's foraging. However, all of the factors mentioned above impact on the burrow and territorial usage.

Bolt holes are a security network of temporary burrows which are usually positioned every 40m (130ft) or less in multiple directions throughout a territory. These are often created after extended digs for food and seldom have more than two to four entrances. They are not commonly used for sleeping unless the Meerkats are trapped by a predator, rainfall, dust storm, fire or intergroup aggression. Meerkats even use hollowed out trees as the equivalent of 'bolt trees'.

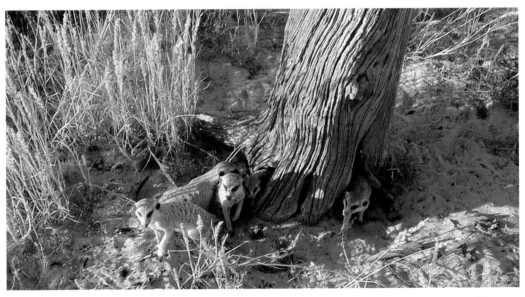

OPPOSITE: *A Little Karoo Meerkat climbs onto a large succulent to get a better view over the surrounding area and scout for possible danger.*

ABOVE: *A Kalahari Meerkat uses an escape tunnel inside a hollow tree. These 'bolt-trees' are scent marked and renovated like 'normal' underground tunnels.*

Burrows have many different entrances to allow for greater safety, and they do not all face in the same direction. The interior of a burrow has a gradual slope, allowing water to infiltrate the first few metres of the tunnel without flooding the sleeping chambers. These have an ecological impact as the equivalent of nature's storm-water gutters.

Over many generations of digging architecture these designs have been perfected and maintained to allow water to easily soak into the ground but prevent the flooding of the inhabitants. Of course, all badly designed burrows would have collapsed or killed the inhabitants, resulting in those designs not being used by others through natural selection.

Burrows that occur in different soil-types may be used more frequently in hotter or cooler times of the year. Certain burrows may be used for better visibility or because they are in different topography, allowing for more sunlight in the winter months, or less in the summer. These burrows may be more sheltered from temperature changes at different times of the year by being blocked by shadows or sheltered by mountains or other features respectively.

Meerkats in the same area will often emerge at different times due to these geological and topographical variations and their activity periods are also influenced by other factors mentioned in the diet and predator sections.

Burrows are inherited and maintained from one generation to the next. Nobody knows how far back these burrow systems and Meerkat families can be traced beyond a few decades of field research.

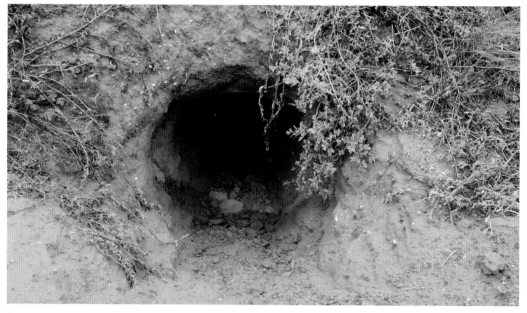

Burrow systems are designed to avoid flooding, but can serve an important ecological function preventing severe soil erosion by channeling water rapidly deep into the ground as natural storm water gutters.

Wildlife hotels and residents

Although burrow systems are commonly shared between many different species, these are the equivalent of a 'hotel' for wildlife, with many residents sharing the same structure but mostly sleeping in different chambers.

Even though meerkats actively share these sleepy sanctuaries with other species, they do not usually encounter each other in a competitive way as they are not often competing for sleeping space or the same food or activity periods. The hotel guests will renovate or add additional chambers to the structure.

A large earth-excavator such as the Cape Porcupine (*Hystrix africaeaustralis*) is primarily a vegetarian and is mainly nocturnal. It serves the function of the 'hotel lawnmower', keeping the vegetation lower around the burrow which beneficially improves visibility for other residents.

Another earthen mass mover is the Antbear or Aardvark (*Oryteropus afer*), which is the equivalent of a termite and ant vacuum cleaner on legs, eating many hundreds of thousands of these insects each night, and it does not compete for food with the other nocturnal vegetarian residents.

The Bat-eared Fox (*Otocyon megalotis*) can be a threat to young Meerkat babies, but is often tolerated by older Meerkats at the same burrow system when there is an abundance of food available, such as the commonly shared termite species or with grasshopper, cricket and locust swarms.

Cape Ground Squirrel (*Xerus inauris*) is a very active digger that often remains at a burrow system for longer periods than the visiting Meerkats. The squirrels are the equivalent of the 'hotel staff' and are frequently chased away from the chosen sleeping chambers of the Meerkats. The squirrels actively alarm if any danger is approaching and do not compete with the Meerkats for food resources.

The Yellow Mongoose (*Cynictis penicillata*) and the Slender Mongoose (*Galarella sanguinea*) will frequently use the same burrow systems as the Meerkat. Although they can be a threat to Meerkat babies, these mongooses are often active at different times of day to the Meerkat and also commonly eat a diet consisting of larger vertebrates so they do not compete with the Meerkat directly either.

South African Springhare (*Pedetes capensis*) is a nocturnal rodent which is often chased out of its sleeping chamber by visiting Meerkats. The secretive Scrub Hare (*Lepus saxatilis*) will also use the same burrow system as the Meerkats and may be evicted when Meerkats visit. Other rodents that could be caught by the Meerkats also use the same sleeping burrow system but make smaller entrances. These include the Karoo Bush Rat (*Myotomys unisulcatus*), the very sociable Brants's Whistling Rat (*Parotomys brantsii*) and the Striped Mouse (*Rhabdomys pumilio*).

I have noticed the remnants of terrestrial nesting bird excavations in burrow entrances too.

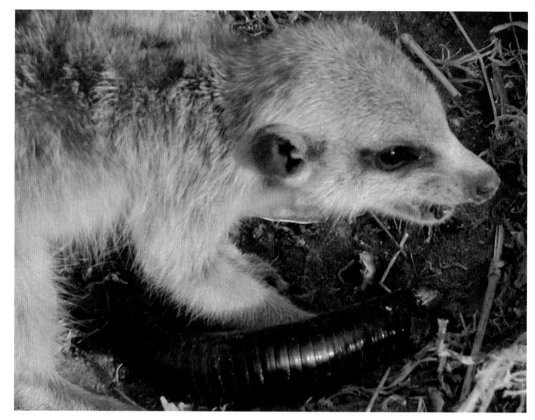

Arthropods such as millipedes act as mobile moisture reservoirs that can be eaten during times of drought. These food items are chemically defended and not commonly eaten when other food is abundant.

Although tortoises often use Meerkat burrows to escape from the cold and to aestivate over the winter months, they are simply another 'wildlife hotel resident' and are not a threat to the Meerkats. Tortoises such as the Leopard Tortoise (*Geochelone pardalis*) and Angulate Tortoise (*Chersina angulata*) are often sniffed and may have younger Meerkats climb onto them in play. Predatory snake species often move into burrows and these will be discussed in the section on predators.

Insects such as wasps also use burrow entrances to make their own nests, and the dung beetle actively removes dung from burrows and is surprisingly not attacked and eaten by Meerkats.

Often hundreds of invertebrate millipedes will swarm out of burrows after good rainfall to go and breed and create nests in the softer wet soil. Meerkats will commonly dig millipedes out of their chosen sleeping chamber, but seldom eat them unless there are not many food items on the seasonal menu. Millipedes may serve the function of

mobile moisture reservoirs as they are often attacked in the hottest and driest times of the year and especially over drought periods, but left unharmed for the majority of their Meerkat encounters when more succulent species are abundant.

I have noticed how Meerkats who were born during drought periods with very little food variety available and who were raised on millipedes still favour these chemically defended items when other Meerkats born in wetter seasons will not even attempt to eat these. This illustrates that what a Meerkat baby is taught to eat influences its food preferences as an adult. The seasonal food variations will impact on food selection choices for individual Meerkats.

Interestingly, when millipedes are breeding they are left alone as they will breed during the seasonal rainfall periods. These wetter times provide an abundant selection of alternative tastier food items for the Meerkats to hunt instead. These infrequent arthropod population reductions still favour the millipedes' survival, even when living with one of its hunters.

Spider species also inhabit burrows and often make their webs over entrances.

Clearly burrows have complex ecologies and provide habitat for a wide range of species. Tragically these burrows are often ploughed over or trampled by livestock and need to be actively protected.

Scent maintenance

I imagine that if I could see the scent trails of Meerkats leading from every burrow in their territory it would appear to be a vast webbed network of olfactory scent highways and trails. Some would glow brightly and others would be faded, in accordance with the most recent scent marking maintenance in an area.

After rainfall Meerkats often forgo foraging for food and appear to go on energy expensive 'Meerkat marathons'. During these energetic days great distances of many kilometres can be travelled with almost no resting, in order to re-mark all the rain-deleted messages around the territorial message boards.

There is an obvious increase in intergroup encounters after rainfall, also suggesting that scent warnings are no longer present to warn rival groups.

It may take three or more weeks for the Meerkats to complete scent marking all of their territorial boundaries after rainfall, which suggests that the scent duration begins to fade after that time and new 'smell mail' needs to be refreshed and posted.

Although Meerkats do not typically have a communal midden as many mongoose species do, Meerkat dung is deposited in shallow scrapes around the territory. This usually happens during foraging when the Meerkat has dug up a food item, often amongst plant roots, and the dung is deposited like compost for the plant.

However, in overlapping ranges where more than one group of Meerkats use the same burrow system, extensive communal defecation occurs by multiple members together. This is also referred to as over-marking, when scent is actively marked over by a group. After a fight with a neighbouring group or after being separated by any event, over-marking on Meerkats within the group also occurs through scent-wipes which appear to reaffirm group bonds.

Dung is not buried and acts as a longer term scent message that may announce the breeding status of various group members, how many males and females are within a group and whether or not there may be a 'breeding vacancy advertised' for migrants or simply as a message to broadcast 'stay out of this area – you have been warned!'.

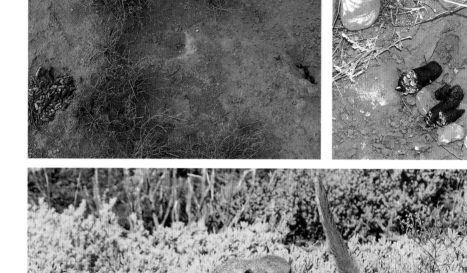

CLOCKWISE FROM TOP LEFT: *Unlike the Yellow Mongoose, which uses a large dung midden every day as seen on the left, the Meerkat will not use a midden and will make a shallow scrape and deposit a long-term scent 'package' as seen on the right at the same shared burrow; Meerkats dig a hole but do not cover their dung, leaving it as a lasting scent message to others. They frequently dig around the roots of plants, feeding them with recycled nutrients; the 'stamp of approval' is given to all recognised group members, and some members may be 'approved' many times over!*

To prevent intruders from surrounding Meerkat groups consolidating an unmarked territory into their own, frequent scent marking must be performed. This is basically what I call 'smell mail', the Meerkats' equivalent of emails, or an 'SSMS – scent short message system', an olfactory bulletin board of events within a group.

When visiting a burrow system for the first time over a day, the dominant male will typically scent-sniff the entrance very cautiously before exploring the burrow tunnel and connecting chamber, upon emergence the male will then scent mark the entrance with his paired anal glands – giving them the 'all is well stamp of approval'.

The dominant female will occasionally also scent mark entrances, but not as frequently as the dominant male. She will also urinate on entrances.

Many different Meerkats within the group will then begin to investigate the scent-approved burrow and begin with burrow maintenance. This co-operative digging is not a specialised turn or role or even a duty reserved for specialists as has been believed and any individual may dig. Often relays of many Meerkats in a row form as they clear away loose sand and debris and enlarge damaged burrow entrances.

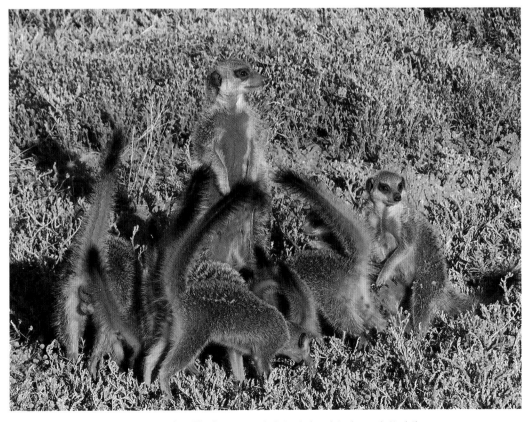

There is an ongoing daily territorial war where Meerkats aggressively track down intruders and attack them.

Meerkats at War

Although Meerkats within a group are highly co-operative, which benefits their daily survival, they are highly aggressive with regards to other foreign Meerkats who surround their territory.

It is a violent and dangerous world that a Meerkat group inhabits. Meerkats are totally intolerant of their opposition, and although encounters are uncommon between groups and actively avoided they can be deadly. There is an ongoing 'Meerkat war' – most of the time it is a cold war, amounting to nothing more than warnings and posturing. Actual aggression is to nobody's advantage as devastating losses could occur.

Migrant male Meerkats are the equivalent of 'suricate scent spies' as they migrate and investigate the possible breeding opportunities and strengths and weaknesses of surrounding Meerkat groups.

It is far better to avoid any confrontation. Occasionally hostilities are put on hold due to rainfall and floods, dust storms, fires and predation. Despite these environmental 'suricate cease fire' intermissions, Meerkats continually scent mark their territories to install preventative security measures. If one Meerkat group encounters another occupying the same overlapping territory at the same time there is war.

After intergroup encounters, separated young are occasionally consolidated into a foreign group which could have an unintentional genetic dispersal benefit to Meerkat populations.

Larger territories may contain more resources but also require additional members to protect the larger boundaries. The balance between available resources within a territory and group sizes seems to be well balanced. If the demand on resources exceeds the supply, Meerkat groups may go extinct or disperse or simply not have many litters survive. This balance between the resources and the predatory Meerkat is a stable one.

Meerkat territories overlap with each other, utilizing all possible habitat space. These interlocking areas are sometimes shared burrow systems from more than three groups. If these groups arrive at the same burrow together, a very aggressive and impressive visual and vocal spectacle usually ensues. This has been called the war dance or agonistic display.

OPPOSITE: *Agonistic displays consist of Meekats puffing out their hair, arching their tails over their backs, climbing onto vegetation, scratching the ground and standing up on their back legs. Meerkats move menacingly towards any intruders they encounter and try to intimidate rather than attack and risk injury. Usually this posturing is sufficient to persuade a smaller rival group of Meerkats to withdraw from the contested area.*

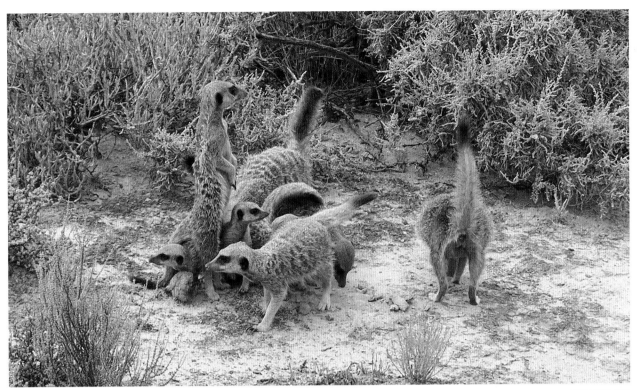

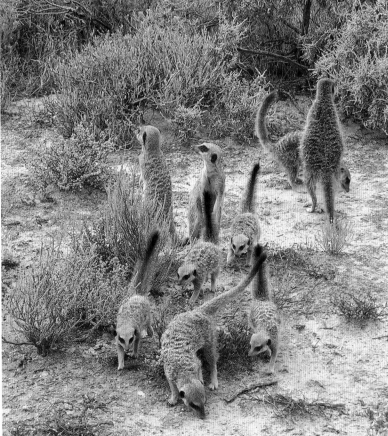

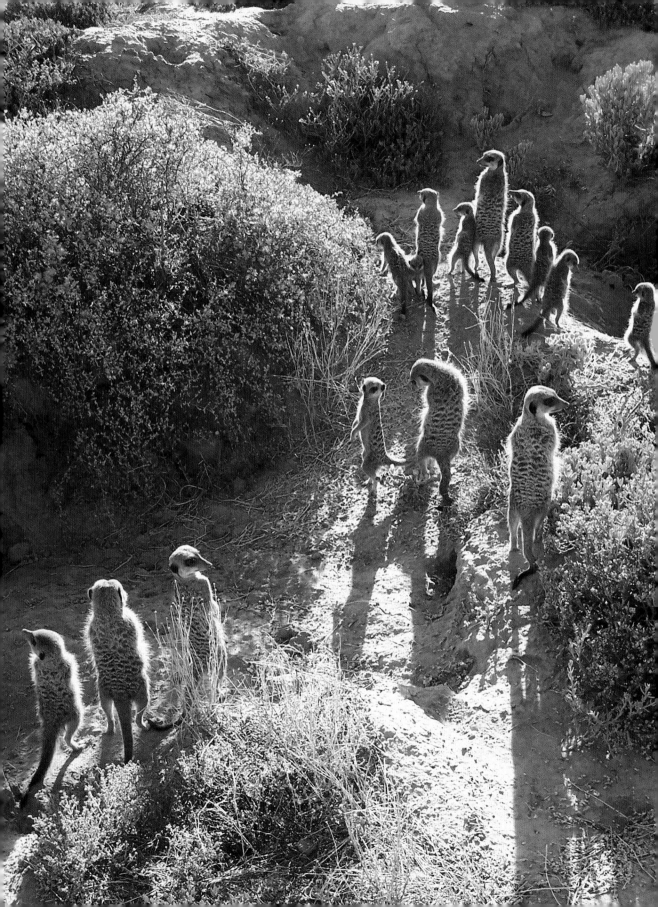

The breeding burrow system

Moving from one burrow system to another can also be determined by the breeding status of a group, when they have young they will remain at the same burrow for two weeks to over a month. Food availability is reduced exponentially the longer a group forages in the vicinity. When the young are old enough to move to a different burrow location, it allows food reserves an opportunity to replenish before the Meerkats return to that region again, which is usually after a few weeks on average.

Breeding burrows have much larger sleeping chambers than normal sleeping burrows from many generations excavating them for the arrival of babies. These tried and tested baby 'suricate sanctuaries' are readily identifiable by the much larger mounds of sand outside the usually flat burrow entrances.

These act as an elevated position for babysitters to guard from more effectively with better visibility over their surroundings.

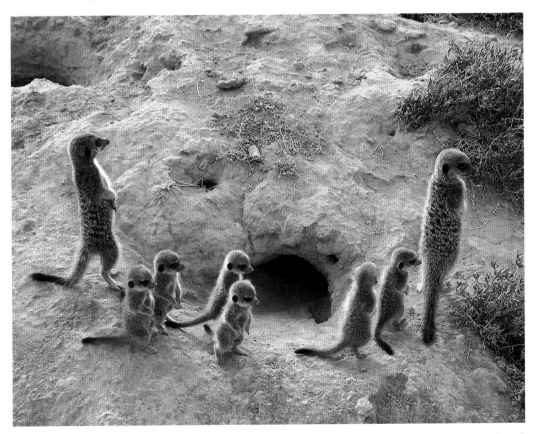

OPPOSITE AND ABOVE: *'Suricate sanctuaries' are tried and tested greatly enlarged breeding burrow systems where many generations of Meerkats have been born and raised.*

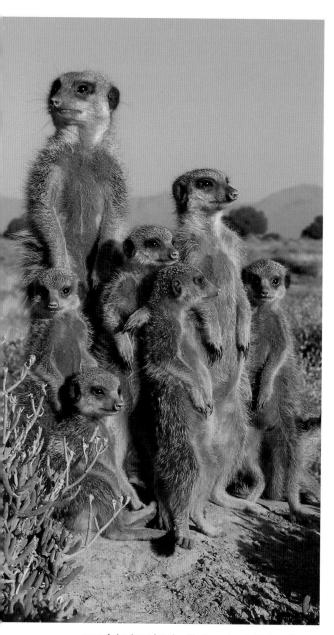

ABOVE: *A dominant female will often return to the breeding burrow where she was born to give birth.*

OPPOSITE: *The enlarged earthen mounds at ancient burrows allow Meerkat babysitters to guard more effectively.*

These earthen barriers help to prevent dangerous burrow flooding. Any water entering is channelled safely into the ground without destroying the sleeping chambers. These 'suricate subterranean tunnels' act as 'nature's storm-water gutters', preventing surface flooding and severe soil erosion.

Watching hundreds of generations of wild Meerkats grow up from babies to breeding adults has been an incredible life experience for me to cherish as a research biologist. I have noticed an interesting pattern where surviving females who outlive their mothers, and who have inherited her territory as her daughters, have actually given birth to their first litters at the exact burrow they themselves were born at. This is another reason to conserve these historical burrow systems for future Meerkat generations.

Frequently these very old ancestral family homes are located further away from the territorial boundaries, almost certainly as a security feature to avoid possible encroachments and infanticide from surrounding and competitive Meerkat groups. The more central location of the breeding burrow also allows for a better foraging distance to neighbouring burrows in different directions around the territory when the Meerkats have babies and are subjected to using the same sleeping burrow for many weeks. If the burrow was situated in one remote part of the territory it would be too far to travel to scent mark the boundaries and return again to the same burrow at the end of the day.

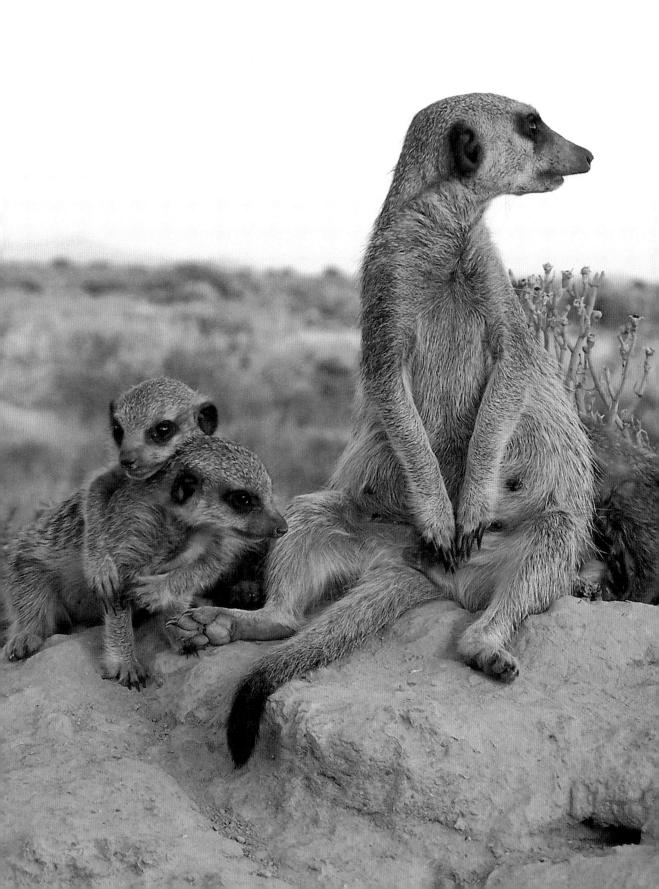

Territorial archives and range expansion

Migrant unrelated males bring new territorial information with them from their own natal territories. They will follow the dominant female since she and not them will know her territory that they visit. The matriarch will assimilate the range information that they bring with them into her territorial archives. All her surviving offspring will acquire the new territory information.

An old dominant female may learn about additional burrows and areas from more than one migrant male over her lifetime. If she was to die or be captured as a pet, an entire group could go extinct since they would lose her inherited survival experiences of many generations in their territory.

Her daughters, who may survive to replace her and inherit the family's territory, will become the new libraries of this information. In time these territorial fragments will be passed onto their own babies who will grow up in the consolidated territory and protect it as their own.

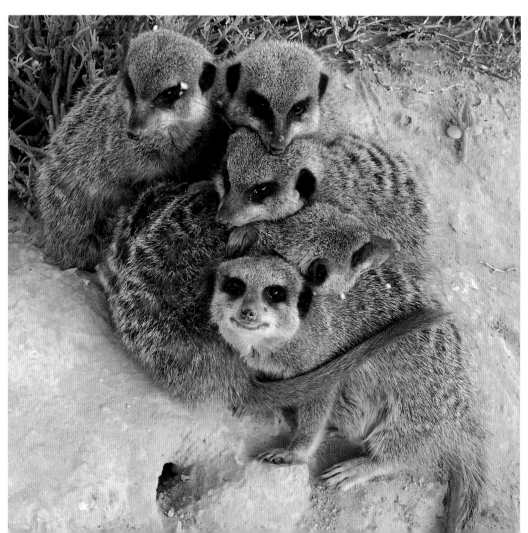

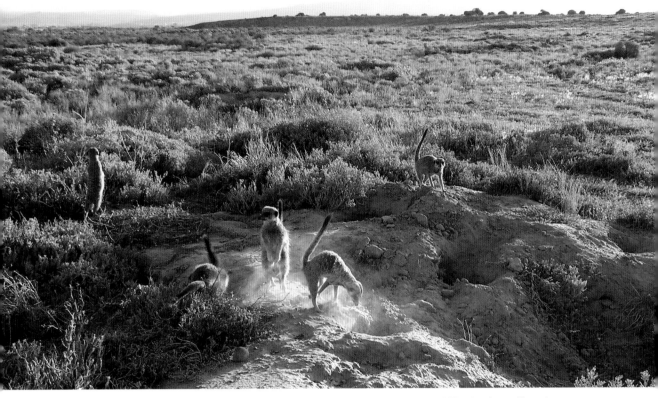

OPPOSITE: *The dominant female will assimilate a lifetime of territorial experiences as a living archive. All her daughters will acquire this information from her and pass it on to their own offspring.*

ABOVE: *Surprise attacks by neighbouring Meerkat groups may result in babysitters being overwhelmed and killed along with any babies, although usually the intruders are unsuccessful and leave.*

A besieged breeding burrow under attack by rival Meerkats

Usually breeding burrows are a safe distance from other Meerkat groups. However, on rare occasions infanticidal intruder marauding Meerkat groups may trap babysitters at a burrow that they encounter on a range overlap with their territory. These besiegers will attempt to enlarge the burrow entrance to allow multiple attackers to enter in an attempt to overwhelm the few defending babysitters.

The burrow can be well defended by only a few greatly outnumbered babysitters, who actively repel attackers at each breeding burrow chamber entrance. The babysitters are able to withstand attacks in the equivalent of a defensive castle form of siege warfare. Attacking Meerkats usually end up getting severely bitten on their faces and forelegs as the babysitters will lunge at any intruder heads and limbs entering the burrow.

Sometimes the sudden element of surprise from an attack can overwhelm babysitters before they can defend the burrow entrances. The results are catastrophic! Intruder Meerkats will kill every baby and even babysitter that they overwhelm. They will often have multiple attackers bite and kill a single rival Meerkat and drag them to the surface. These killed defenders are aggressively bitten and dragged around, but not usually eaten. Persistent neighbours invariably overwhelm poorly defended burrows through their relentless onslaughts. Meerkat groups who lose their young never use the same burrow again for breeding.

A researcher can determine that a Meerkat group has been involved in a burrow siege by simply observing the uniquely situational wounds inflicted on the attackers. Defeated Meerkats will often have numerous infected bites on their forelegs and heads. Due to the Meerkats' diet of chemically defended and venomous prey, bites often become infected and result in the attacking Meerkats limping and getting very stiff and sprained battle-damaged limbs.

Territories often overlap with more than two Meerkat groups, which can result in badly situated breeding burrows receiving repeated attacks from neighbouring Meerkat patrols.

The breeding burrow selection process through past experiences of breeding success is yet another reason for the older and most experienced matriarch giving birth in the safest burrow she knows of.

If she gives birth away from the known security of the breeding burrow, she will actively carry her babies all the way to the breeding burrow of her choice.

Evicted subordinate females who manage to get pregnant and give birth on the outskirts of their natal territory are at the greatest risk from these burrow raids, as they do not have their own large and well-defended territories. This is another reason for them to rather abort their young and return to assist the matriarch in raising her young. The almost certain alternative is the failure of a breeding attempt on a range overlap on the outskirts of their home territory.

This is a territorial agent of reproductive suppression of subordinate females. There are seldom any uninhabited areas of territory for a new Meerkat group to simply form, as larger well-established groups will simply absorb these areas into their own ranges. Temporary migrant male and evicted female coalitions often disperse due to lack of territory space.

OPPOSITE, CLOCKWISE FROM TOP LEFT: *If babies are born at an unsuitable burrow, the dominant female and others will commonly pick up the pups and move them. It may take multiple moves to get to the main breeding burrow; baby Meerkats may be carried for hundreds of metres by their nose, ears, tail or neck. They remain silent so as not to attract predators; the Matriarch learns which burrows are safest from past experience. Subordinate females seldom manage to raise young born while they are evicted and exiled from the security of the main burrow systems.*

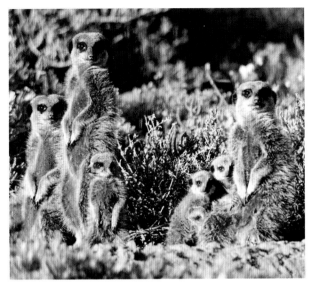

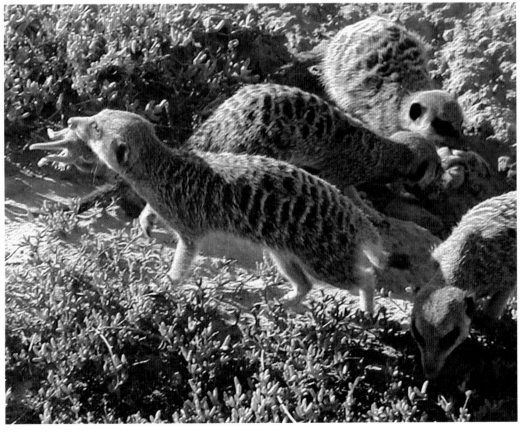

Pup tunnelling and self reliance

This is an activity limited to baby Meerkats. The babies' strong survival instincts motivate them to dig their own narrow escape tunnels into the burrow's many entrances.

These are too small for older Meerkats to enter, including any babysitters who will often call and try and dig the babies out of their safety tunnels. This behaviour has probably resulted in any babies who perform this tunnelling to have additional security and a better chance of surviving a predator's attack. It may also help them to survive a surprise assault from intruder Meerkats, who will then not be able to reach them easily, giving them additional safety over and above the usual protection offered from babysitters.

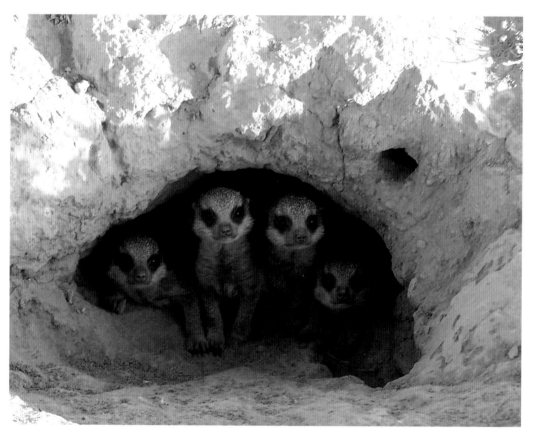

ABOVE: *Baby Meerkats learn to remain in the safety of the burrow and will only explore outside when there are older Meerkats around them such as babysitters.*

OPPOSITE TOP: *As baby Meerkats venture beyond the safety of burrow entrances, they quickly begin to master their strong front nails and make their own tunnels into the burrow.*

OPPOSITE BOTTOM: *Practicing digging and tunneling for safety begins during the first few weeks of life.*

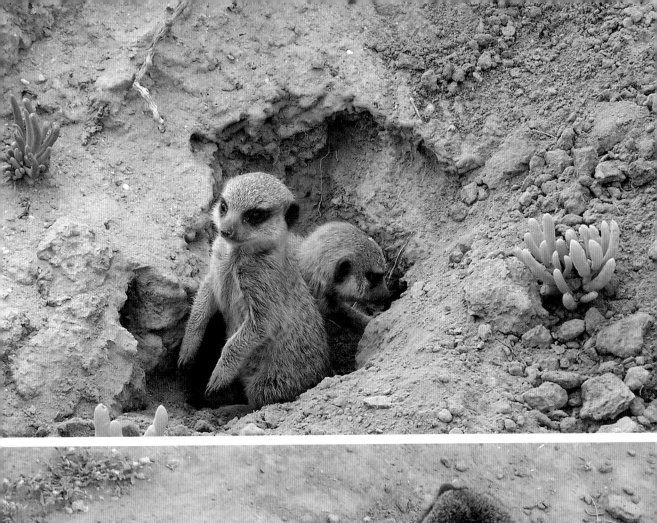
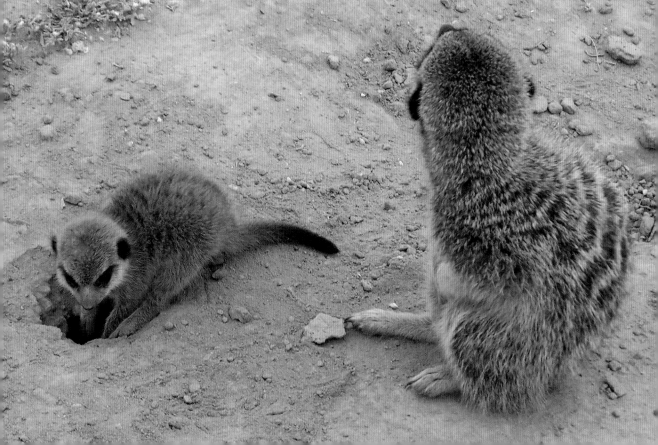

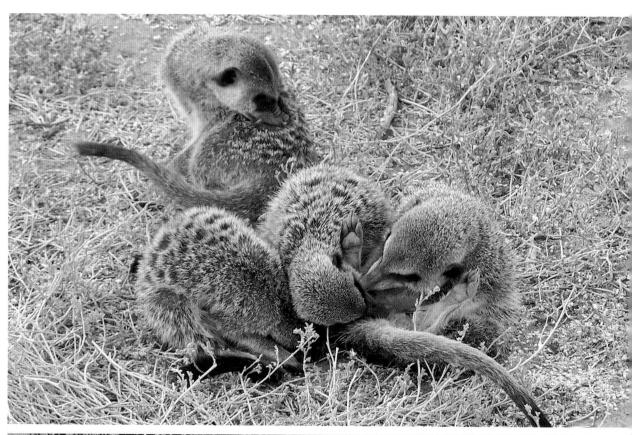

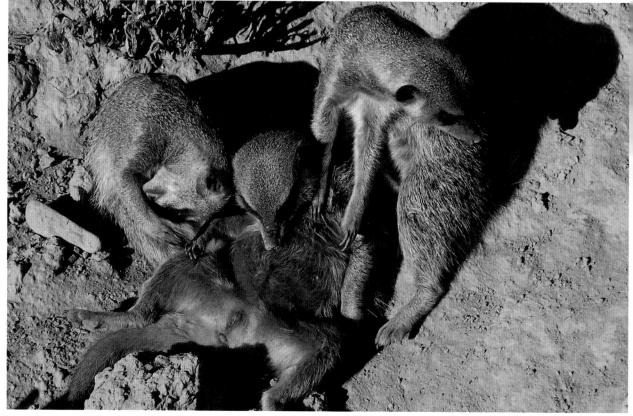

PARASITES
BODY FLUID BURGLARS

FLEAS ARE A CONSTANT DRAIN of Meerkat energy and often densely infect burrow systems that have been used for longer periods, such as breeding burrows for baby Meerkats. Sometimes these infestations become so extensive that the fleas can be seen jumping around in the equivalent of rapacious eager anticipation of their next predictably arriving meal.

These insatiable blood-sucking creatures remain in the protective shade of the burrow entrances just out of the reach of the searing sunlight. The burrow system and its many tunnels are reminiscent of a subway station, with the train being the unfortunate host benefactor, upon which the fleas will hitch an unwelcome ride.

Some burrow inhabitants such as the Cattle Tick (*Rhipicephalus microplus*) and related smaller tick species make a living off others and are not welcome 'wildlife hotel guests'. To avoid parasite loads Meerkats frequently carry out 'house cleaning' by actively digging, the equivalent of sweeping out burrow chambers. Meerkats will also travel from one burrow system to another to escape from these unwanted 'body fluid burglars'.

Meerkats also suffer from internal parasite infestations from Nematodes and Platyhelminthes worms which they inevitably ingest from their food. These internal parasites may also, however, be spread to other Meerkats by the paired anal scent gland pouch, which is used in extensive territorial and individual Meerkat marking.

Eating certain toxic bulb species such as *Boophone disticha* may serve as an anti-helminthic medicine to help rid the Meerkat of internal parasites.

Meerkats actively renovate burrows not only to repair them and remove debris and obstructions, but also in an attempt to remove parasites. Meerkats also groom frequently, but evicted females and migrant males and small Meerkat groups suffer a very high energy and health cost when they are unable to groom often.

OPPOSITE: *Meerkats move around their territory in a futile attempt to escape the hordes of parasites that live inside burrows; grooming offers only a temporary reprieve.*

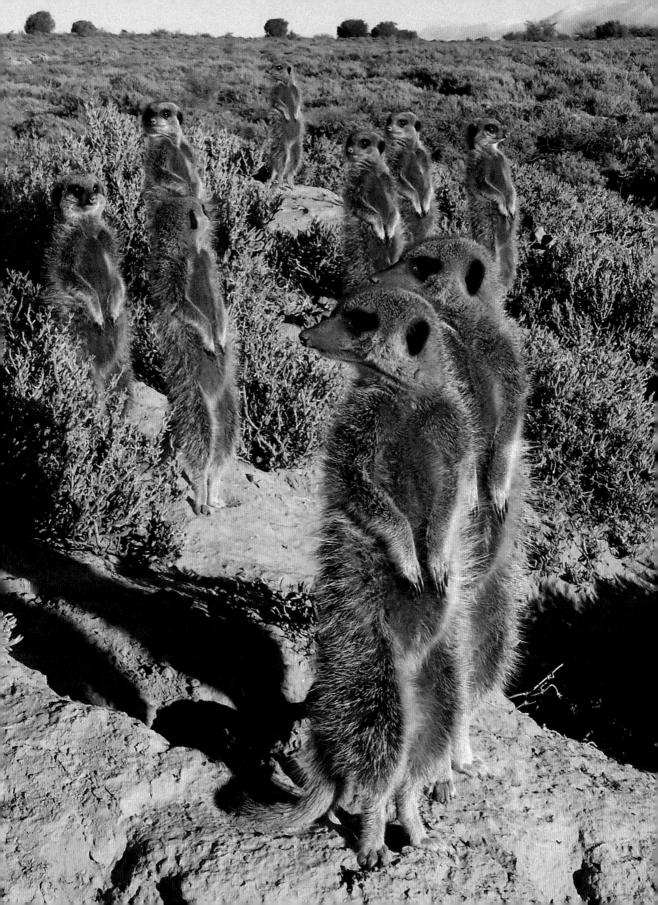

THERMOREGULATION

THERMOREGULATION ALLOWS THE MEERKAT to survive in extreme climatic variations while being able to maintain their core temperatures. The Meerkat has numerous adaptations that help in preserving a stable internal temperature to ensure homeostasis.

The Meerkat's metabolism is also adapted to preserve moisture and prevent energy loss in the harsh environments that it inhabits. During summer Meerkats are commonly exposed to extreme temperatures over 45°C (113°F) with surface temperatures of over 60°C (140°F) – hot enough to cook food! In winter temperatures may drop to well below 0°C (32°F) with ice on the ground.

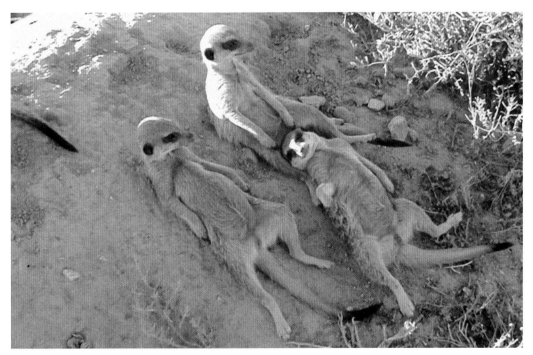

OPPOSITE: *Being able to warm up and cool down rapidly are essential adaptations for living in environments with climatic extremes. Meerkats use their bellies like solar panels.*

ABOVE: *Lying on their backs is a very efficient way to cool down in the shade and radiate heat away from their sparsely haired undersides during hotter periods of the day.*

The weather forecaster

On a cold or overcast day Meerkats will often sleep later into the morning. On warm sunny mornings Meerkats often emerge before full sunrise as the first rays of light trickle into their dark burrow entrances.

The flat-topped head of a Meerkat or tentatively protruding nose is usually extended out of the morning sleeping burrow before others may venture outside of their subterranean security. There is no set routine or turn as to which Meerkat emerges first to do this. I refer to the first emerging Meerkat as the 'weather forecaster'.

If the Meerkat decides that it is too dark or cold, or that there is any danger present, it will rapidly retreat beneath the ground once again. It may even make an alarm to announce to the group that it is not safe to emerge.

A different Meerkat may then emerge and assess the day and threat level, and this process may be repeated several times before an individual decides to leave the safety of the burrow. If it is safe for others to emerge, the forecaster will often look into the burrow and make soft reassurance calls.

Other Meerkats will then first watch the forecaster before emerging much more rapidly with the security of another who has already emerged and checked for danger. On a warmer sunny day, the forecaster will quickly assume the upright standing position and stretch its belly towards the sun.

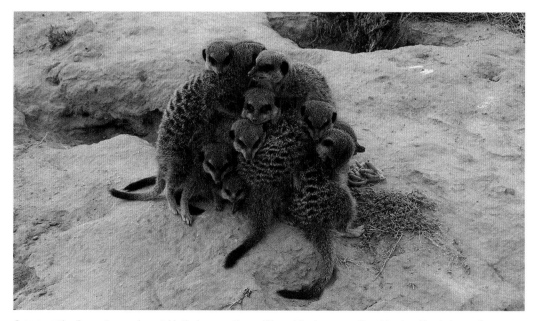

Once a weather forecaster remains outside the burrow, others will be quicker to emerge. On colder days Meerkat mounds soon begin to grow into ever larger stacks of heat seeking bodies.

Sunning

Meerkats are nature's solar panels. On a hot, sunny morning they are famous for their upright stance and golden glowing coats of puffed out hair – they are the 'secretive solar-soaking suricates'.

Not surprisingly the characteristic stance of the upright Meerkat using its non-prehensile tail as though it were a monopod chair, has given these 'solar sponging suricates' the famous German name of 'Erdmännchen' or 'little earth men'. This behaviour is commonly called sunning or sunbathing. Having enlarged supportive hips and narrow shoulders the Meerkat can easily stand and balance upright to warm its belly.

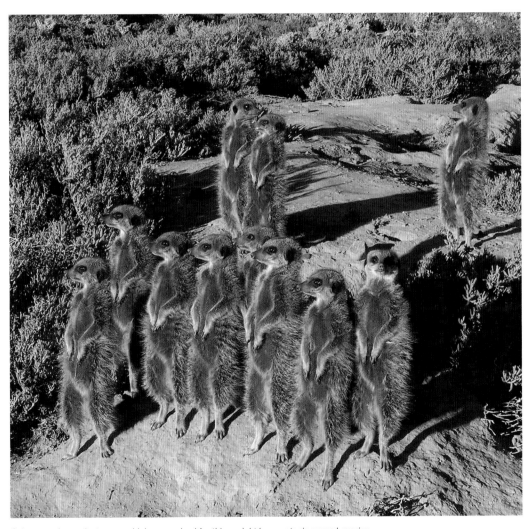

Solar sponging suricates are widely recognised for this upright homeostasis around sunrise.

Even during this activity, when some individuals may not be fully awake or others begin to fall asleep, there are always those who are actively guarding and warming themselves too.

They have very short hair sparsely covering the dark grey skin on the ventral surface and no hair on their paws. The hair is coarse and not finely packed as with a typical mongoose's hair. This allows the Meerkat to both warm up and cool down rapidly, which is an essential adaptation to their diurnal lifestyles.

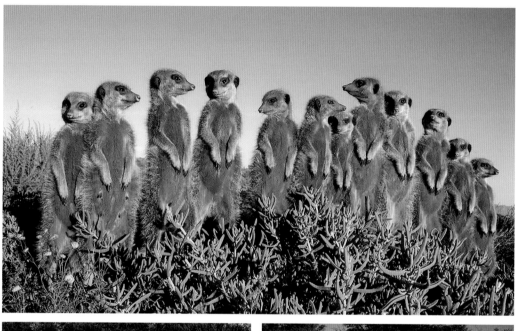

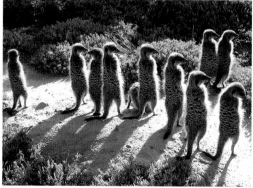

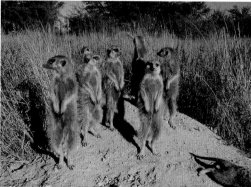

CLOCKWISE FROM TOP: *On an overcast day Meerkats will stop whatever they are doing and turn themselves to collect any incoming sunshine; as predictable as a sunrise, Meerkats will stretch themselves and bask in the warming radiation of a sunny morning; comparing Meerkat sizes and natural markings is best done when Meerkats first emerge and stand upright. This is an opportunity for a researcher to objectively record natural demographics accurately and identify individuals in a population.*

Suricate sunning spatial etiquette and shadow displacement

Each sunning Meerkat will move around and shuffle to find a suitable spot in the sunlight. Young Meerkats frequently stand in front of other Meerkats, resulting in what I call shadow displacement, and an entire group of Meerkats may shuffle around to accommodate this inexperienced younger Meerkat. There is no aggression shown towards other sunning individuals who cast shadows.

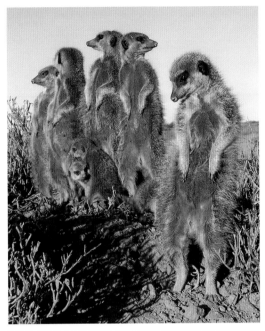
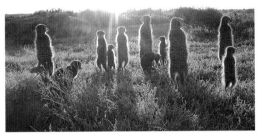
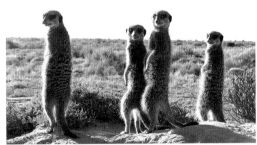
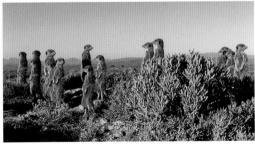
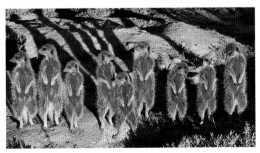

CLOCKWISE FROM TOP LEFT: *Rarely seen mutliple lactating female Meerkats are also easily identified by the dried milk around their mammae which are easily seen during the sunning period of the day; babies do not yet know about sunning etiquette and will often stand in front of adults. This does not result in any aggression, simply repositioning; experienced Meerkats seldom cast shadows on others; often a sleepy Meerkat will begin to close their eyes, and commonly fall over or begin to sway as they bask and awaken from a night underground; a passing cloud will often result in Meerkats moving out of the shadow and causing a ripple of displacement as everybody repositions themselves.*

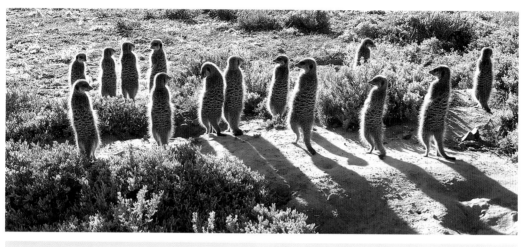

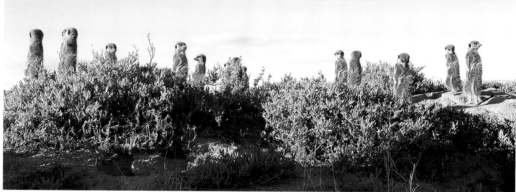

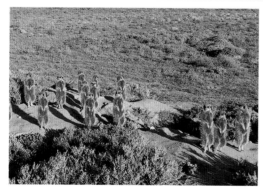

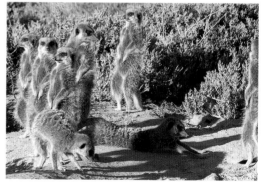

CLOCKWISE FROM TOP: *Individually unique back pattern camouflage is easily recognised when Meerkats are warming up; Little Karoo Meerkats often climb onto surrounding succulents during sunning; a shadow cast over a Meerkat which has already warmed will not result in displacement – they will often stretch, yawn and start foraging for food; even multiple rows of shadows do not interfere with those who are experienced with sunlight spatial awareness.*

OPPOSITE: *Shuffling Suricate scrums are common on colder and overcast days.*

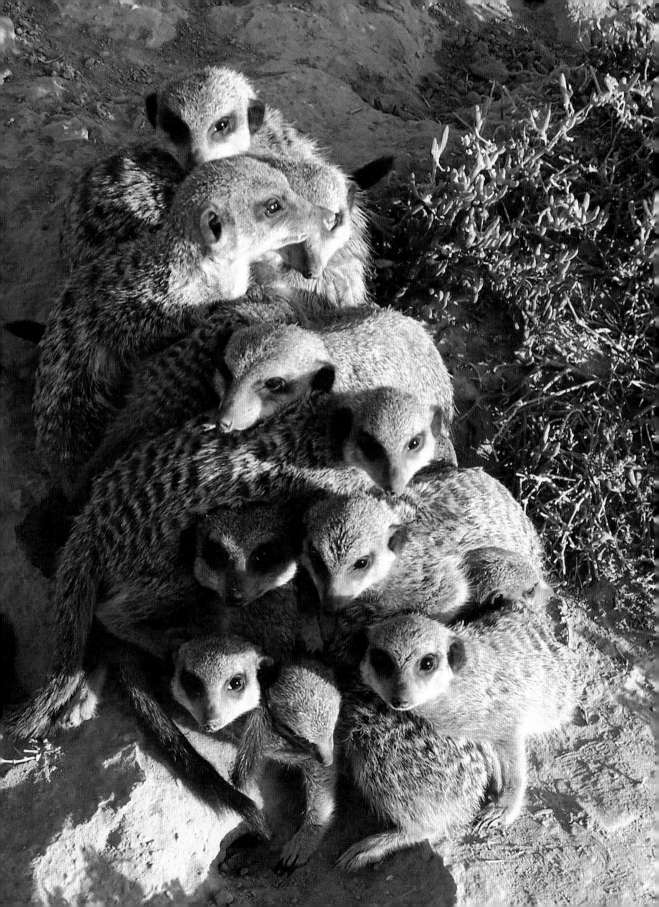

Huddle scrumming

On colder days the Meerkats will actively huddle or hold on to each other, puffing up their hair and protecting their exposed, sparsely haired undersides. These huddles move around and often see the youngest meerkats, who are the most vulnerable to temperature fluctuations with their very short hair, snugly wrapped in the centre of the 'shuffling suricate scrum'.

This forms a writhing mass of overlapping, hugging, heat-retaining bodies as a barrier against the bitter biting cold. Additional warmth is generated for the protected babies inside this inner cave sanctum of co-operative thermoregulation.

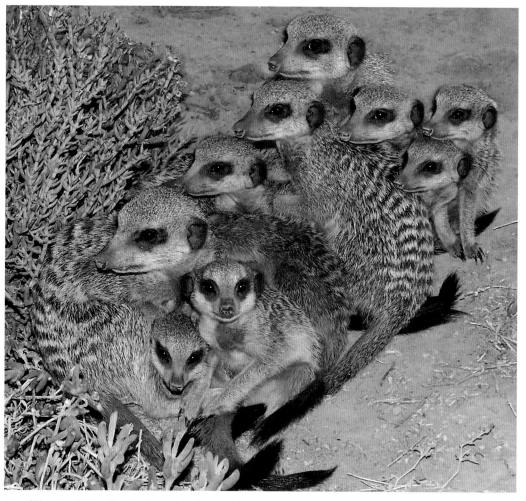

ABOVE: *Although curled together Meerkats can be deceptively alert, with many eyes watching for predators.*

OPPOSITE: *Younger Meerkats, with very little protective hair, often burrow their way into the very centre of the co-operative thermoregulation heat retaining huddle.*

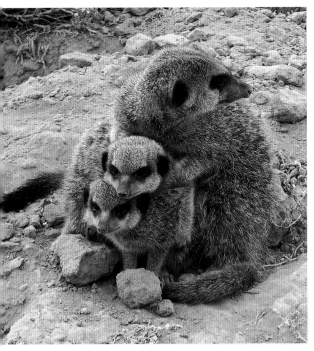

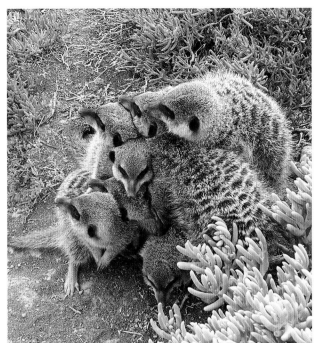

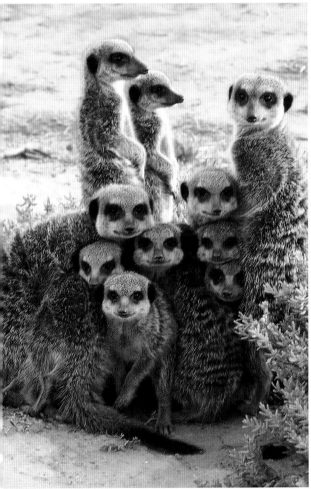

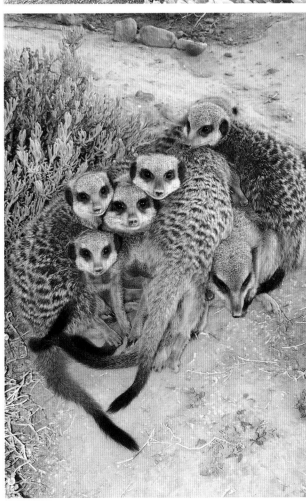

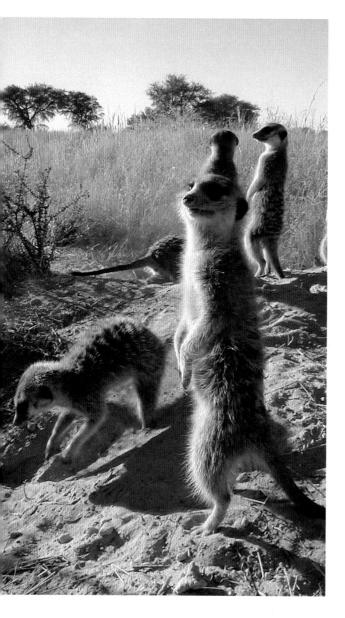

Digging aerobics and burrow maintenance

In the Kalahari Desert Meerkats frequently perform burrow maintenance over the course of the day, irrespective of whether it is hot or cold. This is often a highly co-operative effort of many individuals and can occur at any burrow that may require renovation. This maintenance digging is not the same as digging aerobics though.

In the Little Karoo, Meerkats actively dig at the burrows on cold or overcast days, clearly in an attempt to warm themselves. Unlike the co-operative multi-meerkat relay digging of burrow cleaning occurring over a day, aerobics is usually performed solo and only when the temperature is low in the morning. If it is cold later in the day, Meerkats will simply go below ground to sleep earlier after a day of foraging, without any aerobic exercise.

Burrow cleaning is often a co-operative behaviour and is far less frequent on a daily basis as the soil is highly compacted in the Little Karoo burrows and does not require the diligent maintenance of burrows found in the shifting soft sand of the Kalahari Desert habitat. This digging aerobics does not occur on warmer days in the Little Karoo and is replaced by sunning.

ABOVE: *Kalahari Meerkats spend much more time on burrow maintenance than the Little Karoo Meerkat subspecies. The loose soil of the Kalahari constantly enters burrows and needs to be swept out daily.*

OPPOSITE: *During the heat of a summer's day, Meerkats will stretch out onto their backs and stomachs in cooler shady areas and often sleep while others remain alert. Babies will also climb onto older Meerkats to get off the hotter surfaces, or rest beneath the shade cast by babysistters protecting them from predators and the heat.*

Midday resting and cooling down behaviour

During the heat of the day it is common for Meerkats to rest in burrows or in the shade, or even on or around juicy cooling succulent species which are found in the Little Karoo. Burrow systems are cooler than the surface temperatures in summer or warmer in winter by around 10°C (18°F) respectively.

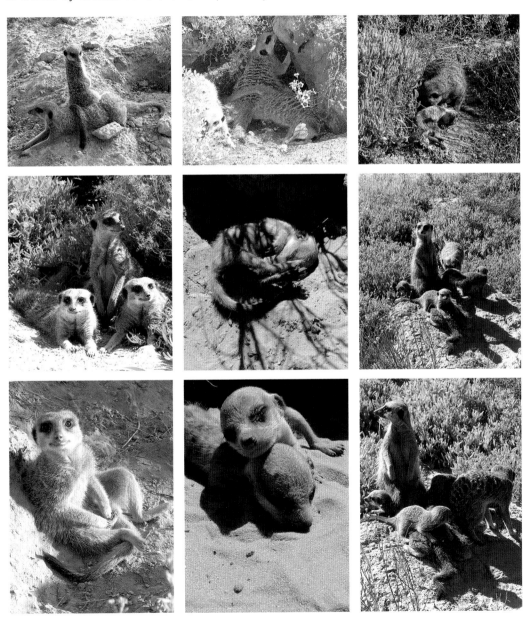

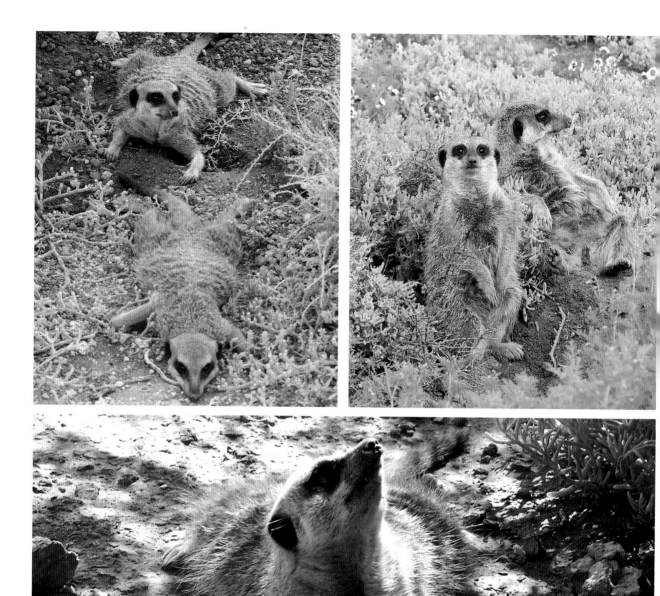

CLOCKWISE FROM TOP LEFT: *The sparsely covered solar panels on the underside of Meerkats are also very good for losing heat rapidly when they are pressed into cool depressions in shady soil; cold and juicy succulent 'chairs' are often leaned on or climbed into by overheated Suricates; Meerkats are sometimes called 'sunbathers' and it is easy to see why people have made this anthropomorphic comparison.*

The Meerkats' very tough, almost rubber-like, hairless feet are easily burned by hot surfaces and Meerkats will quickly move from one area of shade to another on a hot day. Often Meerkats will make shallow scrapes in the cooler soil and stretch their exposed stomach skin into the sand to lose heat rapidly.

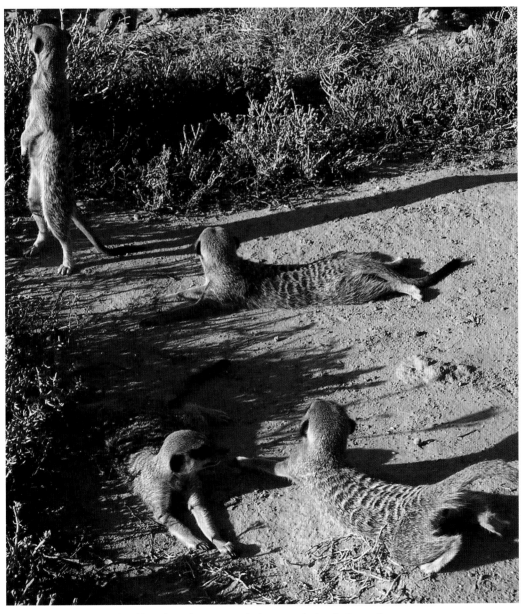

While some Suricates stretch and laze about, they are never far from one who is actively guarding.

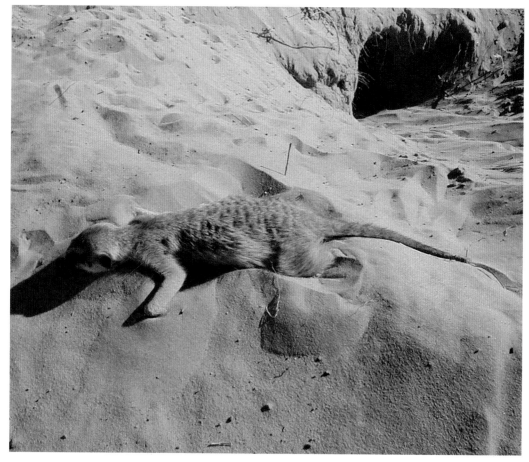

ABOVE: *Meerkats often dig into the soft sand of the Kalahari in order to take advantage of the cooler areas beneath the surface.*

OPPOSITE: *Meerkats will sometimes fall asleep on their backs at the end of the day, or while leaning against cooling plants in the shade.*

Occasionally when in this position a Meerkat will scrape soil onto its body, partially covering it in soothing sand in order to cool down.

In the Little Karoo the cool, juicy, swollen succulents are frequently used by hot Meerkats to cool down their bodies as they lie against them as if they were comfortable chairs.

Basking or lying on their backs to radiate heat away from their stomachs usually occurs later in the day and often at the burrow system. This behaviour has resulted in many anthropomorphic comments from observers about holidays on the beach.

Pregnant females will frequently lie on their backs and rest, especially during later pregnancy. It is possible to see the foetuses kicking while the female is losing heat in this manner.

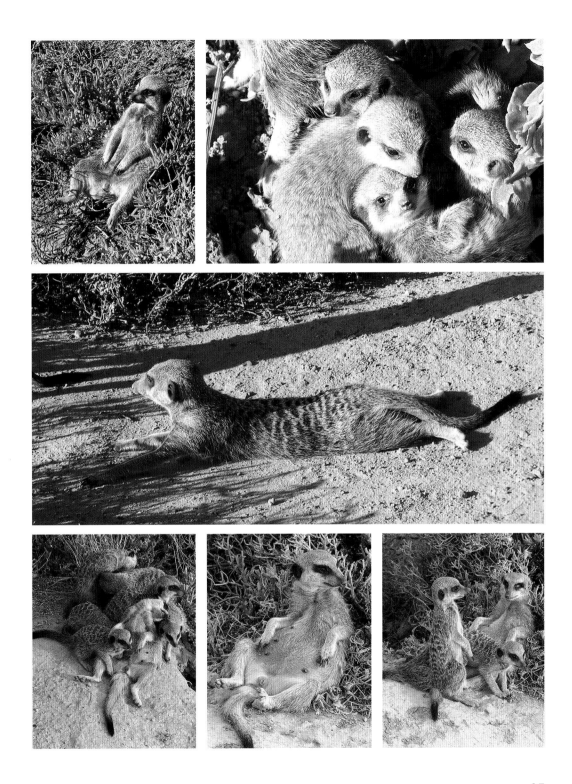

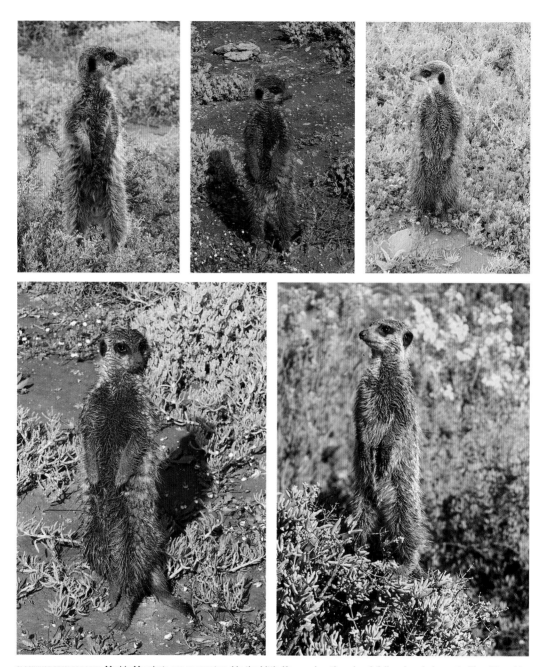

CLOCKWISE FROM TOP LEFT: *Muddy Meerkats are encountered in the Little Karoo when there is rainfall or dew; being wet with cold mud is a very serious homeostasis challenge for the Little Karoo Meerkat subspecies, as this wetness is often accompanied by freezing cold winter weather; Meerkats need to quickly retreat into warm and dry burrows to warm up again after being coated in wet mud; the Kalahari Meerkat subspecies rarely gets wet, as rainfall is quickly absorbed into the sand; the mud inevitably traps pollen and seeds and results in the Meerkat being a transporting agent for plants, pollinating and dispersing them as a significant ecological benefit.*

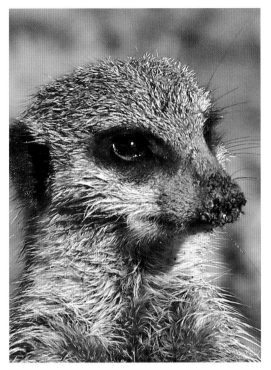

Rarely seen wet and muddy meerkats

Meerkats are very seldom active during rainfall, and if they get wet they will often retreat to their burrows and dry themselves before emerging again. Getting wet and coated in cold mud can be a serious risk to the Meerkat in winter due to hypothermia and the lack of dense hair on many areas of the body.

Because the Little Karoo Meerkat habitat is usually covered in dense vegetation throughout the year, after rainfall this stays wet and wipes off on passing Meerkats. The additional time taken to dry off over the short winter days in the Little Karoo is an added energy cost.

The mud also attracts pollen and seeds from plants which transfer onto the Meerkat and this inevitably aids in seed dispersal.

Wet Meerkats are seldom seen in the mainly dry winters which predominate in the Kalahari Desert, where the rainfall quickly soaks into the often bare sand, leaving the foraging Meerkat mostly dry. The Meerkat does grow a longer winter coat of hair and this is shed for a shorter summer coat.

LEFT TOP: *The additional time required to remove mud through grooming and to dry off results in a large energy penalty during the shorter winter days when there is even less time to forage for food.*

LEFT BOTTOM: *Wet clay-rich sand sticks to tactile hairs, blocks ears and noses, and builds up on nails required for digging. This is an energy cost and could result in less efficiency in vigilance and foraging success.*

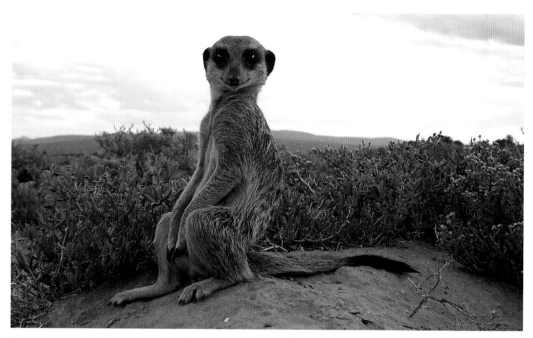

Hot dry days offer a respite from seasonal wet mud or grassy glue in different habitats, giving the Meerkats more time to relax and conserve energy.

Sticky suricates and grassy glue

The corrosive acidic secretions from the Kalahari Sour Grass (*Schmidtia kalahariensis*) coats the Kalahari Desert Meerkats in a burning and itching glue substance during the plant species' growing season. This commonly glues sand dug out from excavations onto the Meerkats' nails and can even glue the front nails together and form lumps of hardened sand. This actually makes digging less efficient and Meerkats will spend a great deal of time grooming these hardened areas each day, so it does have an energy impact on them. It is the equivalent of the Little Karoo Meerkat subspecies being covered in mud.

Tragically this corrosive glue commonly coats the sensitive fleshy ears of the Meerkats too, and often hardens and cracks the delicate skin. The ears then scab over and get further coated in these sticky secretions of grass. Meerkats will groom these ear scabs off repeatedly in an attempt to clean the ears and their specialised sealing valves. As these wounds worsen over a sticky season, Meerkat ears become increasingly damaged. Many a Kalahari Desert Meerkat has lost much of its ears during the course of a life spent in these grassy plains.

The pollen and grass seeds will stick to the Meerkats, making them dispersal agents for this grass species in a similar way to the muddy Meerkats of the Little Karoo.

VOCALISATIONS

MEERKATS MAKE MORE THAN 30 distinctive sounds, and these form a complex communication system in the highly sociable groups in which they occur. These are too detailed to list here in full, but a select few and their functions will be discussed and attempts to imitate the sounds with letters will be made. This is a crash course in the language of Meerkats!

I have transcribed these sounds from personal observation and from detailed sound recordings of all of the calls. Please feel welcome to attempt to imitate the *letter sounds* that are mentioned in inverted commas.

The Meerkat is a very vocal species and does not rely on stealth to hunt its food. The noisy foraging of Meerkats does not allow them to easily hunt vertebrate prey with enhanced hearing, but rather to focus on primarily buried prey that relies on trying to hide rather than escape.

This lack of stealth is an ethical consideration in observational research with the Meerkat species, as their food is not disturbed by human observers and does not impact on the Meerkats' foraging success rates. In contrast, it would be unethical to follow stealthy predators that are often very quiet and solitary when hunting prey with sensitive hearing. These predators would have their hunting ability compromised and their prey disturbed by a human observer following them closely.

'There is no danger' call

This is often one of the first sounds made by emerging Meerkats in the morning once they have determined that it is safe enough to emerge. The call consists of a rapid series of rather soft *'hu huh'* sounds, and can have variations such as *'hu huh hu'* and *'huh huh huh huh'* made in short bursts. This call is heard very often and is frequently made, often every few seconds, when Meerkats are guarding.

The 'let's go' call

This call is an increasingly drawn out, fairly loud *'who waare'* sound and is usually made when the Meerkats begin to choose a foraging direction in the morning or later in the day when they are returning to a sleeping burrow. The dominant female often initiates this call, which becomes louder and more drawn out and culminates in a rapid *'who waare uh huh huh huh'* as the group starts to echo it and move together.

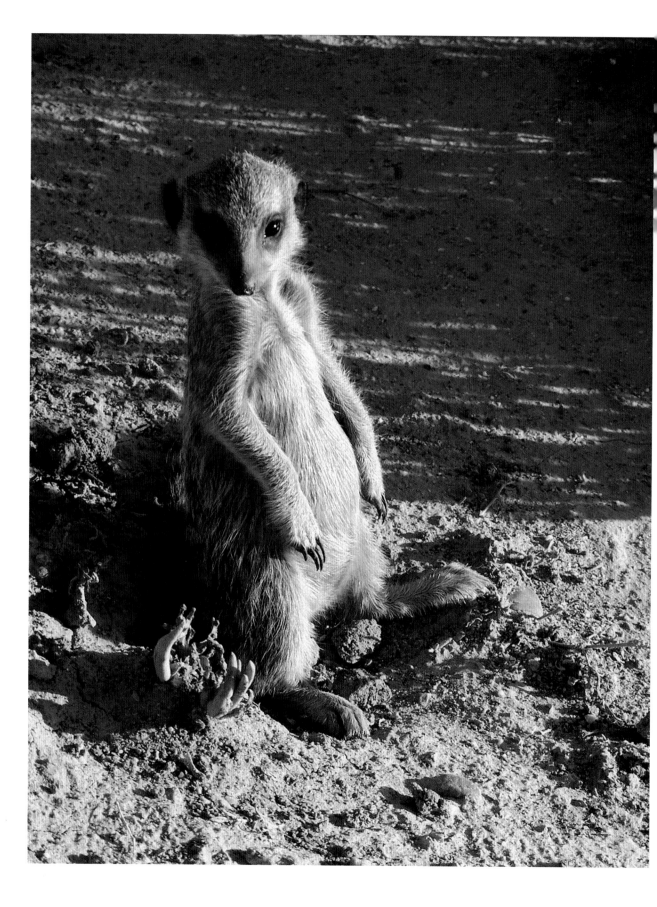

'This is my food – get your own' call

Foraging contact calls are made intermittently by all individuals and these are soft muttering '*ort wort ort*' sounds.

An observer may be misled into thinking that the foraging Meerkats are actually hunting and sharing their food with each other as a co-operative unit. However, there is no tolerance towards other foraging Meerkats when they encroach upon another's hunting site. The regular calls help to keep the group together for safety, and simultaneously avoid resource competition and aggression which is a waste of energy. The contact call increases in frequency and volume with proximity to other Meerkats. This is a constant spatial warning not to impose on another's chosen foraging area.

When foraging, dispersal distances between Meerkats usually increase with lower food availability to 30m (100ft) or more, but this also depends on visibility. The food calls do not increase in volume with increased distance either. With thicker vegetation when foraging, Meerkats are unable to see each other and the calls notify members of their respective positions. Foraging in dense vegetation is dangerous with higher associated predation risks due to poor visibility. This will result in closer dispersal within a few metres, even with lower food availability. When food is abundant, foraging dispersal is often only a few metres or less. Food availability and visibility often determine foraging proximity, which determines the foraging call volume.

Interestingly in some human societies it is considered rude to talk loudly when close, and in others it is rude not to talk loudly when close as this may be interpreted by others as being secretive and conspiratorial. With Meerkats, as they move closer together they can clearly hear each other more easily and yet their calls increase in volume rather than becoming softer, clearly indicating a warning and not a mere contact call for group safety and cohesion. Basically the calls announce that 'this is my food – get your own'!

The exception to this balanced rivalry and apparent foraging harmony is when baby Meerkats are moving with the group.

Baby 'feed me now' call

The loudest babies usually get fed the most frequently. These excited very loud high-pitched squealing '*hu wah hu wah*' sounds are made faster and faster in an almost encouraging way to potential food providers.

Food will even be taken away from one baby who is not very loud and given to a much louder calling baby. Even the former generation of babies who are able to find their own food will feed the current generation of babies, and may on occasion 'assist' babies who are too slow in eating the delivered food by eating it themselves.

Wild Meerkats do not tolerate feeding calls and begging for food from older babies. The length of tolerance of these calls is largely determined by the feeding Meerkats' condition and general food availability for the group as a whole. When food is scarcer babies are tolerated for much shorter periods of only a few weeks, compared to times of abundant prey when babies demanding food may be tolerated for over two months.

Initially tolerant providers become aggressive food hoarders, growling and body blocking food and clearly forcing babies to find their own sustenance as they get older and more experienced. The 'feed me' call is seldom used throughout the Meerkat adults' life, in stark contrast to captive Meerkats which never stop making the demanding 'feed me now' calls throughout their lives in captivity.

Aggressive warning call

When a foraging Meerkat gets too close to a neighbour and the 'this is my food' call is ignored, the call transforms into aggressive growling 'wurr wurr' sounds. This is often followed by body slamming and body resource-blocking and even lying on food with warning bites and nips at the intruder. It can develop into a rapid machine-gunning chattering sound 'che che che che', which is commonly paired with pawing and scratching at the intruder Meerkat. This call is very similar to the aggressive warning call given towards predators and foreign scents, which have an additional loud 'kich kich' spitting sound added between the growls.

Guarding Meerkats perform the function of a receiving interspecies call decoder and translator. Meerkats commonly interpret signals from their surrounding neighbourhood, decipher the significance of these events and decide if they will alert the group to danger or not.

Occasionally 'fake' alarms are given due to signal misinterpretations, almost like the 'cry wolf' fable, but adapted to the 'cry jackal' version. Although costly to foraging Meerkats, who then waste their time and energy responding, it is usually best to respond first and survive than to not respond and get caught. These alarm 'mistakes' are almost immediately remedied with non-threatening calls to let the group know that the alarm was made in 'error'. Initially quick-to-react group members will return to their respective behaviours almost as quickly.

'Terrestrial distant disturbance' alarm call

When Meerkats give an alarm they are able to differentiate between aerial or terrestrial threats, while the distance and danger type also determines the level of alarm. A guarding Meerkat who notices a disturbance that may become a threat if moving too quickly in their direction, such as an antelope or large bird, will result in a trilling and loud drawn out 'huuuuur huur hur' sound.

'Dangerous predator distant' alarm call

An initial warning alarm given to a distant predator that may be a threat if it approaches is an increasingly loud 'hooop hoop hoop hoop' sound.

'Dangerous predator rapidly approaching' alarm call

The drawn out 'hoop-ing' sound becomes much more rapid and much louder as a predator gets closer and the call becomes more of a shortened barking sound of 'huup huup hup'.

'Dangerous predator is attacking' extreme alarm call

As a predator is actively attacking the initial alarm call increases in volume and tempo, becoming a very loud piercing barking sound 'WAUK WAUK WAUK' with shrill almost screeching choked barking sounds.

The 'alone and separated from the group' distress call

After rival group encounters it is common for Meerkats to become separated from each other. This also happens during dust storms and predator attacks. This is the loudest call I have heard from Meerkats and is a much louder, more drawn-out, barking alarm type of call, but it is only ever made in these circumstances.

It has a clear soft start which becomes increasingly loud and more rapid, often accompanied by frantic exploration of the nearby area and burrows, sniffing of scent and very active head bobbing up and down and constant looking around and guarding. The call is a higher screeching, barking 'waaauk wuuuk WAUUUK' sound. This call continues for an extended period of time and can be the longest most drawn-out of all the loud calls. I have heard this call from a distressed Meerkat from hundreds of metres away. Usually the group will find the separated calling Meerkat and be reunited.

Subordinate allogrooming initiation call

When a lower-ranking Meerkat approaches a higher-ranking Meerkat to initiate an often non-reciprocal allogrooming attempt, a very low and rapid series of calls are made which are superficially similar to the 'there is no danger' call, but faster with more notes as a 'uh uh uh uh uh uh uh' sound.

There are many other 'Meerkat muttering' calls which form part of their complex social language.

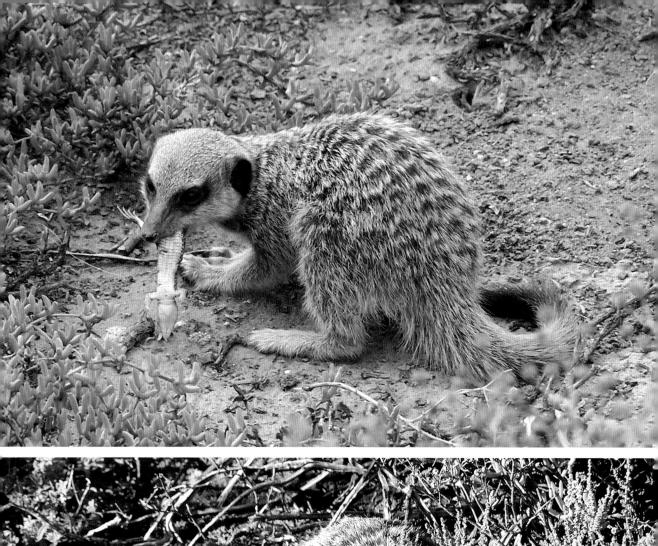
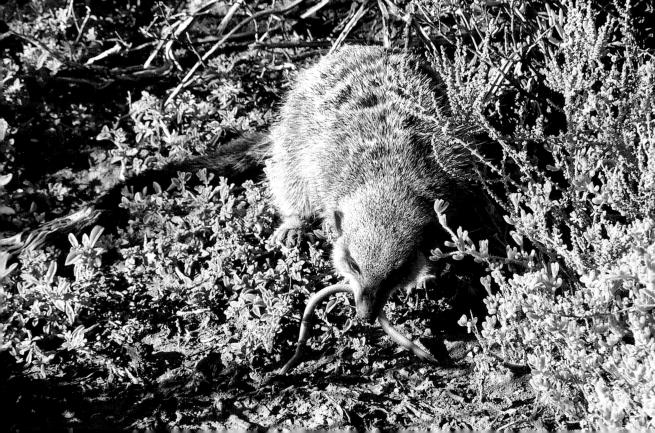

DIET

MANY MEERKAT FOOD ITEMS have their visual and chemical defence mechanisms stripped away by hungry Meerkats. Although hiding and being well camouflaged is an excellent defence against certain hunters, Meerkats bypass these visual impairments by smelling their food irrespective of how well hidden it is to other hunter species.

Aposematic and toxic food items

If consumed, toxic caterpillars have their gastric revenge. Even brightly marked aposematic species which actively advertise that they are toxic are often eaten by Meerkats. This can have adverse effects and result in inexperienced Meerkats losing their entire stomach contents and all their foraging efforts in a moment. Other Meerkats will be quick to attempt to eat the vomit, but usually the unfortunate retching Meerkat will eat the lost meals as quickly as they exit. The sick Meerkat will gobble up as much of the lost victuals as they can before any other Meerkats manage to deprive it of its energy earnings.

OPPOSITE TOP: *Burrowing creatures are easily revealed by Meerkats' incredible olfactory senses. Without suitable cutting teeth, Meerkats take longer to consume tough-skinned reptiles and expose themselves to predation by investing more time eating and less time being vigilant.*
OPPOSITE BOTTOM: *Eating larger reptiles requires more time and poses an increased threat from predation, but the additional energy is very welcome. Weighing up the balance is a daily gamble.*
LEFT: *Inexperienced Meerkats soon learn that brightly marked food items are not as tasty as they may appear to be!*

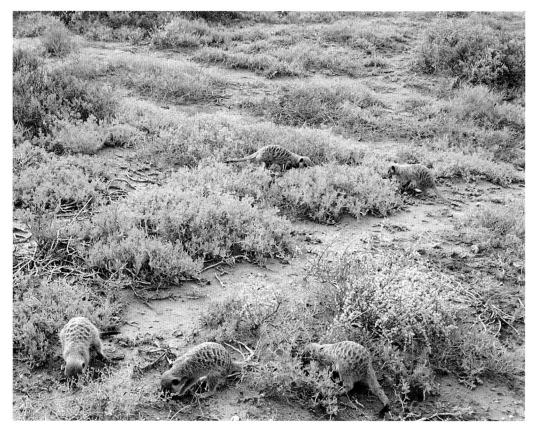

ABOVE: *Foraging Meerkats are soil engineers and walking crater-diggers. They break up severely compacted surfaces, helping to prevent water and wind soil erosion.*

OPPOSITE: *From moments after their emergence baby Meerkats scratch at the soil and try to reveal the permeating seductive smells that are tantalisingly close to the surface.*

Pioneer mammals in action

The prolific amount of digging that Meerkats do on a daily basis displaces many times their own body weight in soil, and is one of the primary reasons for me calling them 'pioneer mammals'. The thousands of digs that each Meerkat may initiate over a foraging day are essential at breaking up infertile and compacted soil, and are highly beneficial in facilitating water infiltration.

The Meerkats' foraging digs consist of rapid shifting and tilling of the soil with their paws and long front nails, accompanied with loud inhaling and exhaling sand-snorting of the uncovered scent to detect if it is worth pursuing or not. The Meerkat dances around, scratching continually at any areas which may potentially harbour prey. These intensive foraging scent probes are accompanied with announcement vocalisations every few seconds.

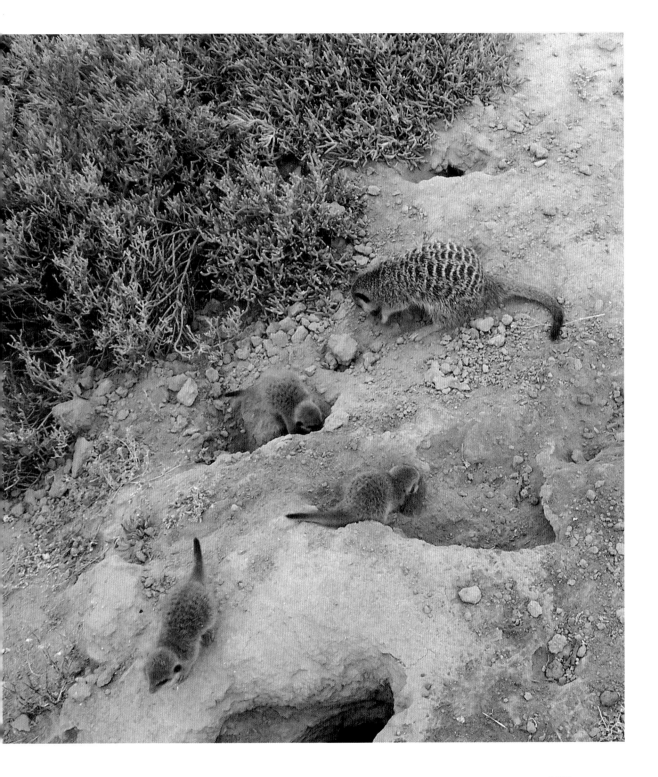

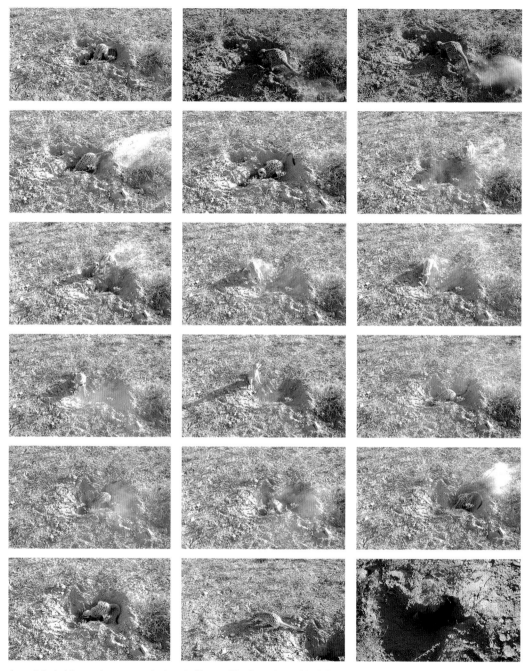

A great deal of time and energy may be invested in searching for an item of food. Frantic digging with intermittent pauses for vigilance and vocally marking a foraging location accompany an extended foraging attempt. Deeper digs may have to be abandoned if a Meerkat is being left behind the safety of the group as they move on. Fortunately this Meerkat's investment was rewarded with a great energy bonus in the shape of a burrowing scorpion meal.

If a certain area has recently been worked by a Meerkat and the prey items removed, other Meerkats will only sniff the digging site briefly before moving on, suggesting their ability to determine whether food is still present or not. This would be a good foraging trait to have to prevent a waste of energy and time in a digging area that has been harvested. The eating calls and prey-finding sounds made by Meerkats invariably assist in preventing wasted time in an area that has been audio marked to have its food depleted.

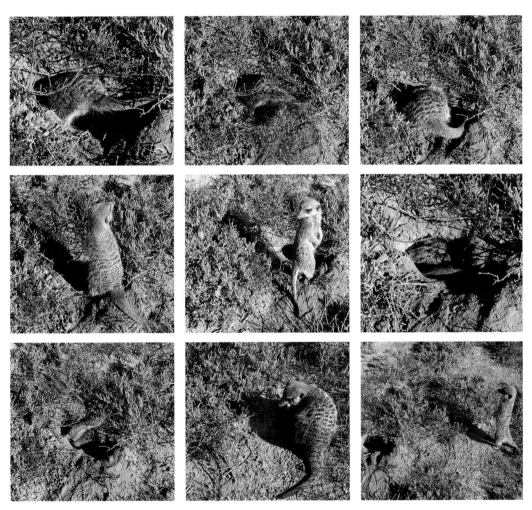

Meerkats will commonly dig for food many times deeper then their own body length. In future these sites may be enlarged into an escape burrow or even a new sleeping burrow system. Meerkats actively alter the landscape to the benefit of many other species that inhabit the ecosystem. Frequently large investments of time spent digging result in no energy reward. More experienced Meerkats will even abandon a digging site after an initial investment of time. This foraging session paid off with a reptile reward for the persistent eco-excavator.

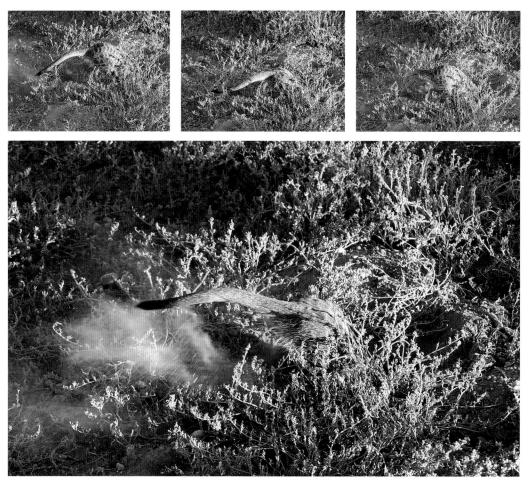

Within moments a Meerkat can displace many times more soil then its own body-weight in search of a potential reward. The eye membranes and ear valves protect the Meerkat as it digs and creates a storm of displaced dust and debris.

If a promising scent is located, often the prey may be superficial and is snatched up in one sweeping motion of the front nails to the mouth, or with a quick grabbing action from the jaws. If the food item is buried deeper in the ground, the calls are made much more loudly and more frequently as the Meerkat announces to other Meerkats to leave it alone and find their own promising food discoveries.

The digging will be interrupted every few seconds with intensive sniffing and snorting into the excavation followed by rapid furious digs. Often in the excitement of the deeper digging session, the Meerkat will turn onto its side and even roll upside down onto its back in an attempt to enlarge the digging entrance. It will often dig sand onto its own upward facing stomach and become totally covered in an earthen shroud.

The nictitating eye-membranes keep the eyes protected from dust and digging detritus, while the ear-valve seals off the ear to prevent foreign particles entering. The short hairs on the upper body allow the Meerkat to rapidly remove sand after a dig with a quick shake, in a similar way to a dog shaking water off its body. The narrow shoulders and large hips allow the Meerkat to easily anchor its back legs while stretching forward and scooping up sand with the front feet, allowing it to reach into very narrow spaces.

The Meerkat will also often bite at and chew on any vegetation that may be blocking the digging site, resulting in some human observers erroneously believing that the Meerkat is eating the plants. The Meerkat's head is commonly used to lever objects out of the way as it forages, and the head is used as though it was a crowbar. Gradually vegetation that was blocking a digging site is lifted and pushed aside in a series of short, fast head-lifting movements.

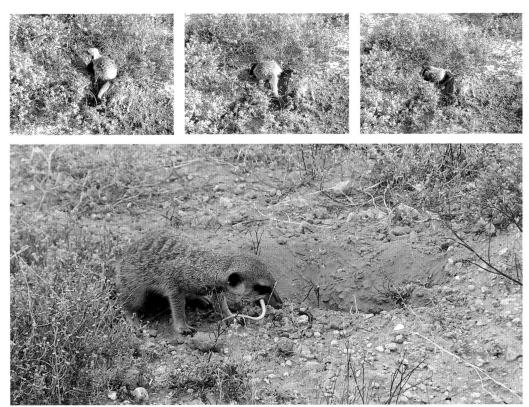

ABOVE TOP: *Being buried beneath the soil is very dangerous for a Meerkat as it is unable to effectively watch for danger at the same time as it searches for food.*

ABOVE BOTTOM: *To discover the victual treasures hidden beneath the surface, Meerkats dig into concrete-like soil to reveal prey such as this reptile.*

In an attempt to save time and associated foraging energy, the Meerkat will often reach down as far as it can into the digging area. It will use its nails, scratching and groping around to attempt to impale the food, and will often even bend its neck almost completely flat against its highly flexible spine to get that extra reach to the promising and elusive item.

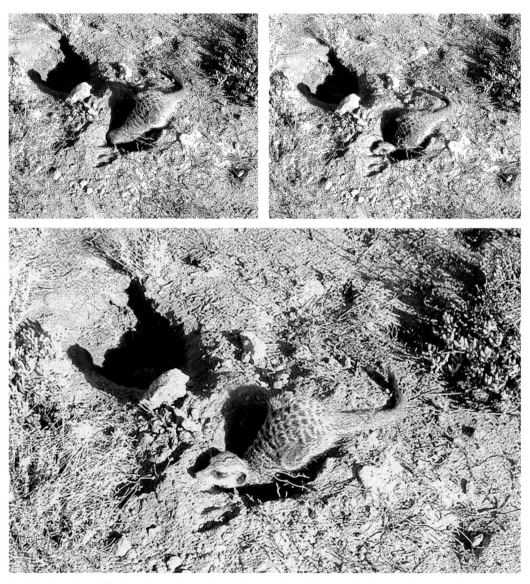

Neck bending and stretching to reach snacks saves time and energy, the additional reach gained can allow an experienced Meerkat to get food faster.

Opportunistic drinkers

The Meerkat receives the moisture it requires from the juicy food that it eats, but it is also an opportunistic drinker and if water is encountered it will often drink when it can.

In captivity Meerkats are often badly dehydrated from an artificial and unsuitable diet lacking in sufficient moisture and appropriate nutrients, which results in numerous skin allergies and health issues.

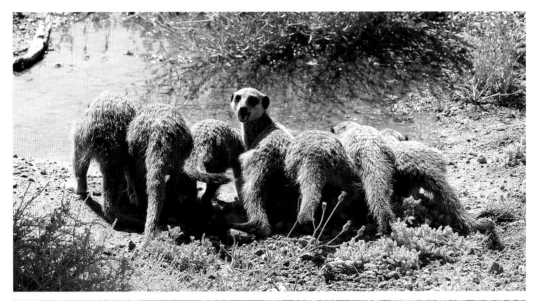

When juicy food is scarce during drought periods, Meerkats will lick the dew off plants or drink from puddles left by thunder showers.

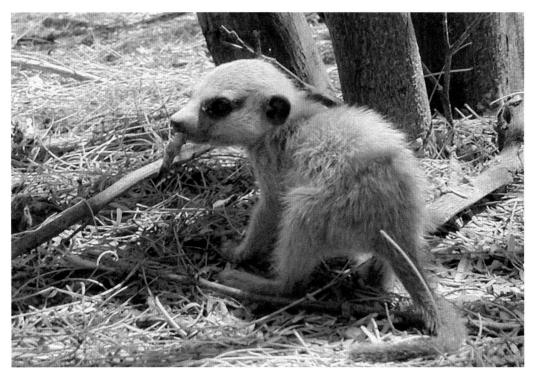

ABOVE: *A pup rapidly dispatches a wriggling larva to ensure that no other litter mate attempts to 'help' with the task.*

OPPOSITE, CLOCKWISE FROM TOP LEFT: *Usually a reptile has little chance to escape once a Meerkat has located it; a reptile can help a younger Meerkat to make up for many failed foraging attempts. These rare food items are aggressively defended from other Meerkats; larger food items given to begging babies are sometimes 'confiscated' by feeders if the item takes too long to eat, thus reducing the time that they are exposed to danger; many reptiles are commonly slowly eaten from the tail end, although sometimes they are more 'fortunate' and rapidly dispatched head-first.*

Food selection and associated risks

Due to the specialised crushing and puncturing dentition of the Meerkat with adaptations for hard shelled food, the diet consists primarily of invertebrates that can easily be eaten.

Although larger food items are also consumed opportunistically, there is a higher risk involved as the Meerkat's inadequate dentition for slicing and cutting large food results in a longer exposure time to predation.

Meerkats which encounter bigger food items that protrude from their mouths will often need to stop foraging and moving with the group in order to manipulate the food with the front legs. This further endangers them from being left vulnerable to predation away from the safety of the group, when the group continues to forage and leaves them behind. Larger food items are therefore too high risk and are sometimes only partially eaten before being abandoned.

Occasionally a food tug of war may occur with larger reptiles being grabbed and pulled in different directions by three of more Meerkats which actively contest the ownership of the food. There is often growling and body blocking and twisting to attempt to secure the largest portions of the unfortunate prey.

116

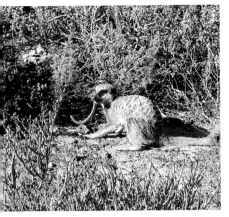

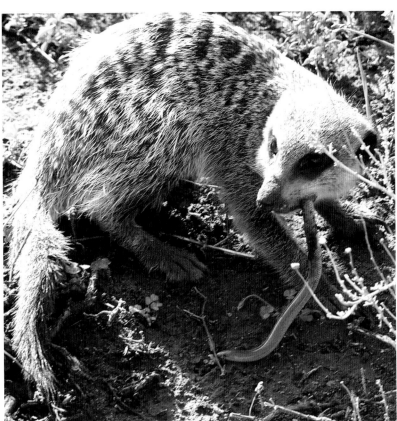

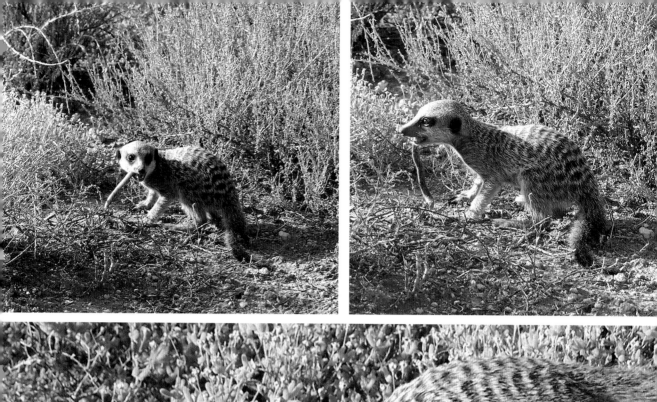
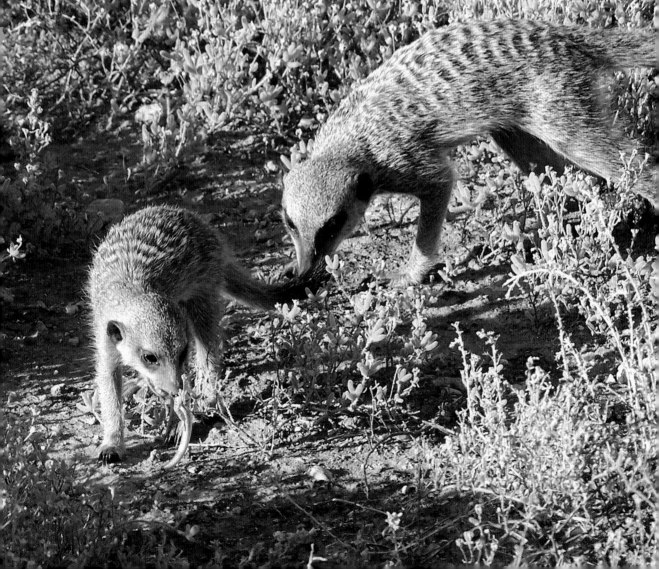

It is safer for a Meerkat to spend less time making rapid shallow digs for smaller food items, rather than investing more energy making slower and deeper digs that may result in no food in return for all the effort. These deeper extended excavations are also a higher safety risk with predation, since more time is spent with the head beneath the ground. Older and more experienced Meerkats spend less time foraging and have higher energy returns from the food that they find more quickly, which allows them to have more time for guarding and other activities.

It seems that there is a direct correlation between nasal length and the depth of digs and foraging success. Older animals with longer noses have a higher foraging success rate then shorter-nosed younger Meerkats, which often make shallow digs and still receive very little or no food for their efforts.

Fortunately for these hungry babies they are provisioned with the best food available by feeding helpers. The baby Meerkats' clear excitement at receiving these proffered food items is apparent and understandable after their own almost constant failed foraging attempts.

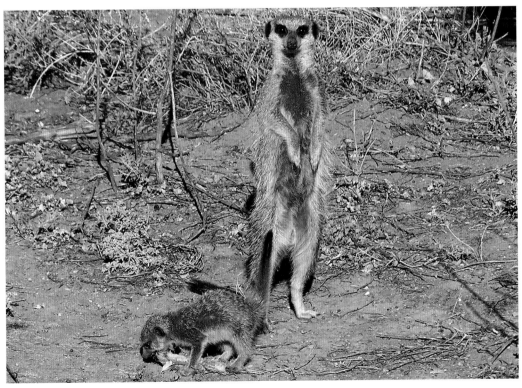

OPPOSITE: *Young Meerkats have their rare foraging successes bolstered with supplementary food supplied by more experienced carers.*

ABOVE: *A baby struggles to chew through silky casing to reach a nest of spiders. An adult stands guard to ensure other Meerkats do not approach.*

Foraging Meerkats will run without hesitation to an escape tunnel if danger is sighted. Afterwards they will navigate back to the same site.

Spatial awareness when foraging

Foraging Meerkats do not only call to warn others of their foraging location and maintain the safety of the group, but also have a very impressive spatial awareness of their surroundings. This is most apparent when Meerkats which have been involved in a prolonged digging effort suddenly respond to an alarm given by a guarding Meerkat. Depending on the severity of the alarm, the Meerkat may simply raise its head briefly and investigate, or may stop digging and run to the nearest escape tunnel.

The fascinating aspect that follows the apparent abandoning of such a promising digging location, is when the Meerkat directly returns to the exact foraging area and continues its hunt. This spatial awareness has been seen from Meerkats moving over 50m (165ft) away from their digging site, often around vegetation or through it, without having first explored the area.

The Meerkat knows where the closest escape tunnel is and immediately runs to it without hesitation, showing survivalist memory. Any hesitation in choosing a direction to run in could lead to a quick demise from a rapidly attacking predator. The Meerkat's ability to retrace its steps back to its temporarily abandoned digging site after any danger has passed is impressive. This pathfinding ability may also be due to temporary scent trails being left as the Meerkat moves, similar to the trail pheromones used by certain ant species.

Medicinal food and toxic phytochemicals

Certain toxic plant species are eaten by Meerkats on occasion, and this may be for the possible use of medicine as an anti-helminthic to rid themselves of internal parasites.

The impact of phytochemicals on the diet of Meerkats is an interesting one. Areas which have become inundated with toxic and exotic plant species through land mismanagement may result in toxin levels building up in Meerkats which do not eat the plant specifically, but do however eat the larvae that eat these plants. This may also result in certain toxic areas being avoided as less suitable habitat. Meerkats that do occur in these areas may have fewer internal parasites due to their ingested plant chemicals.

The impact of people on the indigenous plant and food species of the Meerkat is an important aspect of Meerkat conservation.

Rare sightings of Meerkats deliberately eating toxic plant bulbs may be cases of self-medication against internal parasites.

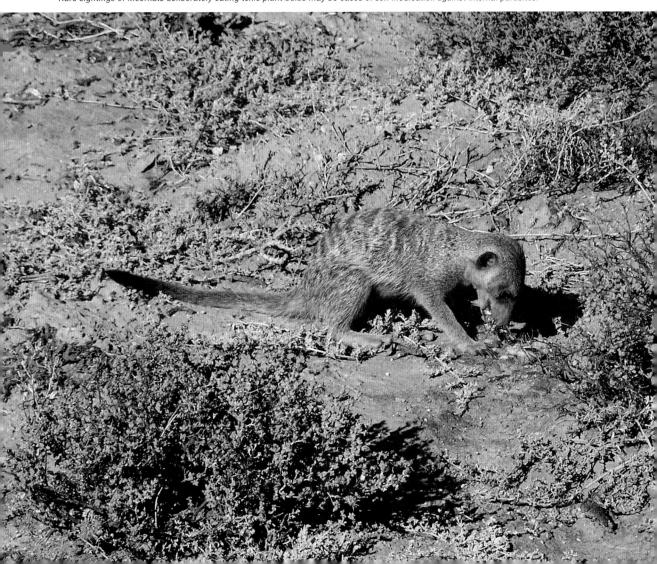

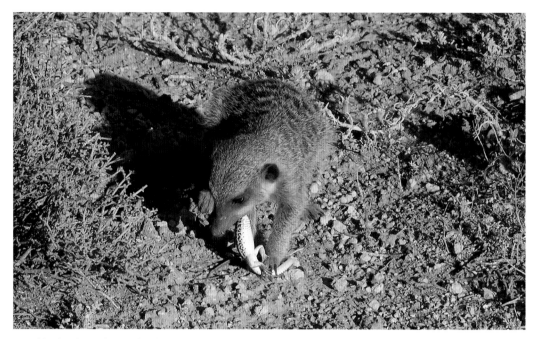

ABOVE: *Meerkats have a large and varied diet consisting primarily of invertebrates, although they opportunistically eat larger vertebrates such as reptiles.*

OPPOSITE: *The discovery of a large food item can result in frantic ownership disputes. The availability of reptiles, rodents and eggs can all result in such opportunistic behaviour from Meerkats.*

Seasonal food variety impacts on feeding preferences

The bulk of the Meerkats' energy intake varies and is mainly determined by the abundance of seasonal food variety and availability. The highest quantity of prey is usually comprised of larvae which are quickly foraged and consumed. A variety of young and adult Carabid and Tenebrionid beetles, crickets, locusts, grasshoppers, ants and their pupae, termites, flies, stick insects, moths, centipedes and millipedes, spiders, solifuges and scorpions are all commonly eaten.

Larger vertebrates such as geckos and lizards are also frequently eaten, but small snakes and small mammals are less common in the diet. Very rarely rodents are surprised and ambushed by noisy foraging Meerkats, which would not usually manage to capture these sensitive hearing species.

Reptile and small bird eggs are also eaten when discovered on the ground.

The Meerkat does not roll eggs between its back legs or throw them to break them like the Banded Mongoose (*Mungos mungo*) does. The Meerkat may only eat smaller, softer bird eggs that it manages to chew open and leathery reptile eggs that it can break when they are dragged along the rough ground using the front feet.

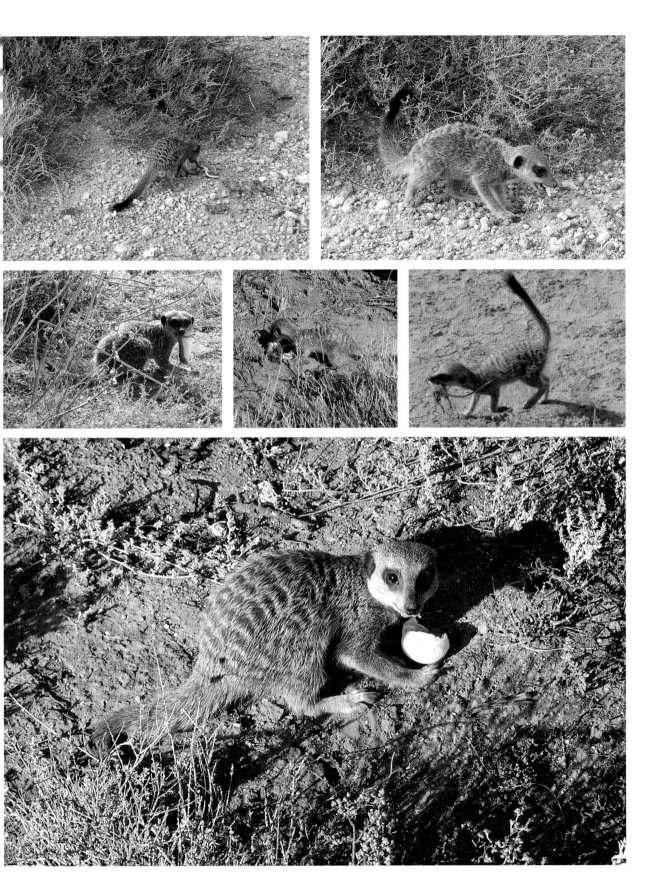

Rare spider prey confuses and outmanoeuvres Meerkats

In the Kalahari Desert and the Little Karoo there is a very rarely seen sand spider that has acquired the ability, when been dug up by Meerkats, to quickly jump onto the Meerkat's back or onto their neck or behind their head, beyond the reach of their mouth and feet. On the occasions I have witnessed this, the spider almost always manages to escape. It is sometimes carried along by the Meerkat for many minutes before jumping off onto another Meerkat or into vegetation. Initially the Meerkat scratches and attempts to bite the anchored arachnid, but most of the time it is unable to reach the spider. After a frantic initial attempt to get the hidden spider it stops looking for it, but it can no doubt still smell it, and it will intermittently stop and scratch itself in attempt to dislodge the tenacious passenger.

Occasionally the spider species jumps onto the side of the Meerkat or too low on the back and the Meerkat manages to scratch it off and eat it. This level of predator-prey relationship must have taken a substantial time to develop. I have observed the same spider behaviour in two Meerkat subspecies with great distances separating their respective habitats of the Kalahari Desert and the Little Karoo.

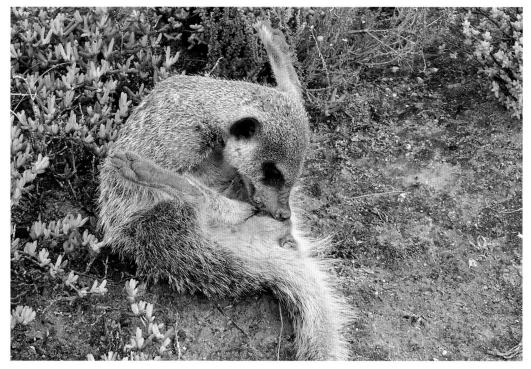

Spiders are often consumed, but there is one species that has mastered the Meerkat by hitching a ride on the attacker's head or back and remaining out of reach until it can escape unnoticed.

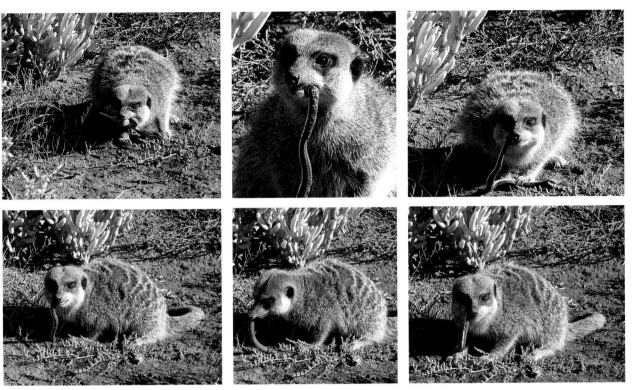

Snakes are seldom eaten by wild Meerkats, but this will not stop a youngster from being curious and attempting to catch one. Some snakes will threaten and posture and manage to deter inexperienced individuals. Older Meerkats will seldom hesitate if they arrive at such a stand-off, and will rush in and snatch the snake. Occasionally multiple Meerkats will arrive and contest ownership of the food item by tugging and tearing it in different directions.

Harmless snakes can intimidate inexperienced Meerkats

Although Meerkats have the ability to kill venomous snakes, they very seldom do so as they are not adapted to eating large food items. Older and more experienced Meerkats have learned many interesting ways of handling prey that younger Meerkats will avoid. Baby and juvenile Meerkats are often clearly intimidated by harmless smaller snake species. These reptiles will coil up and hiss and strike at hesitant inexperienced Meerkats, and appear to be very threatening to any unenlightened observer or foraging Meerkat.

Older Meerkats will often simply rush in and immediately grab and eat these smaller snakes, totally ignoring their pseudo threats. Younger Meerkats will then acquire this foraging experience. In contrast to these inexperienced and intimidated Meerkats, sometimes baby Meerkats are fed medium-sized reptiles and small snakes, and learn to deal with these species from an early age. They are not threatened by these snake encounters as they develop. It appears that inexperienced Meerkats actively learn from teachers.

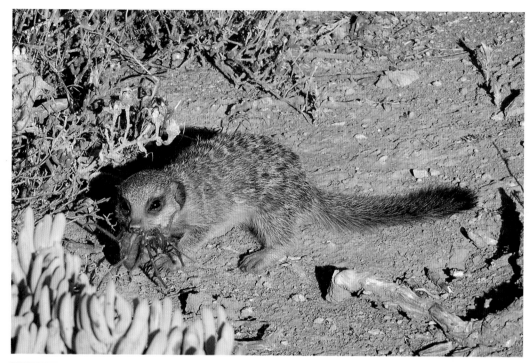

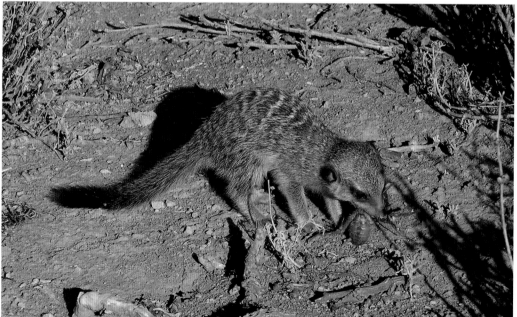

The large, aggressive, speedy solifuge will visciously bite and injure Meerkats who wish to make a meal of it, but once overcome it makes a veritable feast and is packed with moisture.

Adaptations for dealing with chemically defended, venomous, toxic or aggressive food items

The Meerkat is a ferocious hunter and is seldom deterred from taking on the most intimidating, aggressive and well-defended prey.

Before certain aggressive species of food are dug out, Meerkats change their calls from a standard foraging contact to a much more rapid call just before they encounter their prey.

Food rubbing and wiping on the ground occurs with various chemically defended species such as acid-spraying Carabid beetles and with the unpalatable secretions of the millipede. Experienced Meerkats will nullify the impact of toxic hairy caterpillars by pulling them along the ground and then actively skinning them to remove the irritant hairs. The Meerkat will often have a great deal of frothy saliva present after hunting these species, clearly indicating an adverse reaction to their chemical defences.

Aggressive and fast predatory biting centipedes, large spiky chemically defended armoured ground crickets, scavenging solifuges and arachnids such as the baboon spiders are usually dragged extensively to immobilise them before they are quickly chewed on the head to disable the vicious and dangerous jaws.

Baboon spiders documented as part of the Meerkats' diet

Another very rare event that I experienced was the first evidence of the Meerkat species eating a venomous baboon spider. This spider is very rarely seen in the Little Karoo and in over a decade I have only photographically documented two cases of the Meerkat actively digging these spiders up and eating them.

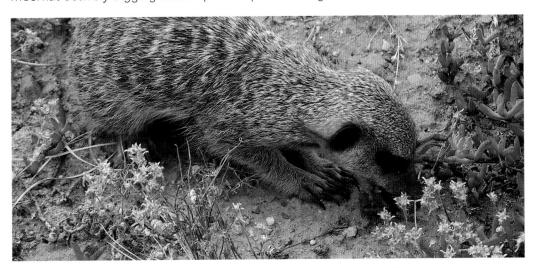

The first photographic evidence of the Little Karoo Meerkat subspecies actually eating an incredibly rare find of a baboon spider.

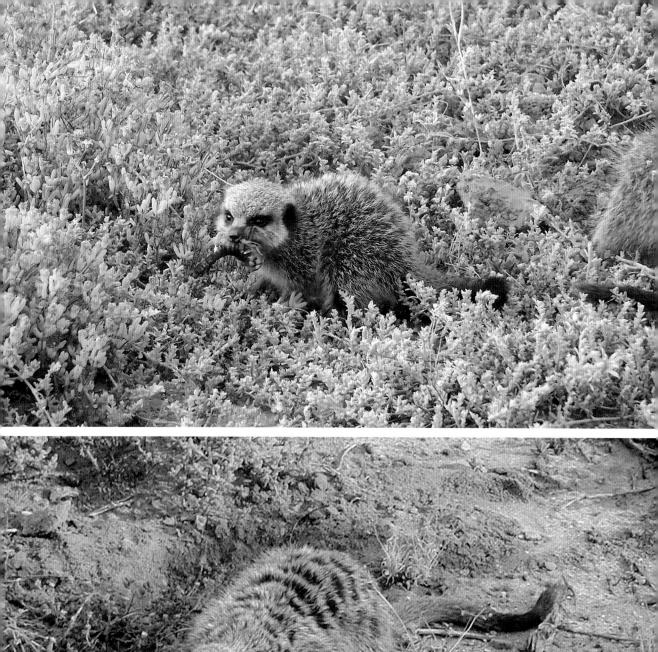
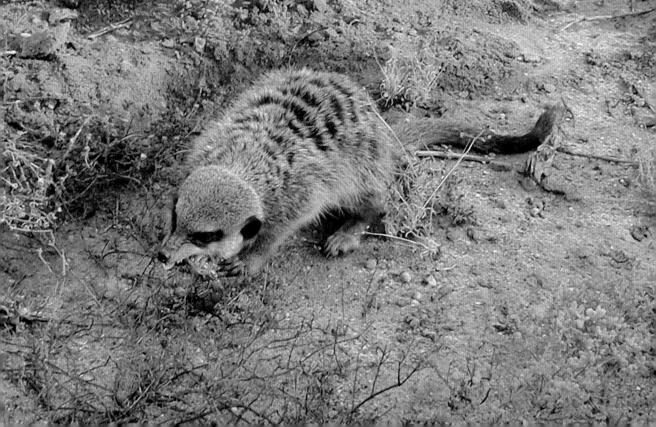

Scorpions are suricate dessert

Meerkats appear to have a very high tolerance to neurotoxic venom from certain snake, scorpion and spider species compared to humans. They are not, however, immune to this venom as is often mentioned in the media, as larger dosages can kill them. Meerkats which survive venomous attacks are usually severely scarred.

Meerkats get very excited when they eat scorpions, which appear to be the equivalent of suricate 'dessert'.

Scorpions are usually dragged with the Meerkats' sharp nails, pummelling the prey on the ground to damage it. As soon as possible the Meerkat will then rapidly bite at the tail and chew off the sting and then proceed to devour the scorpion tail first. If the scorpion possesses powerful pincers these will often be crushed and then the sting will be bitten off afterwards.

The dispatching method used seems to depend on the scorpion species. *Parabuthus* species from the Buthidae family have neurotoxic venom and small pincers so the sting is often prioritised and disabled first. This species has a thick tail with a large sting and small pincers and relies on its venom to immobilise prey. These scorpions often hide under objects rather than digging deep burrows. The *Opistophthalmus* species from the Scorpionidae family have large strong pincers and a weak thin tail and small sting, and the pincers are often subdued first. This species is a very active digger and commonly digs holes to 1m (3.3ft) deep.

Due to these different habits the type of scorpion a Meerkat is most likely foraging for can be predicted. A Meerkat can often dig a hole many times deeper than its own body length in search of these burrowing scorpion species. These extended digs can become Meerkat escape burrows over many years as they are enlarged with subsequent visits to the area.

Baby Meerkats tend to get pinched and stung a lot before they learn to differentiate which scorpion species they are dealing with.

OPPOSITE: *A scorpion sting has a neurotoxic venom dosage large enough to kill a human, but merely causes a Meerkat to scratch for a few moments before moving on as if nothing has happened. I have personally been hospitalised by the excruciatingly painful sting of a* Parabuthus *scorpion and would have certainly died without expert medical treatment. Meerkats appear to prefer scorpions above all other food items that they discover.*

Food teachers and baby apprentices

Pup-feeding and active teaching of the young occurs within Meerkat groups and is a great investment of time and resources when raising a litter.

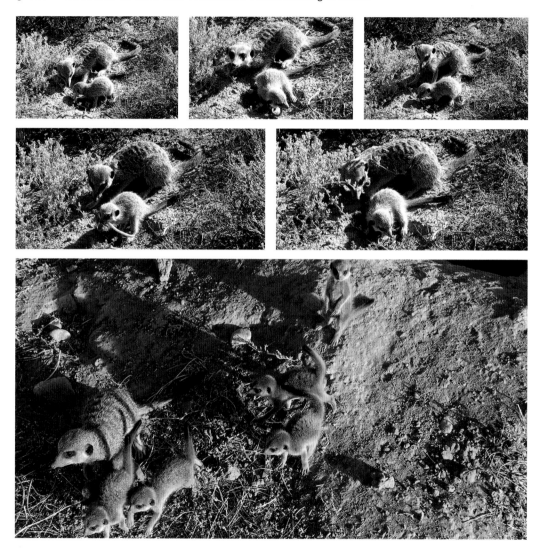

ABOVE TOP: *A young pup is given a very generous foraging find of a reptile by a helper, who remains with the baby to ensure that it is not attacked and that the food does not escape.*

ABOVE BOTTOM: *Baby Meerkats move together in apparent harmony following an adult, but as soon as any food is found this results in hostile posturing and biting of each other.*

OPPOSITE: *After calling persistantly this ravenous baby is rewarded with a lizard from a diligent teacher. Often these charitable adults will feed their hungry apprentices before finding their own nutrition.*

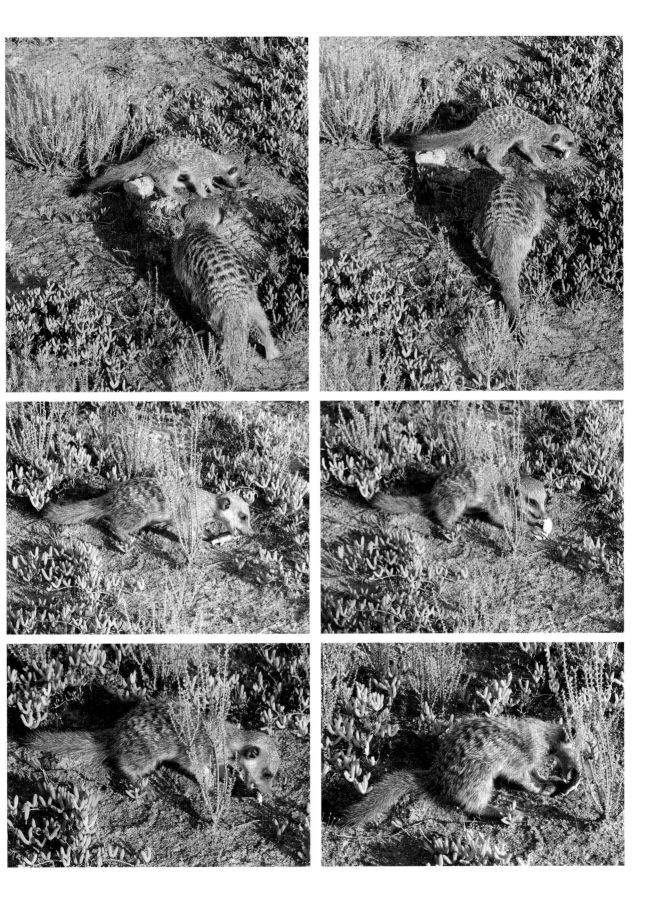

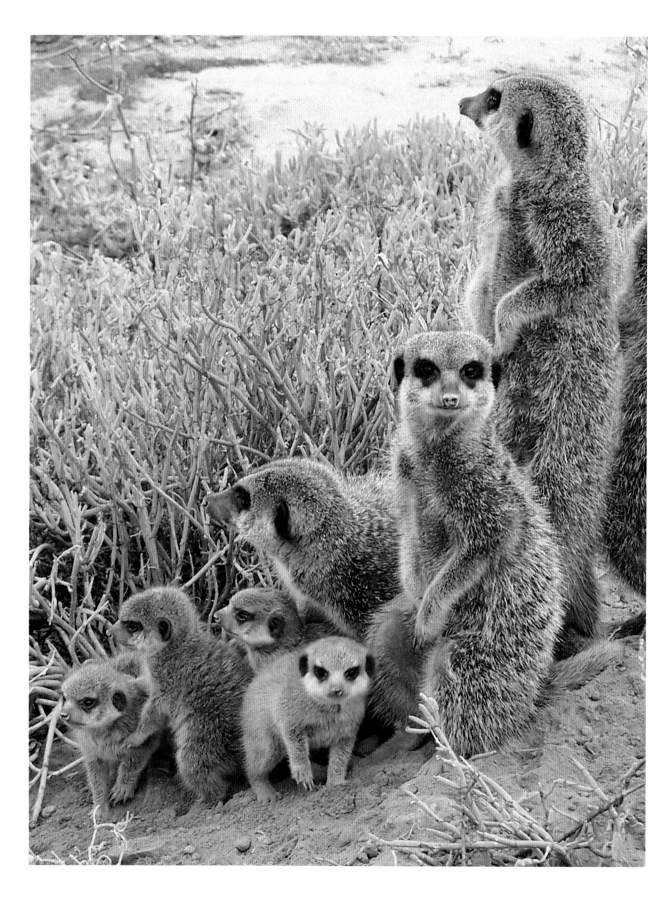

Babies do not share food with anybody and adults do not share food with each other. Any generation older than the current litter of pups will feed young that beg for food. Babies follow different older more experienced Meerkats in an apprenticeship of victual provisioning.

Initially food is taken to babies who wait in the safety of burrows and who do not actively follow teachers. Even when they are not calling for food they get fed before they are weaned. Once any baby receives food it will make a very excited high-pitched eating sound. As babies become stronger and more mobile they are able to follow the foraging group further each day.

When foraging with the group initially, babies get tired very quickly, often collapsing after a few hundred metres.

They are guarded by a babysitter while feeders continue to bring food to them and encourage them to eat and follow.

Soon food is only taken short distances to waiting babies, and they quickly learn to follow food teachers who will often stand guard and ensure that the fed baby eats the food.

OPPOSITE: *Hungry apprentices are encouraged by babysitters to follow them short distances away from the burrow. The babies learn to follow further each day as they are rewarded with meals.*

ABOVE: *It is an exhausting period when babies begin to move from their first burrow to explore their territory with the group. They will often curl up and sleep whenever they can after being well fed.*

Babies gradually learn to recognise the prey species' defence mechanisms and how to disable them. They initially get stung repeatedly when attempting to eat a venomous scorpion as they need to learn how to disable it before they get stung. Initially food helpers will bring a very chewed up and immobilised scorpion to a baby.

Over many days of feeding, babies will be presented with far more mobile scorpions, and then scorpions with their stings still very active. Babies soon learn to eat the tail of a stinging scorpion first, often leaving the pincers dangling from the masticating maw.

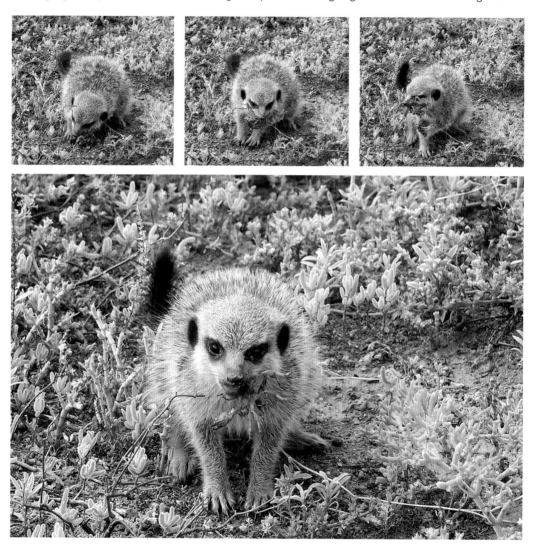

As baby Meerkats gain experience in dealing with aggressive delicacies such as scorpions, they quickly learn to debilitate them by devouring their sting and tail first.

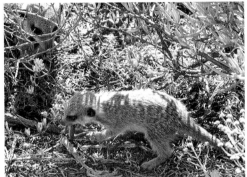

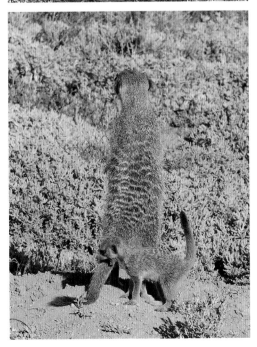

Babies will aggressively defend their chosen teachers from any baby who is not currently following a teacher of their own and who attempts to follow the same teacher. Often babies will run after each other and growl and spit, and in the process lose the food that was brought to them, and simply follow another nearby teacher.

Aggressive babies which chase other litter mates away often end up turning on approaching feeders in their excitement, biting them hard on their noses, legs or ears and tails and holding on. The feeders never show any aggression towards the babies, but simply wait for the baby to detach itself and take the food that was brought for it.

Initially food is very well chewed and given to babies with any defences incapacitated. As the babies get older, food is given to them in various stages of increased mobility. Babies continue to hone their growing arsenal of predatory skills and respective prey scent recognition and associated behaviours over weeks.

LEFT TOP: *The sharp jaws of the solifuge inflict severe bite wounds and babies quickly learn to attack the source of the pain and bite back. Solifuges are prized parcels of concentrated energy.*

LEFT MIDDLE: *Reptiles are often immobilised before being brought to babies as meals, to prevent them escaping from an inexperienced student pup.*

LEFT BOTTOM: *Baby Meerkats will often attack anything that resembles food and this frequently includes the teacher. Adults resist fighting back, even when babies are biting their tails, ears and noses.*

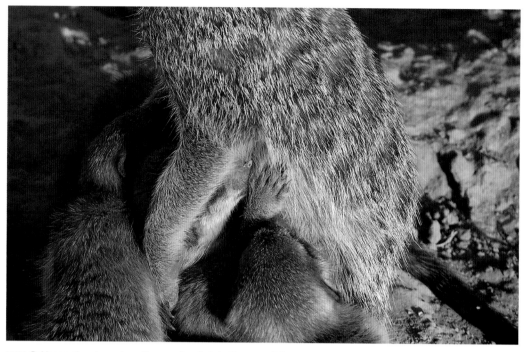

ABOVE: *Babies continue to receive milk even when their teeth grow and they are eating solid food. This weaning process can be extended if there is an abundance of food, or shortened when food reserves are depleted.*

OPPOSITE: *Babies receive lessons on how to discover and dispatch a larva. Initially the larva is mangled when given to a baby, but in time the pup will learn how to follow and take over a hunt from a teacher and become an independent hunter.*

After three to four weeks they are usually fully weaned off milk and their dentition is much more suited for crushing their prey. The duration of pup provisioning is linked to food availability, lasting longer (for two to three months) when food is abundant and ending sooner in times of food scarcity. This feeding duration is also superseded by any new litters of babies born. The youngest generation automatically gets fed and the older generation will no longer be provisioned or have their food calls tolerated.

Apprenticed babies do not have the same teachers every day, and will simply follow any adult who may feed them. Although a lactating female requires additional food to produce milk before the babies are fully weaned, they will also feed babies who follow them. Dominant males and females will feed babies too.

The scent of prey and its associated behaviour is actively taught to babies who do not simply passively watch and learn but are actively shown how to hunt, and feeders will introduce food at various stages of mobility to learning Meerkat pups. As the babies hunting abilities improve, the feeding teacher will increasingly provide food lesson challenges to the babies.

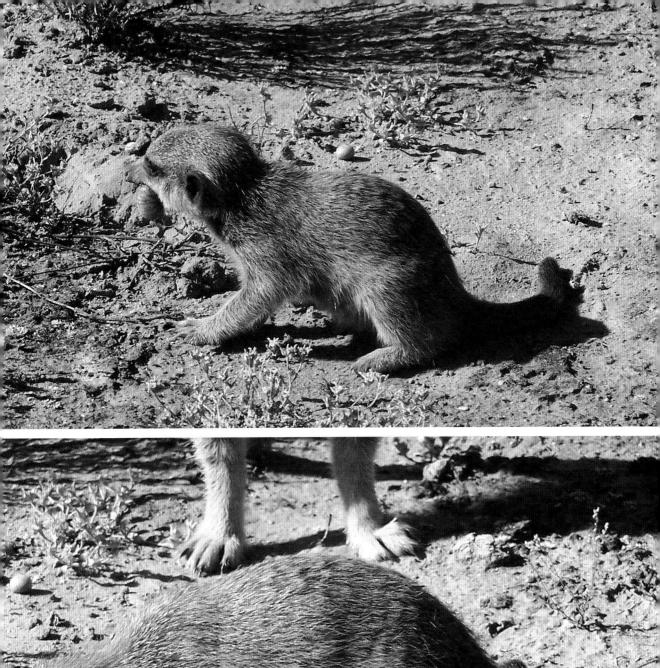
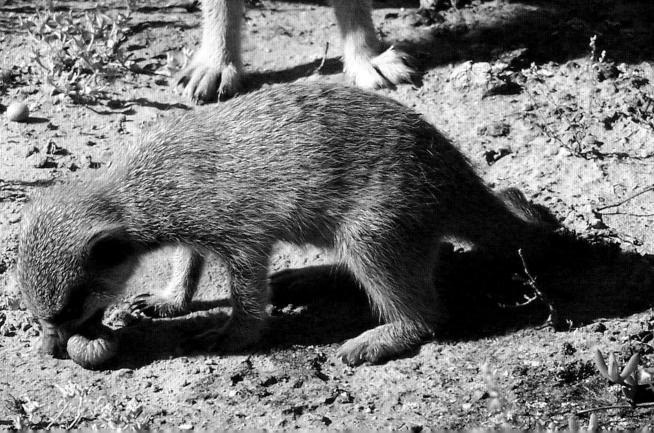

Babies expend a great deal of energy making ineffectual shallow digs that do not provide more than the occasional small snack of a beetle. As the babies' nails and noses grow so too does their independence and foraging success.

Another example of active teaching of young is when a Coleoptera larva is initially dug up away from a baby. The beetle grub is then removed from its hardened mud cocoon and chewed up and delivered to a waiting baby. Over a period of a few days the same species of insect grub is less chewed on delivery. After another few days the baby will actively follow the feeder who will only take the fully functioning larva a short distance before giving it to the baby. The final teaching stages are when the larva is left in the broken open mud cocoon and taken to the baby to open.

The next stage in this food handling lesson is when the baby pushes the teacher out of the digging site and breaks open the mud cocoon itself to get the larva. From this late teaching stage the babies will frequently push in front of teachers who are only starting to dig for larva and the teachers will sometimes paw at the digging site or exposed food, but not interfere with the soon to be independent foraging apprentice.

Very mobile prey such as fast spiders and centipedes and jumping crickets are commonly held down on the ground when they are dropped between the front feet at the baby. The baby will run up and bite the feeder, and the feeder will start to move its feet that are trapping the fast prey. Often the prey will start to escape and be captured again, and the process will repeat. Finally the baby will move the feeder's feet to get to the active prey, or the prey will simply escape and not be pursued after repeated failed feeding lessons.

Occasionally younger feeders will simply eat the food or even take it to another nearby baby. If a baby already has food, and is the only baby, many teachers will bring it food continually even when it no longer calls for food. It will simply stuff itself with as much food as it can eat, until it can hardly move and then collapse in exhausted contentment. If there are only a few babies and one has food, additional food is sometimes taken from one slow eating baby and given to another.

Pain versus gain ant and termite nest raiding

Experienced older Meerkats seem to have acquired skills in dealing with highly aggressive biting and formic acid-spraying ants and termites. The main nest is avoided, and the less well-defended nursery with the juiciest pupae is usually raided first by seasoned veteran Meerkats. I call this the 'pain versus gain' foraging principle. The time taken to vacuum up as many tasty pupae as possible must be weighed against the increasingly ferocious formic acid and painful bites of soldier ants or termites that quickly swarm over any nest-renovating Meerkat.

Younger Meerkats are inadvertently thrown into the deep end of the ant avoidance and tasty termite pupae foraging pool of experience. Plaintiff Meerkat babies often sit around and call and whine to their feeder Meerkat, oblivious to the biting pain and searing acid burns they are about to experience from their first and memorable ant or termite encounter.

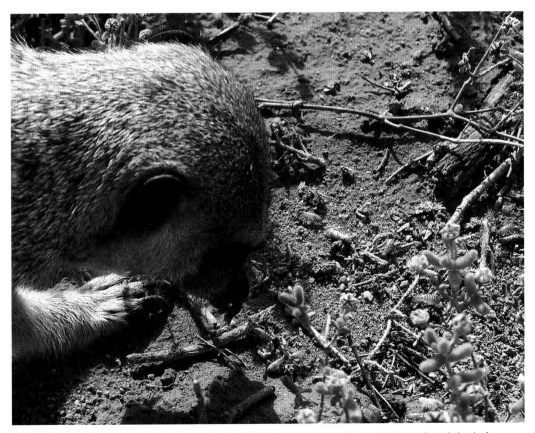

Raiding biting insect nests can be very rewarding, but the rewards can soon be overshadowed by increasing pain levels. An experienced Meerkat will minimize the bites it receives by attacking rapidly and then retreating.

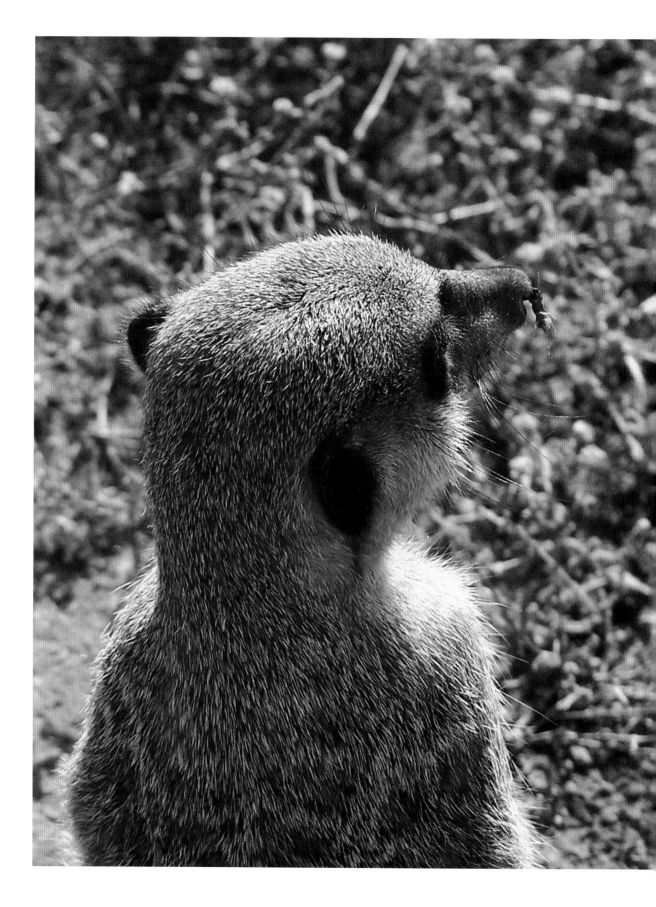

When the nest is cracked open by a hungry masterful Meerkat and the ants or termites come pouring out in overwhelming numbers, older Meerkats are quick to snatch up pupae and then run off before getting badly bitten. The long guard hairs on their legs prevent most of the ferocious social insect bites, and the thick rubbery padding on their limbs acts as armour.

The baby meerkats do not seem to realise where the pain is coming from at first, as they start jumping up into the air, and running around and around and stamping their feet in an attempt to dislodge the aggravated assailants.

Unlike older Meerkats, babies do not have long guard hairs or thick skins. Their short noses are often covered in the still biting ant or termite heads at the end of the foraging day, with the appearance of strange adornments or medals of nest-raiding experience. Older Meerkats are also not immune to these relentless biting trophies.

Ants and millipedes are not high on the list of tasty preferred food items and often seem to be reserved for the driest, least food-abundant times of the year. In contrast, termites are clearly a veritable feast for hungry Meerkats who will eat as many as they can find as quickly as possible. They effectively help to control termite swarms from becoming plagues as a major ecological benefit.

Scent association and behaviour prediction of hidden prey

It appears that older, more experienced Meerkats gradually learn to predict the prey behaviour they are digging up by recognition of the scent prior to encountering the food species.

A very interesting example of this is with the vocal and well-camouflaged reptile the Common Barking Gecko (*Ptenopus garrulus*). At certain times of the year these geckos are an abundant food source for the Meerkats. Meerkats which learn to eat this gecko acquire an interesting scent-associated prey behaviour-predicting trait. This gecko species often has an escape tunnel built into the entrance of the main passage where it takes refuge, and the male uses this to amplify his characteristic *'tik tik tik tik tik'* barking calls.

Initially a less experienced gecko-hunting Meerkat will simply follow the gecko's scent and try to dig it out. The gecko will usually crawl very slowly out of its side escape tunnel, lying very still and using its cryptic sand-coloured patterns in an attempt to avoid detection. It will then move away slowly and stop and repeat this process until it manages to get away from the menacing Meerkat. Of course its crypsis is inconsequential when faced with the Meerkat's olfactory gifts.

OPPOSITE: *It is easy to deduce that termites or ants have been pillaged by raiding Meerkats, simply by the assorted collection of defenders that often tenaciously cling to their noses.*

After a substantial time investment the Meerkat will sniff around the digging site and then abandon it, usually with the gecko at a safe distance. However, this all changes when a Meerkat happens to notice a gecko escaping from the side tunnel. Immediately the gecko will be grabbed. The gecko still has other defence measures, though. When it is attacked the gecko initiates caudal autotomy and the incompletely fused vertebrae of its tail break and its wriggling and predator-attracting and -distracting tail is abandoned. The gecko will often escape while the Meerkat is preoccupied with eating the tantalising dancing tail. If the gecko does not manage to escape, it will bark loudly and even bite and hold on to the Meerkat's face in an attempt to prevent it from being eaten. Unfortunately this final endeavour to escape never appears to deter a hungry Meerkat.

Having reinforced the associated escape behaviour of the gecko with this reptile's prey scent, a fascinating transformation occurs with the now more experienced gecko-hunting Meerkat. With each subsequent dig the Meerkat appears to know that it is digging up this gecko species by the very marked change in its foraging behaviour patterns. The Meerkat no longer simply digs continually while the gecko escapes. The Meerkat digs only briefly, stopping often and actively walking around sniffing the ground near to the entrance tunnel. It repeats this process until it is ultimately rewarded with the gecko not escaping and the prey species' behaviour and associated scent is further reinforced.

This adaptive foraging strategy is very clear and develops with individual Meerkat experience. I have witnessed an even more unusual and never again seen behaviour based on the gecko-foraging pattern. One elderly very experienced dominant Meerkat female out of hundreds of Meerkats clearly learned that when a foraging Meerkat within her group began circling around their digging site there would be a tasty gecko lying outside of the digging area. She no doubt initially discovered this through chance and developed the association through positive reinforcement.

This female became the true master gecko-hunter. She learned to wait for others to do the work of digging up the gecko, and would simply move towards these uniquely circling foragers, going from one gecko burrow to another, catching geckos as they attempted to escape. The more experienced and circling foraging Meerkats would continue digging long after this female had already eaten their reward and moved onto another gecko-hunting Meerkat's foraging attempt. The dominant female was able to expend very little energy, and through repeated positive energy rewards was able to effectively procure food from others without them even realising that they had been 'robbed'!

In addition to the expert gecko-hunting Meerkat, another rare and localised foraging behaviour sighting has been noted with a different older dominant female Meerkat. She

OPPOSITE: *Pregnant dominant females will commonly requisition other Meerkats' food by simply pushing them out of the way.*

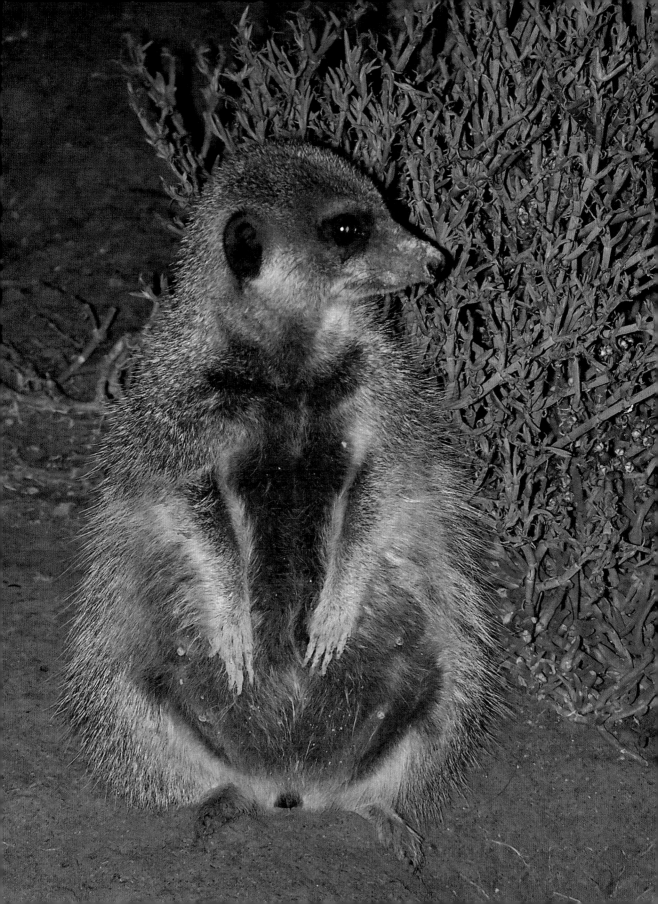

would only approach other Meerkats that had almost dug a hole deep enough for them to be hidden in, clearly a substantial energy investment dig, with a possibility of a high energy return. Usually any older approaching Meerkats are warned and chased away from a foraging site. Although the dominant female would be warned, she would persist in approaching these diggers.

Rather than expend her own energy, she would then simply walk over to them and start digging them out of their own foraging site, scratching at their backs and flinging them backwards between her legs as if she was performing burrow maintenance digging.

Without exception, these displaced Meerkats never had an aggressive reaction to this, and it would appear that they simply had no defence against such a rare and localised behaviour. If they did approach to attempt to reclaim their own dig, they would be aggressively repelled by the dominant female defending her newly acquired hostile takeover digging site.

This foraging leapfrog behaviour was truly localised and I have never seen it happen with any other Meerkats in the Kalahari Desert and Little Karoo study populations.

Both of these uniquely talented dominant females were either pregnant or lactating during these recorded events. They clearly had acquired an energy-saving strategy for foraging with the increased demands on their own bodies to feed their young. These amazing behaviours may be viewed anthropomorphically as the equivalent of 'nature's energy tax' taken by the matriarch or government of the group.

PREDATORS AND THE HUNTED HUNTERS

MEERKATS ARE HUNTED HUNTERS. They are on the extended menu for many predatory species, and being primarily carnivorous themselves, they not only need to actively search for food, but to take precautions so that they themselves do not end up as prey for a hungry predator. It is essential that a Meerkat learns from a very young age how to recognise potential threats in their territory and how to rapidly respond in order to survive.

Baby Meerkats are actively taught survival skills by the group. This is not merely learning by observation but active teaching and time investment from experienced Meerkats. Both visual and vocal alarms are used when encountering predators.

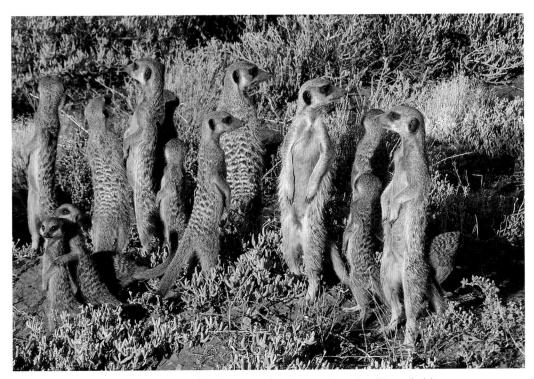

Being hunted hunters requires great vigilance. Meerkats are masters of cooperative anti-predator methodology.

The Meerkats survive in a very hostile and hungry predatory world. Although Meerkats have an extensive security network of burrows and escape routes, there is never any true safety for them during the day or night. They need to be highly alert and maintain a constant vigil within the group in order to survive each day and night. There are predators hunting in the sky, on the ground and also under the ground in the Meerkats' own burrow systems.

Basically any predator that eats mammals is a possible threat to the Meerkats in their territory.

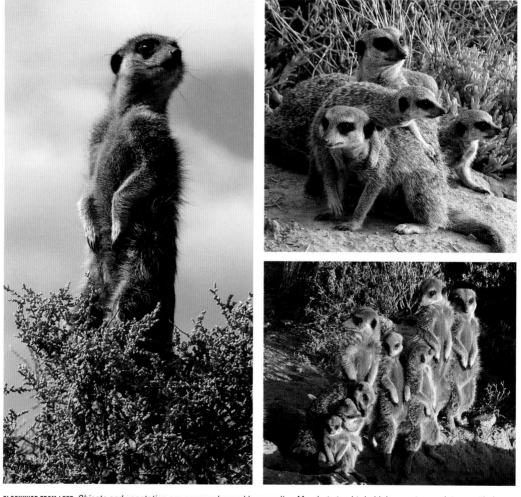

CLOCKWISE FROM LEFT: *Objects and vegetation are commonly used by guarding Meerkats to obtain higher vantage points over their surroundings; younger Meerkats practice their climbing and guarding skills from an early age; older more experienced Meerkats often guard more frequently, which allows younger Meerkats to play and develop their skills.*

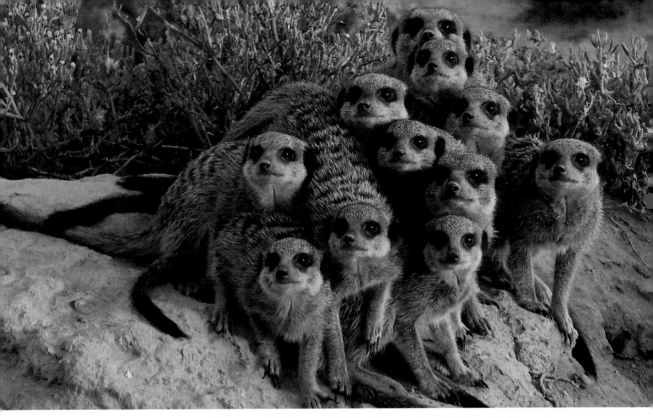

Possible danger seldom goes unnoticed. If the many unblinking eyes sight a threat then guarding will rapidly resolve into warning alarm calls.

Aerial

Any bird of prey that is large enough to hunt a meerkat could be a threat. The larger the bird species the more of a threat is usually associated with it. Although nocturnal owl species are not commonly encountered by the Meerkats during the day, if a resting owl is disturbed it may leave its daytime roost and attack unsuspecting Meerkats that may have wandered under the shade of the tree it was in.

Because owl species are so very well camouflaged, if one Meerkat sees a movement and then begins to alarm at the 'hidden' owl, many other Meerkats will also become alarmed and begin to look in the same direction of the rapid head-bobbing alarmed Meerkat which saw the owl. Rare Meerkat encounters with the following nocturnal owl species have been observed: Giant Eagle-owl (*Bubo lacteus*); Spotted Eagle-owl (*Bubo africanus*); and Barn Owl (*Tyto alba*).

The list of predatory bird species is very large, so a few frequently encountered species will be mentioned. The larger diurnal birds of prey are amongst the most dangerous Meerkat hunters and include: Martial Eagle (*Polemaetus bellicosus*); Tawny Eagle (*Aquila rapax*); Bateleur (*Terathopius ecaudatus*); Black-chested Snake-eagle (*Circaetus pectoralis*); Jackal Buzzard (*Buteo rufofuscus*); Pale Chanting Goshawk (*Melierax canorus*); Gabar Goshawk (*Micronisus gabar*); Lanner Falcon (*Falco biarmicus*); Peregrine Falcon (*Falco peregrinus*); and Yellow-billed Kite (*Milvus aegyptius*).

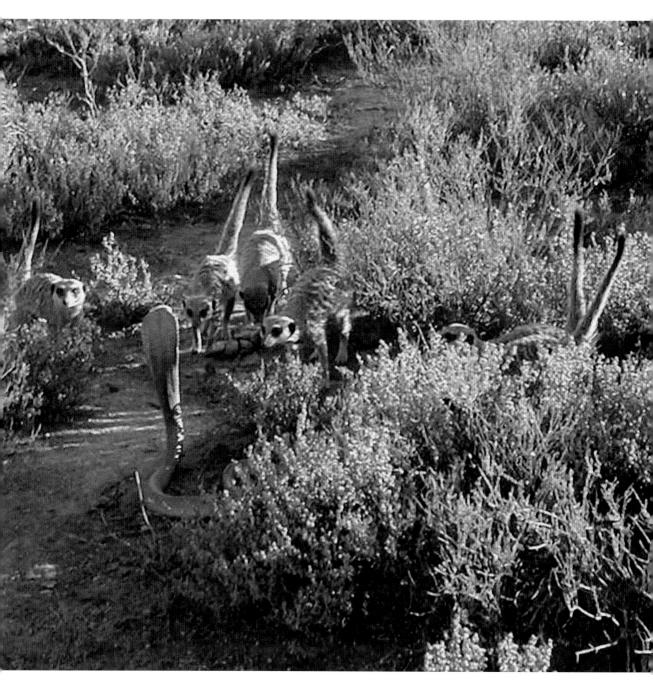

Venomous snakes such as the Cape Cobra are among the most dangerous of all the Meerkats' many predators. The threat level is much higher around the confined areas of a burrow system and Meerkats will accordingly expend far more time and energy deterring them in such situations.

Terrestrial

Mammals:

There are many terrestrial mammals that actively hunt Meerkats, or may on occasion attack them even if this is rare. Some of these species include: Black-backed Jackal (*Canis mesomelas*); Side-striped Jackal (*Canis adustus*); Bat-eared Fox (*Otocyon megalotis*); Cape Fox (*Vulpes chama*); Lion (*Panthera leo*); Leopard (*Panthera pardus*); Caracal (*Felis caracal*); Small Spotted Cat (*Felis nigripes*); African Wildcat (*Felis lybica*); and Honey Badger (*Mellivora capensis*); as well as one recorded sighting of a Yellow Mongoose (*Cynictis penicillata*) killing a baby Meerkat.

Reptiles:

Reptiles are the most dangerous of all the Meerkat predators as they hunt them in the very safety of their burrows during the day and at night.

The Rock Monitor (*Varanus exanthematicus*) has also been seen attacking Meerkats, and smaller monitor lizards will enter burrows. Larger groups of Meerkats will sometimes manage to repel these lizards and even chase them away, with the lizard sometimes climbing up into a tree for safety.

Snakes often sleep in burrow systems during the day and aestivate over the colder months in the warm burrows, increasing the Meerkats' risk of encountering them in the limited space of a burrow chamber or tunnel. Meerkats will even abandon a burrow if they are unable to get a snake to leave it. The constricting and venomous snake species are the most dangerous and frequently encountered predatory reptiles, for example the Mole Snake (*Pseudapsis cana*) is a constrictor species and suffocates its food in its muscular coils.

Venomous snake encounters

Certain snakes are more dangerous to Meerkats than birds of prey or other terrestrial predators, especially when Meerkat babies are inside a burrow. These snake species actively hunt during the day and night and frequently within the very burrow systems that Meerkats use to escape from most of their other predators. In addition to this constant threat from snake encounters in the confined burrow spaces, the Meerkats' disruptive cryptic patterns do not assist them when escaping from a snake actively hunting prey using its heightened olfactory senses.

The most notable Meerkat predators amongst the snakes are the Cape Cobra (*Naja nivea*) with its neurotoxic venom, which is the same venom type found in the Buthidae scorpion species (that the Meerkat eats and has a high tolerance towards). A large

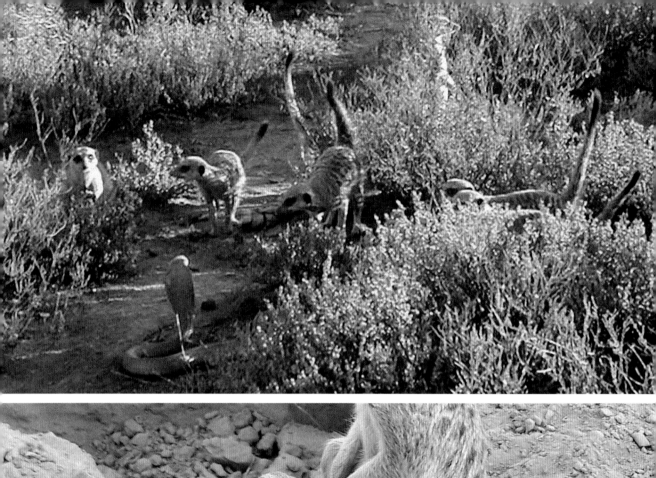

venom dosage from a cobra bite is fatal, though, and this is proof that Meerkats are not immune to scorpion venom, only highly tolerant of lower dosages.

The Puff Adder (*Bitis arietans*) has highly destructive cell-destroying cytotoxic venom, which can cripple a Meerkat or result in limb loss or death through open wound infections. Surviving Meerkats are often severely scarred and have limb deformities. Snake bites often target the swaying tail of the Meerkat, resulting in tail scarring.

The Horned Adder (*Bitis caudalis*) commonly buries itself in sand as an ambush predator with only part of its head protruding .

When Meerkats encounter the scent of a potentially dangerous snake in their territory they will aggressively growl and warn each other of this danger. Following this growling and often spitting vocalisation the Meerkats will piloerect their hair, enlarging their appearance and bending their puffed out tails over their backs.

They will actively group closely together, swaying their bent black-tipped and brightly marked orange or yellow undersides of their bottlebrush-like tails as a visual warning of danger. When the Meerkats group together this may often intimidate or confuse a predator, making it more challenging to attack an individual.

Interestingly, Meerkats will spend very little time being aggressive towards snakes that they encounter away from their own burrow systems. A snake encounter at a burrow system elicits a far more determined mobbing and pestering of the snake which the Meerkats may nip at and scratch in order to encourage it to leave the area. Although Meerkats in captivity are known to have killed snakes, wild Meerkats very seldom attack and try and kill venomous snakes, even though they are able to do so.

By attacking large reptiles such as the cobra or adder species, the Meerkat increases its own chances of being attacked, not only from the snake but potentially by other predators that it may not be actively guarding against. Meerkats will often carry babies away from a burrow that has been visited by a snake. If the snake does not leave after being mobbed, frequently the Meerkats will move away.

Meerkats do not have carnassial or cutting teeth, but rather puncturing and crushing teeth. Their teeth are not suited for cutting a large and tough-skinned snake as a meal. Any Meerkats who may attempt to kill or eat a large venomous snake would expose themselves to great danger while chewing ineffectively on an unsuitable food item.

OPPOSITE TOP: *A Cape Cobra has very little chance of surprising a Meerkat away from the sleeping burrows. Meerkats will unerringly trace the scent of any snakes within their vicinity and confront them aggressively.*

OPPOSITE BOTTOM: *Tail scars are grim reminders of an encounter with snake venom. Often striking snakes will target the distractingly swaying tails of the Meerkats and occassionally manage to bite one.*

A lesson from nature

I believe that the intolerance shown by many humans towards snakes that are not even hunting them is tragic for snake conservation. Although Meerkats are actively hunted and easily killed by venomous snakes, and have the ability to in turn kill snakes, they very seldom do so. Perhaps this could be viewed as one more lesson of tolerance from 'nature's classroom' towards other species?

Aggressive defensive displays towards predators

Meerkats do not abandon each other in the event of a predator attack. They will often group tightly together and puff up their hair, making individual Meerkats difficult to target. They will arch their tails over their backs with the distracting black tips swaying as a small and difficult to attack focal point, distracting the predator's attention away from their sharp puncturing teeth. Snakes will often be scratched at and given quick nips to try and encourage them to leave the area.

If there are any young present these will either be carried to safety usually by the neck or even by the ear or nose if the babies are very young. Older Meerkats will sometimes gather around the young and escort them to safety in a tight phalanx-like formation.

If a Meerkat is trapped away from a security escape tunnel, it will as a last resort flatten itself against the ground and lie motionless, relying on its excellent camouflage to avoid detection from aerial predators. This approach is not used in the presence of terrestrial predators.

And just as prey species camouflage is superfluous when facing the incredible olfactory detecting abilities of a Meerkat, so too is the camouflaged Meerkat's defence ineffective against scent-hunting reptiles.

The back patterns distort the shape of the Meerkat when it forages under plants and the shadowy patterns created by the vegetation create mottled shapes on the Meerkat. The disruptive cryptic patterns on the Meerkat's back allow it to easily blend in with its surroundings.

Burrow imprinting associated with alarms

Babies are actively taught where to run for safety and are introduced to the bolt hole and tree security networks between the main sleeping burrows. Alarm calls are often made, without the rest of the group responding, while a few teachers run and escort the apprenticed babies to a secure area which serves as an imprinting method for when they hear an alarm call. These are the equivalent of active 'fire drills'.

OPPOSITE: *Apprentices actively learn the locations of the vast network of safety burrows within their territory through frequent alarming and running with the pups to each secure system. Extensive burrow maintenance usually follows these 'fire drills'.*

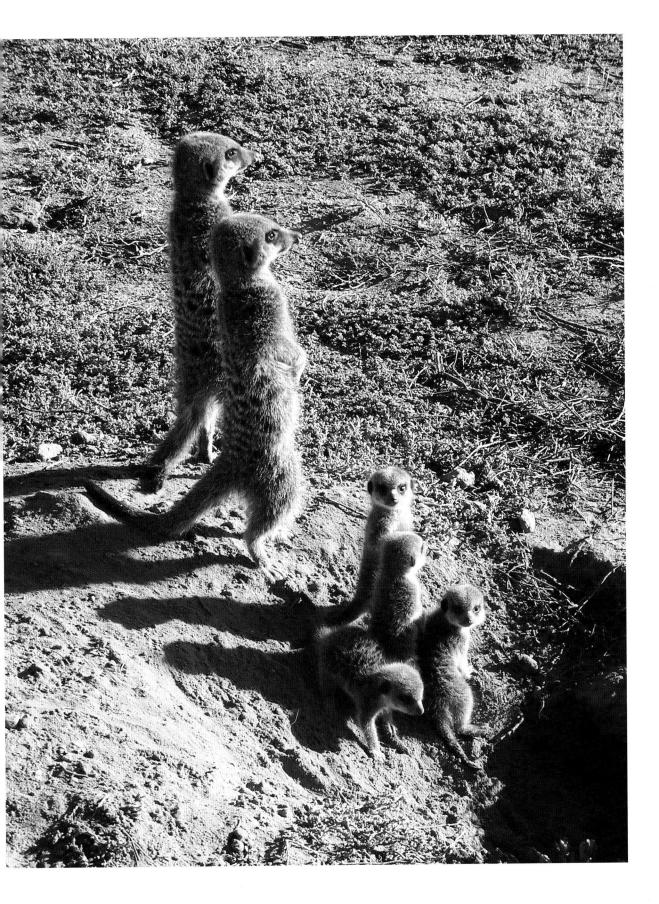

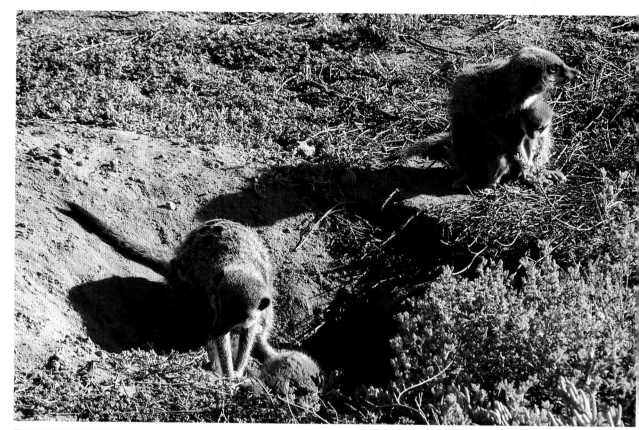

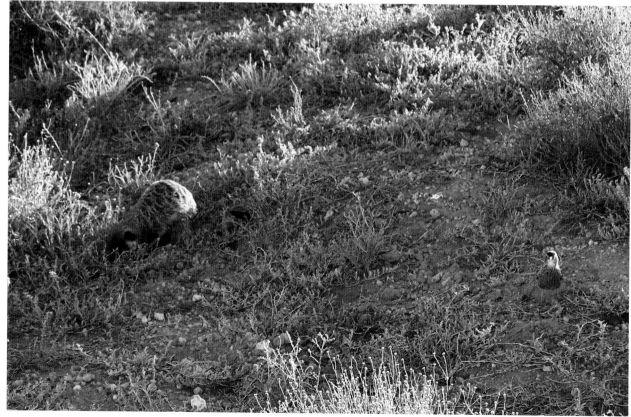

THE NEIGHBOURHOOD WATCH
COSTS AND BENEFITS OF ALLIES

EVERYBODY IS TRYING TO make a living in the Meerkats' habitat. Some neighbours eat each other, some take more than they give back and some benefit from being around each other for safety in numbers and enhanced shared sensory perception. Many species learn to recognise the Meerkats' alarm calls and also reassurance calls, and the Meerkat learns to recognise the calls and behaviours of the species that it grows up with.

These are complex interspecies relationships and form a network of reliance. Removing or introducing a Meerkat to an unknown habitat would be the equivalent of placing a human in a foreign country with no localised experience.

These associative calls are learned through frequent encounters and shared time together with other species over many generations of inherited taught knowledge. Meerkat adults teach and share their experiences with younger generations.

It may initially appear that the exposed Meerkat guarding stands isolated and vulnerable to attack. The Meerkat is intently relying not only on its own finely tuned survival senses, but also upon those of the entire neighbourhood watch. From diminutive insects such as the cicada to various birds and other species, through a lifetime of localised associative learning, the guard can immediately recognise a potential threat. This is filtered through an advanced relay alarm interspecies network long before an individual Meerkat is able to see any danger, through the interpretation of calls and behaviours from other inhabitants. This is interspecies communication in action!

As a professional wildlife researcher, I soon discovered that initially other species would alarm at my presence. However, over time they learned that I was not a threat to them because I was associated with non-alarming Meerkats. I realised that this tolerance from other species only happened when I was closely following Meerkats, when I was not with Meerkats, encountered species alarmed at me.

OPPOSITE TOP: *Meerkat babies are introduced to a variety of neighbourhood alarms and learn over time to recognise those from the various species that they encounter.*

OPPOSITE BOTTOM: *A great variety of birds have learned to follow Meerkats in search of their fleeing prey. They can benefit Meerkats by actively alarming to danger approaching, although certain bird species will 'deceive' Meerkats into actively dropping food for them.*

By being tolerated by Meerkats I was able to approach other species with the Meerkats that would initially be alert when seeing me, then look at the Meerkats around me and continue their behaviours without becoming alarmed. These encounters were not with tame animals, but completely wild animals who tolerated me due to my association with one of their own neighbourhood alarm species. Anybody approaching me when I have been with Meerkats would be alarmed at, even while I was not perceived to be a threat walking amongst the Meerkats.

I call this the 'Meerkat passport into the neighbourhood watch'. These vigilance networks are recognised and contributed to from many species that live in a specific area for a longer period of time. Meerkats that grow up in one environment learn to recognise the warnings of species in that area. Meerkats in different areas may not recognise alarms from different neighbourhoods as I have noticed from the Kalahari Desert and the Little Karoo.

Subspecies are distinctly unique populations and have different adaptations to their varied habitats, with their own localised survival strategies.

This is another reason not to release captive Meerkats into an environment where they have no known alarm associations, and is an important ethical consideration.

Certain bird species follow the Meerkats and act as additional eyes and ears which can warn about approaching danger. With the Meerkats' prolific soil-turning and revealing of concealed and difficult-to-reach food items, it is not surprising that they attract a great following of 'friends and enemies' who are not simply around them by chance.

Many bird species actively follow foraging Meerkats and will frequently snatch food directly from them or pick up left over morsels from foraging excavations, such as ants that have their nests raided. Among these bird species are: Southern Fiscal (*Lanius collaris*); Crimson-breasted Shrike (*Laniarius atrococcineus*); Bokmakierie (*Telophorus zeylonus*); Cape Glossy Starling (*Lamprotornis nitens*); and Pied Starling (*Lamprotornis bicolor*).

I have noticed that the Fork-tailed Drongo (*Dicrurus adsimilis*) actively makes alarm noises that sound very similar to Meerkat alarms in the Kalahari Desert and the Little Karoo populations, which often result in Meerkat babies dropping their food and running for cover. This allows this species to effectively procure the Meerkats' food and not simply eat leftovers behind a foraging Meerkat – it is active 'stealing' through deception!

The Southern Yellow-billed Hornbill (*Tockus leucomelas*), African Grey Hornbill (*Tockus nasutus*) and Red-billed Hornbill (*Tockus erythrorhynchus*), with their large eyes and menacing beaks, frequently approach and intimidate young Meerkats into dropping their food, which is then quickly snapped up and swallowed, including larger food items such as geckos and scorpions.

OPPOSITE: *Antelope are commonly encountered around foraging Meerkats and the two will react to each other's alarms.*

The Cape Crow (*Corvus capensis*) often mobs and harasses various predatory birds and makes a loud rasping call that Meerkats will alarm towards, long before any aerial predator can be seen. This appears to be an associative advanced anti-predator warning specifically with aerial attackers.

The Southern Black Korhaan (*Afrotis afra*) acts as an early terrestrial predator alarm system, and will call out loudly and burst into flight if it is disturbed by any threat. The Helmeted Guineafowl (*Numida meleagris*) and various francolin species which spend most of their lives as terrestrial scavengers will also call loudly and rapidly take to flight if they are disturbed by any potential danger on the ground.

The Meerkats are very quick to respond with their own alarms and actively become vigilant looking for terrestrial disturbances. They have clearly learned to recognise the different alarm calls from neighbouring species and even to learn if these are advanced warnings for aerial or terrestrial threats judging by their own guarding behaviours.

Certain antelope species also forage close to Meerkats, such as the Springbok (*Antidorcas marsupialis*) and the secretive Steenbuck (*Raphicerus campestris*).

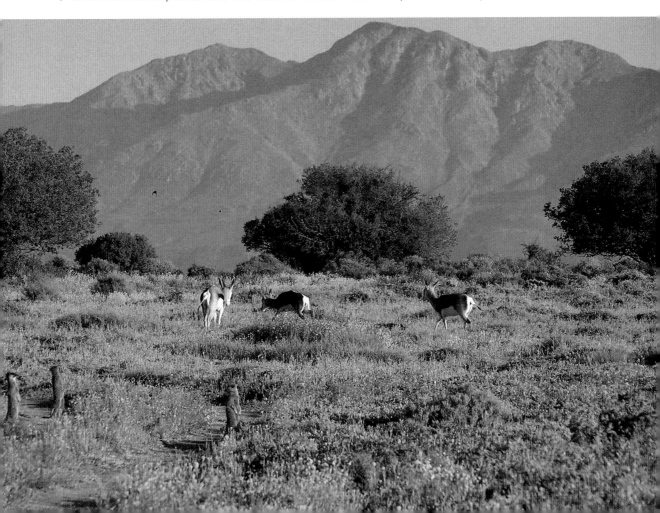

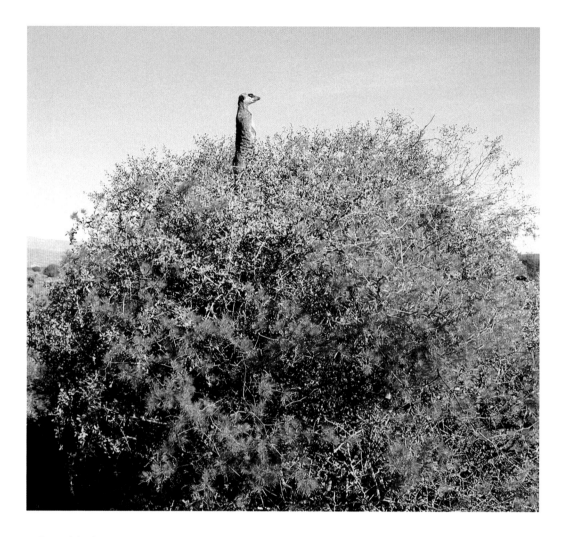

Sociable burrowing rodents such as the Cape Ground Squirrel (*Xerus inaurus*) and Brants's Whistling Rat (*Parotomys brantsii*) often make piercingly loud whistling calls at any sign of danger and Meerkats are quick to respond to these calls. The rodents also react to Meerkat alarm calls.

Even changes in the behaviour of small insects can result in the most noticeable Meerkat vigilance in the neighbourhood watch. The secretive cicada makes one of the loudest calls, which is often heard on very hot days. If this call suddenly stops due to the insect seeing danger, Meerkats will often become very alert and stand on guard. This insect species frequently triggers many alarms in different species when it suddenly stops calling.

The following poem was inspired by the neighbourhood watch and the cicada.

The Silent Call

Secretively hidden in plain sight
compound eyes shining bright
drinking and feasting on delicious plant sap
but like a hidden snare
all visitors here should beware
caught by the all-seeing eyes
in this insect alarm triggering trap.

Cryptically cloaked
adorned with transparent
blotchy bark back patterned wings
tymbals in your abdomen vibrate
allowing you to sing
resonating louder on the hottest of days
beating in rhythm with the pulsating
shimmering furnace heat haze.

As if you were nature's own finely tuned bush
 thermometer
As the heat rises so do your singing exercises.

The shrouded secretive subtle mask
this diminutive spy wears in daily bask
attempts to never reveal this creeping insect to our
 bewildered daze
unless it is disturbed
when it launches into a rapid buzzing flight
only to land once again
and vanish from human sight.

With any disturbance
no matter how small
the most piercing alarm of all
is from the cicadas silenced call.

The silence
echoes...
echoes...
reverberating throughout the myriad senses
that perceive potential threat
who reside in balanced rivalry
in The Meerkat Magic Valley Reserve,
and yet...

The silent call is louder then
a deafening roar to all those who cannot ignore
what the sudden change
in piercing volume screams.

The multifaceted omatidia compound eyes
of the sneaky cicada tell no lies
being a true master of nature's neighbourhood watch
if danger is sighted
it's song once ignited
is suddenly gone
extinguished and replaced with a warning gong
shattering any neighbours slumbering dreams.

In The Meerkat Magic Valley Reserve,
silence is never as peaceful...
 as it seems.

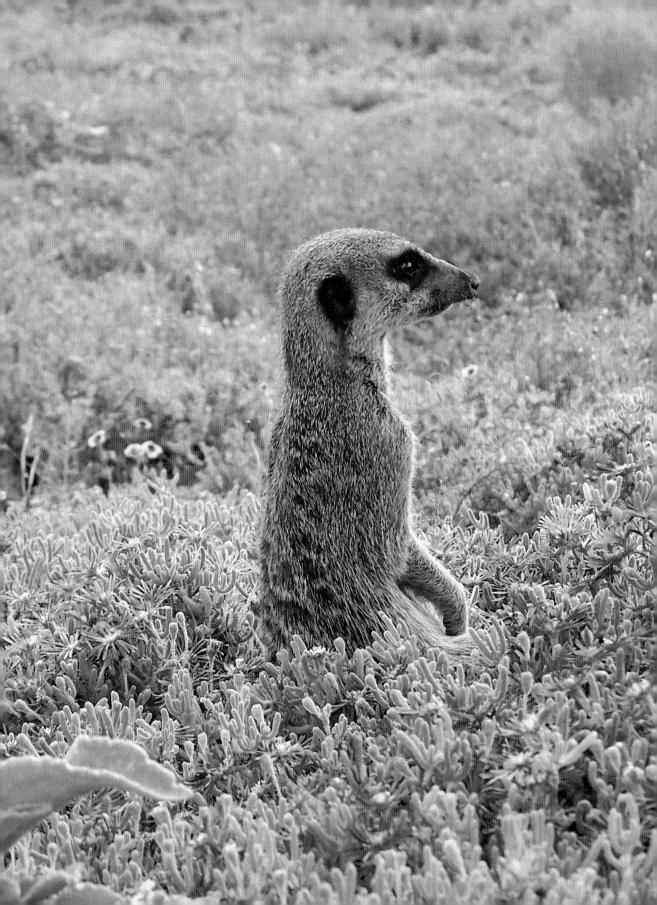

GUARDING

The commonly used term for Meerkat guarding behaviours is 'sentinel duty', and this is widely and incorrectly believed to show that a Meerkat takes turns in guarding ... this will be disproved and illustrated.

Meerkats do not actually take turns to guard or perform guard duty. When foraging they will frequently pause and look around, often standing up or even climbing onto objects to do elevated guarding.

They appear to be one large creature with many heads and eyes, almost like a mythical multi-headed hydra, when one head vanishes from view another appears!

The cooled succulents of the Little Karoo make soft and comfortable guarding platforms.

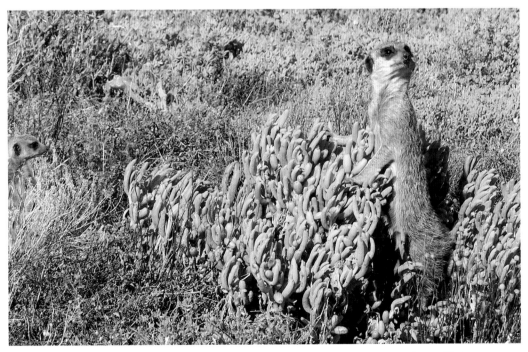

OPPOSITE: *Meerkats guarding in the Little Karoo position themselves among the lush vegetation to scout for possible danger.*

ABOVE: *Succulents are often chosen as vantage platforms on hotter days by guarding Meerkats in the Little Karoo.*

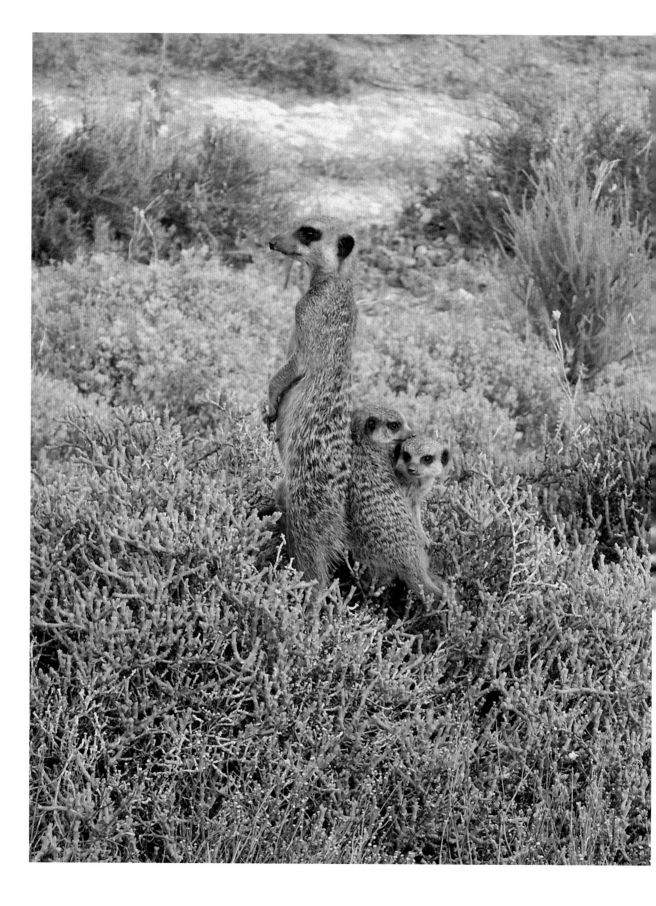

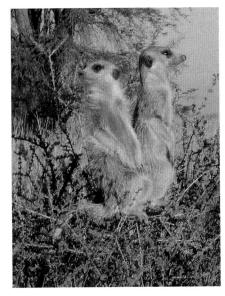 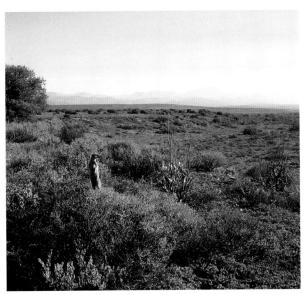

OPPOSITE: *A previously believed idea that only male Meerkats partake in elevated guarding is incorrect. Here a female Meerkat and accompanying babies actively guard on a large succulent in the Little Karoo.*

ABOVE LEFT: *Meerkats do not take 'turns' when elevated guarding. Any Meerkat may conceivably guard at the same time as others if suitable conditions exist, as is the case here in the Kalahari.*

ABOVE RIGHT: *An elevated guard has an incredible visual advantage but it actively attracts predator attention by being so exposed.*

Elevated guarding

Elevated guarding with Meerkats is frequently and misleadingly referred to as sentinel 'duty'.

Interestingly, this guarding is not a duty at all, which implies that it is an assignment or obligatory role for certain individuals within a Meerkat group.

Multiple Meerkats can partake in raised guarding at the same time, and not only a single specialist Meerkat.

Some scientists believed that only selected Meerkats performed guarding duty and that this was actually an appointed turn system or specialised task. It was also thought that only adult male Meerkats would do this and that they were doing this for the direct and primary benefit of the other Meerkats in their group.

Even young Meerkats will guard on objects, but this is probably an imitation learning process for them.

It is not uncommon for a Meerkat to climb onto much higher objects around it for a better view. I personally have recorded guarding Meerkats climbing up old trees to over 7m (23ft) above the ground. The guarding Meerkat can remain on guard for anything from a few minutes to well over a few hours.

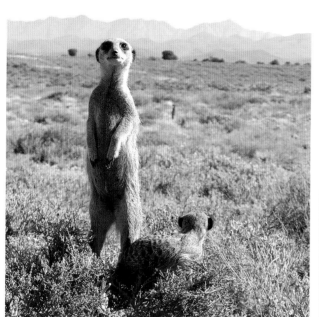
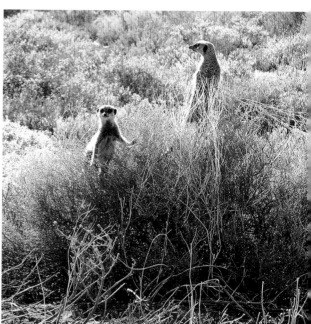
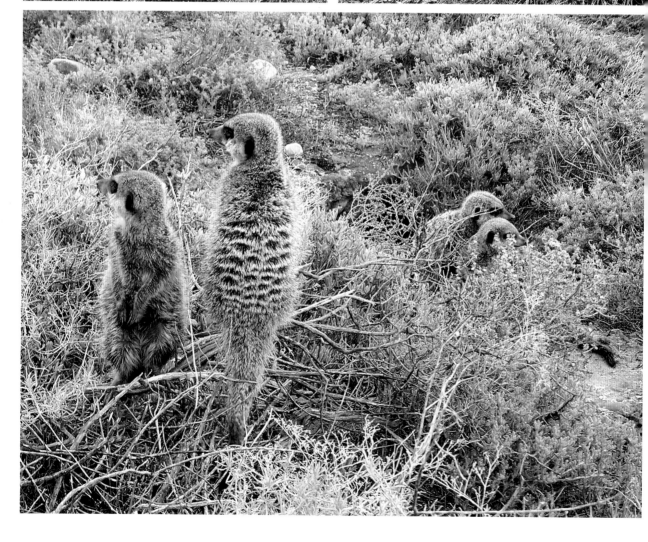

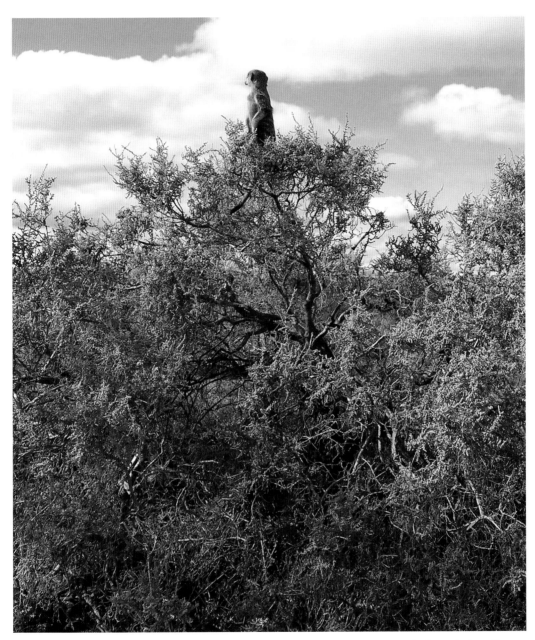

OPPOSITE, CLOCKWISE FROM TOP LEFT: *Here a female Meerkat is on elevated guard with a youngster and another is on raised guard in the distance, showing that they do not 'take turns'; double raised guarding and not individual 'turn' based guarding does occur in Meerkats; younger Meerkats will occasionally guard. The energy status of any given individual can determine the frequency of guarding, which is not decided by sex or age.*

ABOVE: *The muscular tail is very good for balance when raised guarding high above the ground.*

Raised guarding can be very hazardous with long sharp thorns sticking into bodies, and long nails that are not suited to gripping branches effectively. Excellent balance is essential to a guard. And although Meerkats are very good at climbing up onto high objects, they are not good at climbing down from these positions.

Their nails often fail to grip on the way down, and they will often fall from heights many times their body length – the equivalent of a person falling head first from a multistoried building.

These high guards frequently make a rapid body-bashing descent, get tangled and hooked up on thorns and sharp branches and inevitably fall hard onto their heads, backs or sides. They very rarely land on their feet as cats often do. Experienced guards usually have 'guarding scars' left as painful souvenirs or even badges of their climbing mishaps.

I have even jokingly wondered if a Meerkat guards for such a long time simply to avoid the pain of descent for as long as possible!

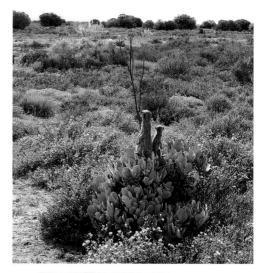

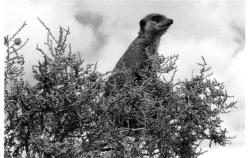

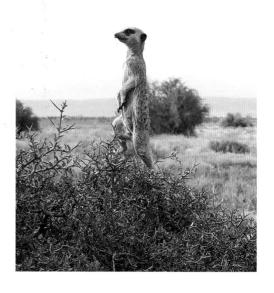

RIGHT TOP: *In the Little Karoo a succulent is often sought out as a guarding position. Apprentices learn from a young age to climb up and guard with a teacher.*

RIGHT MIDDLE: *Guarding Meerkats call frequently to let the group know of any possible danger. They interpret a wide array of incoming neighbourhood interspecies communications and will decipher these and react accordingly.*

RIGHT BOTTOM: *The very thick rubber-like feet allow Meerkats to stand on sharp thorns while elevated guarding.*

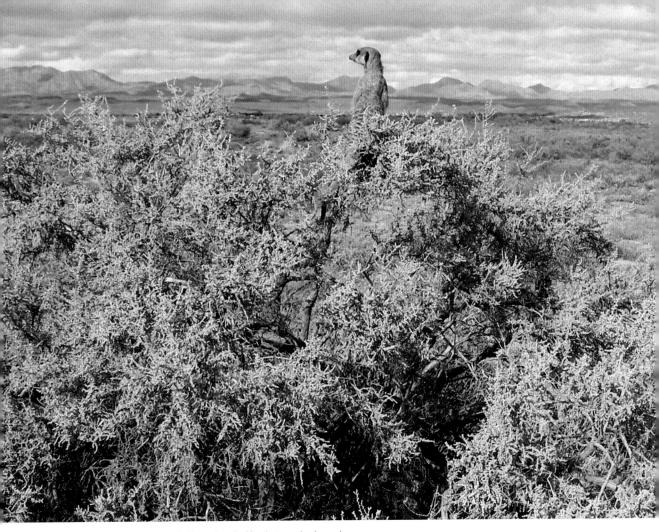

Towering mountains in the Little Karoo dwarf a Meerkat on raised guard.

Observing two of the three wild Meerkat subspecies for over two decades in varying habitats has revealed that male and female Meerkats will commonly do elevated guarding.

Different individual Meerkats of varying ages within a group may do this guarding, and simultaneous multiple guards are not uncommon, further illustrating that it is not the same individual on guard each time.

The individual Meerkat decides the frequency and duration of guarding. This is not determined by a role or duty or turn system within a Meerkat group.

A primary determining factor for any elevated guarding in a Meerkat group is condition. When a Meerkat has eaten very well, it is far more likely to be less hungry and is then able to guard for longer periods and digest food.

Younger and older Meerkats of both sexes may have eaten well and begin to guard. The entire Meerkat group will benefit from this vigilance, but the individual who is guarding will benefit the most.

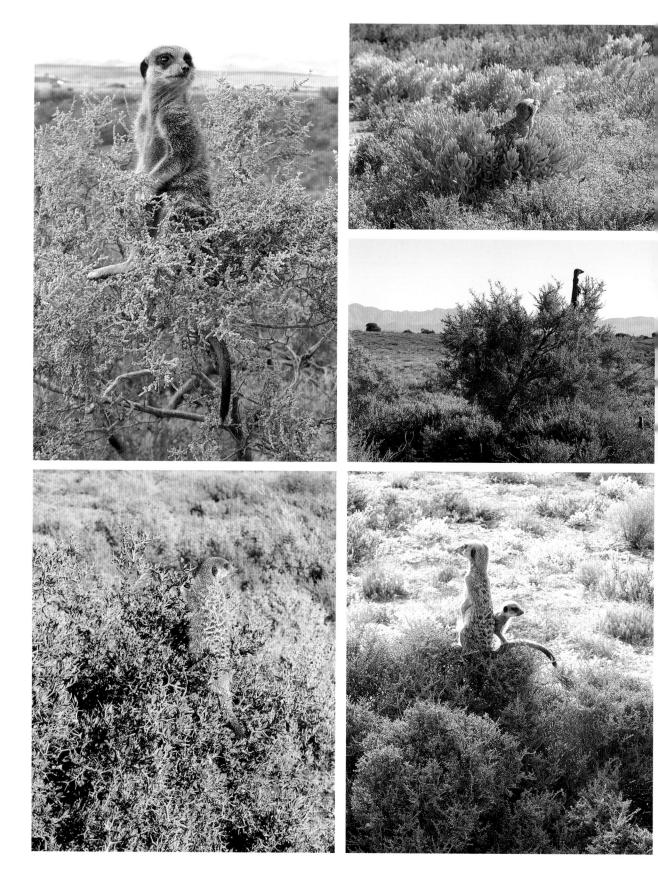

Do raised guards benefit first from their vigilance?

Elevated guarding routinely occurs close to a burrow which can be used to escape from predators. The Meerkat on guard is most likely to notice any predators first, and will benefit from this vigilance by being close to an escape route. The entire group will still benefit from the guard who will announce the presence of any approaching predators, their location and whether they are aerial or terrestrial. The type of alarm will indicate proximity and urgency.

Some viewers have praised the Meerkat on guard as the selfless sentinel, a veritable icon of selfless behaviour. Others have mentioned that because the Meerkat is primarily benefiting from its own vigilance it is in fact being selfish. Interestingly, to follow on these anthropomorphic ideas I will mention the following observation. The Meerkat is not guarding primarily for the group as some believe, nor is it being selfish.

If the Meerkat was to be viewed as selfish it would not make any warning calls at all that directly benefit the group while it guarded, so it clearly is not selfish as it actively will call while it is on guard. And although clearly exposed to the view of predators, it is commonly the closest to an escape burrow.

Another outdoor classroom lesson

The guarding Meerkat is actually an excellent example of a key ingredient in any successful co-operative team, that of good self-maintenance. This is one of many valued lessons taught by 'nature's classroom' observations and I believe that it can be applied to humans equally in daily life. By ensuring its own survival and by being able to guard while other Meerkats are in poorer condition and can't afford to guard, the guarding Meerkat benefits the very survival of the group by taking good care of itself first.

OPPOSITE: *Elevated guarding is fascinating to observe and has a variety of influencing factors. The vegetation being a cooling succulent may increase the duration of a guard for longer than a prickly platform. Wind, dust, visibility, vegetation height and density of predators will also influence the duration. The group size and available pool of guards will also have an impact. Many extended guarding sessions take place very close to an escape tunnel, allowing a guarding Meerkat to primarily benefit from being vigilant and rapidly escape after giving a warning call.*

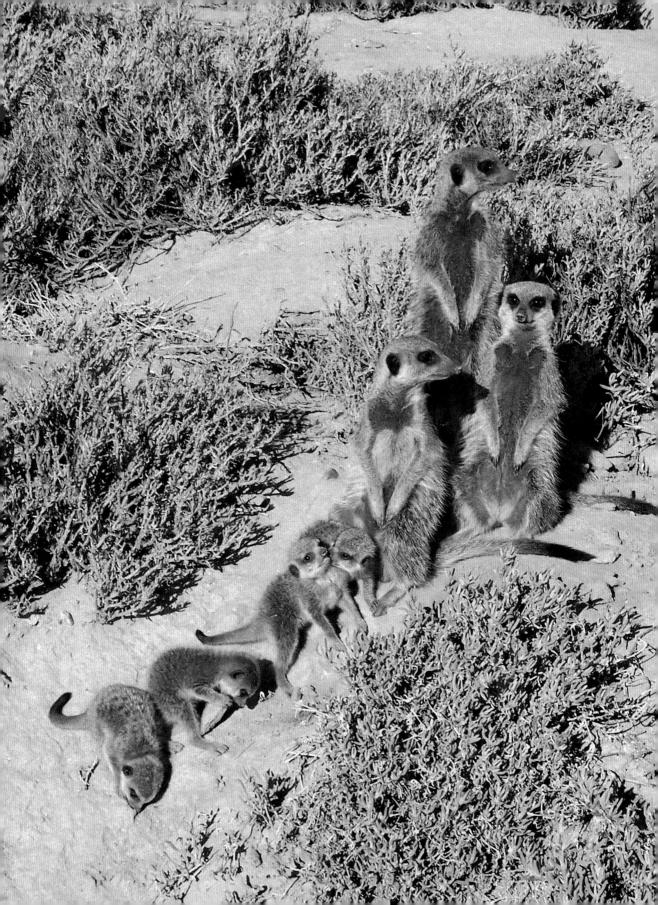

HIERARCHY AND DOMINANCE

THE HIERARCHY IS MATRIARCHAL, usually with the oldest and most experienced female as the leader together with her unrelated immigrant male. They will often pair for life. There are various subordinate individuals within the group who can be related or unrelated. Migrant male Meerkats will attempt to displace a resident dominant male if they have the opportunity. Females born into a group may inherit the dominance from their mother when she dies.

The youngest generation of Meerkats is afforded the highest level of care within a group. They are exempt from the usual aggression directed towards older generations of Meerkats. Within each age category is a hierarchy. Playing baby Meerkats learn quickly where they rank within their litter's hierarchy.

Lower-ranking individuals may increase their position in the hierarchy through active grooming of higher-ranked individuals. Their rank may also benefit from co-operative behaviours such as feeding of babies, babysitting and elevated guarding.

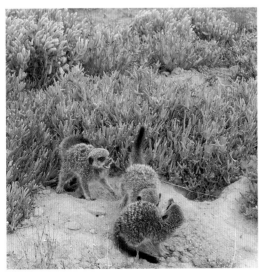 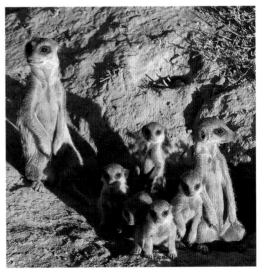

OPPOSITE: *Baby Meerkats are treated with great care and appear to outrank all other group members for a brief period. However this tolerance is not shared between litter mates who will play to determine their social status and attack each other over food disputes.*

ABOVE: *Playfighting is a luxury for those in good condition. Unsurprisingly, well provisioned babies play often.*

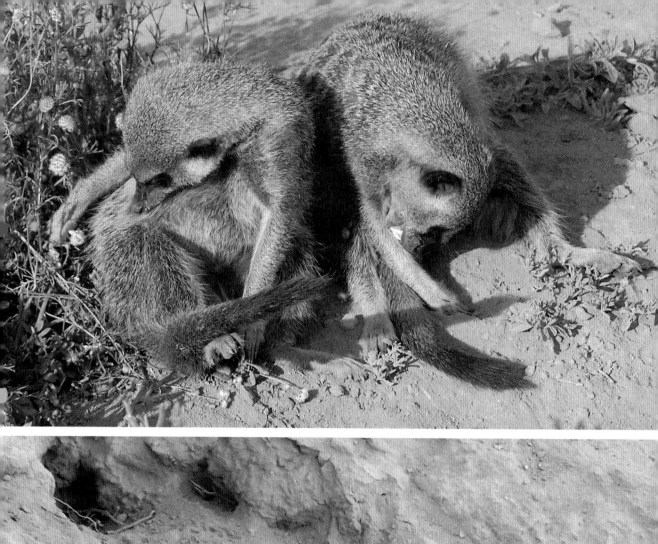
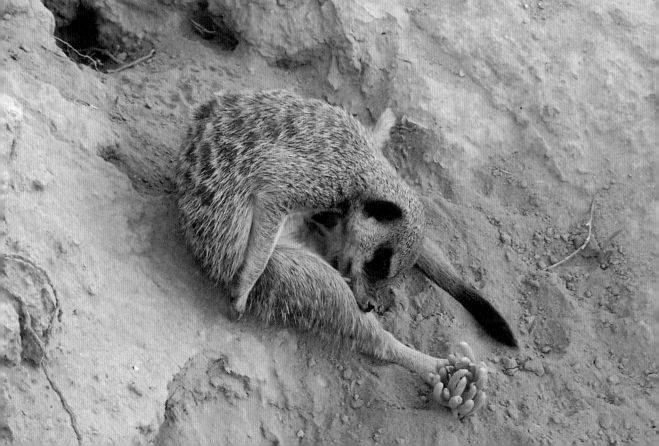

GROOMING

THIS IS AN INTEGRAL social and health maintenance activity and a good indicator of hierarchy and overall condition within a Meerkat group or an individual. Grooming removes external parasites and maintains a healthy coat and skin. The social aspect of grooming other Meerkats is integral to establishing and maintaining relationships.

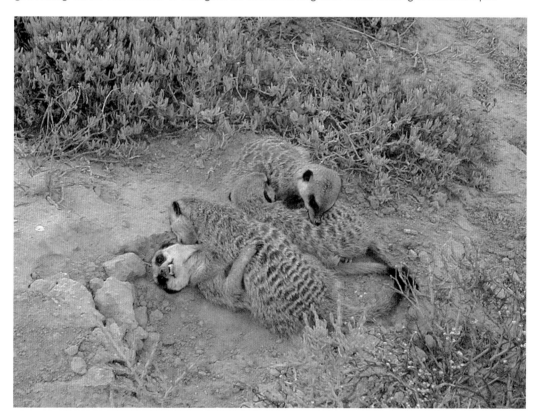

OPPOSITE: *Meerkats clean themselves and those within their group frequently to prevent parasites from spreading and to maintain social cohesion. If parasites weaken one Meerkat it will soon affect others and result in less efficient cooperative activities such as guarding and babysitting.*

ABOVE: *Not all grooming is returned by higher ranking Meerkats, which conserve their energy and further secure their position in the hierarchy by being in better condition.*

Autogrooming

Autogrooming is when an individual grooms itself, however there are limitations as to which areas can be groomed. It is not possible for a single Meerkat to groom its head and shoulders, resulting in these areas being especially vulnerable to parasites.

Being unable to effectively groom their entire bodies strengthens the co-operative bond within Meerkat groups, as they benefit more from helping to groom each other.

Individual Meerkats who are migrant males or evicted females have large health penalties to their condition when they are away from the grooming benefits of their group.

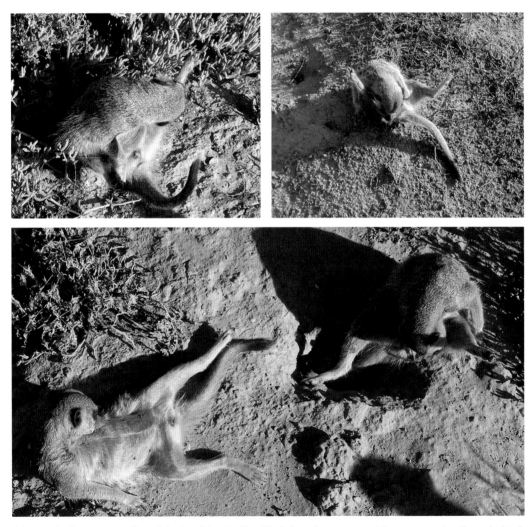

Autogrooming is a common self-care behaviour. It has significant limitations, however, as certain areas are not easily reached and require the grooming attention of others.

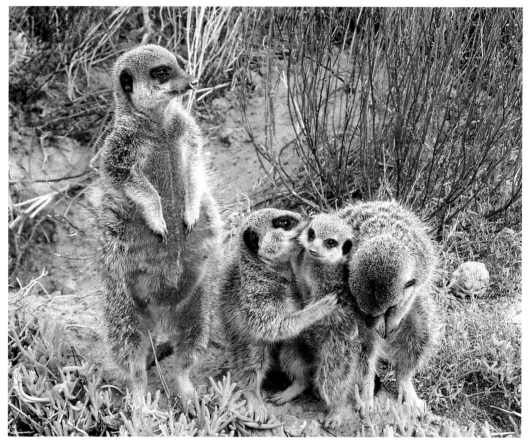

Baby Meerkats are a rare exception to the allogrooming arrangement in a group. Pups are allogroomed extensively but do not reciprocate these cleaning and bonding behaviours.

Allogrooming

Meerkats need to allogroom each other to ensure that external parasites in difficult-to-reach areas such as the neck and face are removed. This level of co-operation is most often observed during the resting periods of the day.

Although baby Meerkats do not reciprocate allogrooming, they get groomed extensively. Unlike older generations who initiate grooming in an attempt to receive grooming back, baby Meerkats do not initiate grooming to receive it.

There is an area above the Meerkat's tail (and also in many other animals) known as an IRM (Innate Releasing Mechanism). This sensitive area of nerves triggers an instinctive grooming response whenever it is touched. This allows any Meerkats who initiate grooming at the base of the tail to cause a grooming response in return. However, the initiator of the groom may not be the beneficiary of the reciprocity! When many Meerkats are allogrooming, an initiator may not be groomed back, although their grooming may result in a relay of grooms being initiated.

Often allogrooming is an excellent indicator of hierarchy within a Meerkat group at any given point in the breeding or non-breeding season.

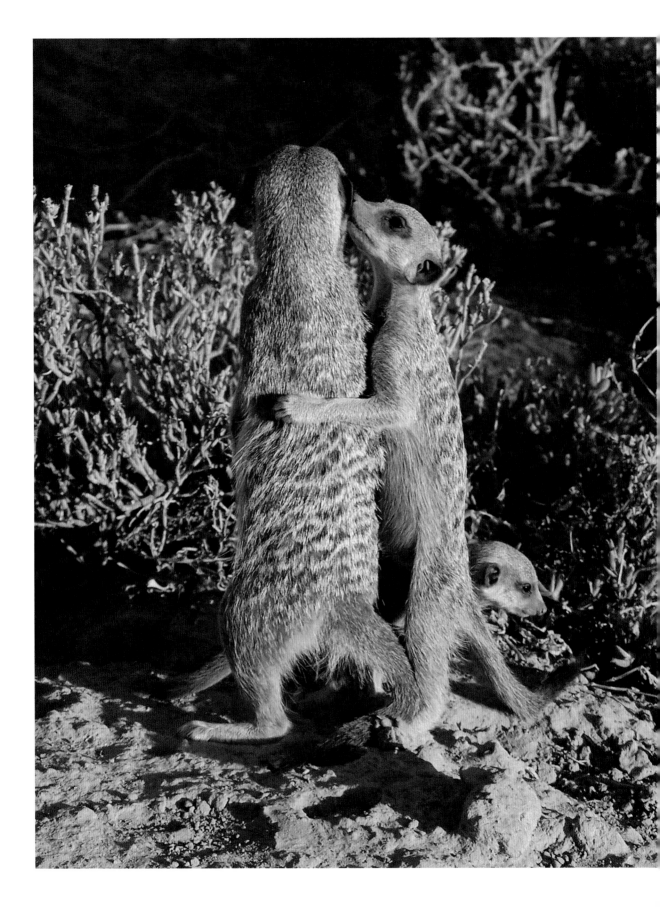

Subordinate Meerkats will frequently initiate allogrooming and higher-ranking individuals will seldom reciprocate.

This results in lower-ranking individuals often being in worse condition due to more parasites, a cost of being lower ranked. By having less energy and being in inferior condition to dominant individuals, dominant animals are better able to maintain their positions without being challenged.

During the breeding season dominant females are all groomed incessantly by lower-ranking females, and although sometimes groomed back, this happens less often prior to them being evicted.

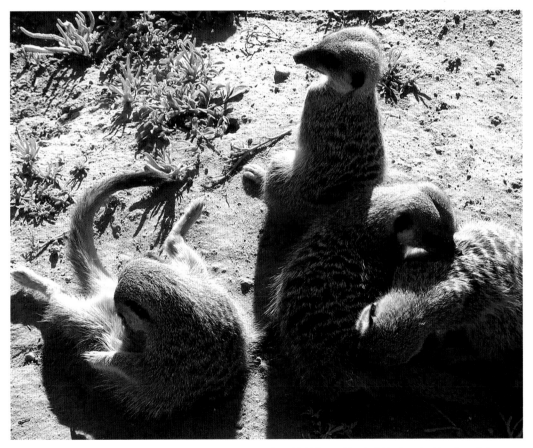

OPPOSITE: *Lower ranking Meerkats will commonly initiate allogrooming with higher ranking individuals and seldom have their grooming reciprocated.*

ABOVE: *Allogrooming is an essential health-maintaining behaviour that is routinely engaged in when Meerkats are in good condition, often at the end of the day. Extensive grooming from fellow group members ensures that difficult to reach parasites are removed, which benefits all.*

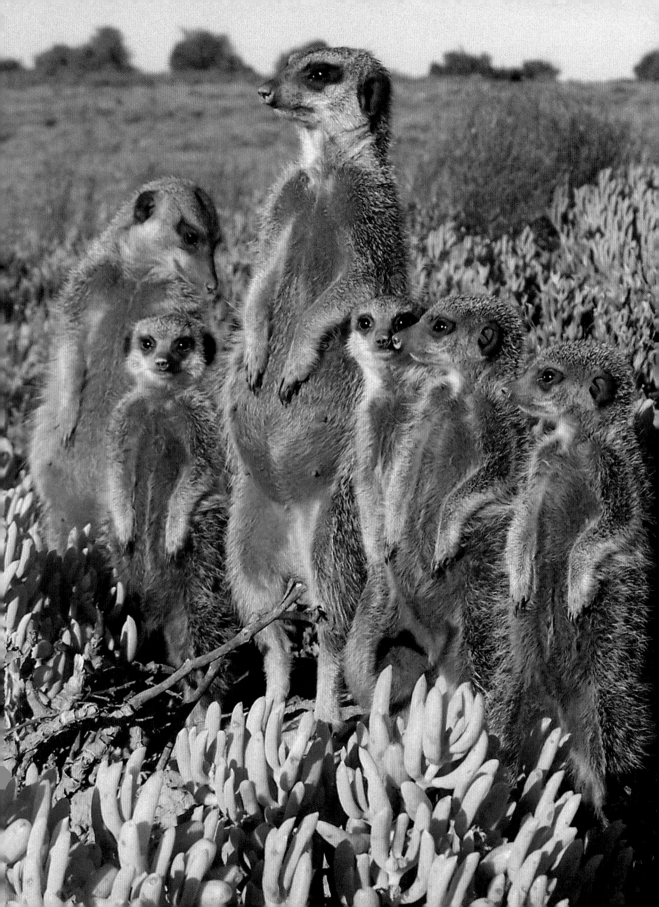

REPRODUCTION

DIRECTLY RELATED INDIVIDUALS within a group seldom breed, which is a stable survival strategy. The size of a Meerkat group also impacts on reproductive success rates, as with larger groups there are more senses to alert the group to any possible danger and protect the young more efficiently.

Groups that have too few individuals do not easily survive, as there are not enough members to watch out for danger and feed themselves and any young.

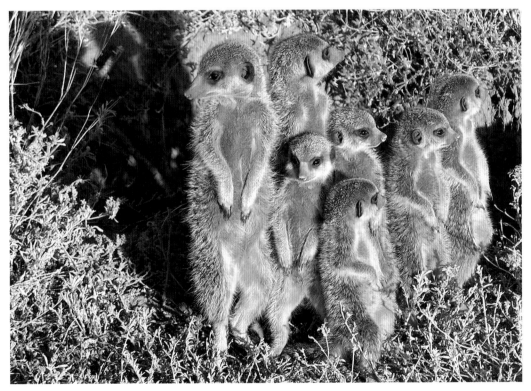

OPPOSITE: *It is very rare to witness multiple pregnant females within a Meerkat group in apparent harmony. Usually lower-ranking females are aggressively evicted in an attempt to prevent them competing with the dominant female and her own pregnancy.*

ABOVE: *There are not usually many survivors from each litter. Here two older Meerkats from a previous generation, the sole survivors of their litter, assist with the care of a newly arrived litter of five.*

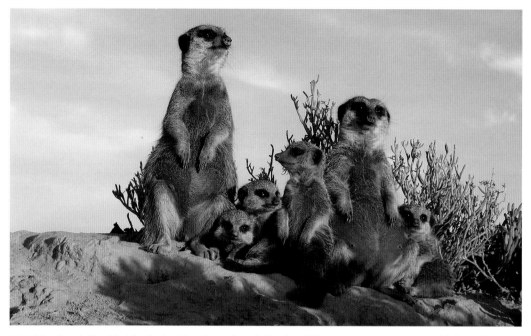

ABOVE: *It has been believed that the dominant female was the only Meerkat within a group to get pregnant, but this is not the case. Rare sightings of multiple pregnancies do happen when conditions are suitable and resource competition is low.*

OPPOSITE: *Seasonal rainfall variations have a very large impact on the frequency and breeding success within Meerkat groups. In order to adequately provide food for many new hungry mouths there must be sufficient resources available.*

This is a primary motivation for fewer groups forming and rather adopting a co-operative strategy. Individuals who remain with and assist existing groups with stable known territories increase their own safety and overall survival.

Sociable mongoose species such as the Banded Mongoose (*Mungos mungo*), which live in areas of food abundance, can afford to have multiple breeding females and many young present with adequate resources to raise them together, without severe resource competition.

However, Meerkats usually have a single breeding female who has a higher success rate of raising a single litter than multiple breeders when there are insufficient resources available in their lower-rainfall habitats. This does not, however, imply that other females will not attempt to breed within a Meerkat group, but they have a much lower success rate of raising their young compared to the dominant female.

Every related Meerkat within the group receives a genetic benefit from helping to raise their relatives, even if these are not their own babies. Helpers gain experience and in time may outlive the dominant breeding female and have their own sons and daughters who will assist with the raising of the former helper's babies.

The breeding season

The breeding season is primarily determined by seasonal fluctuations in rainfall, which directly influence food availability and have a direct impact on the survival chances of any young born.

It was previously thought that Meerkats only had one litter of young in a year and that this was limited to specific months in summer. However, different subspecies occurring in areas with different rainfall patterns may breed at any time of the year, clearly indicating the significance of rainfall on natality.

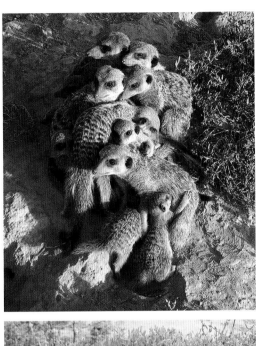

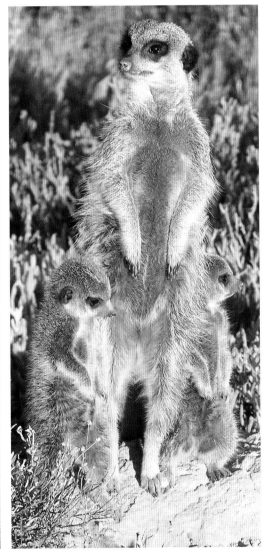

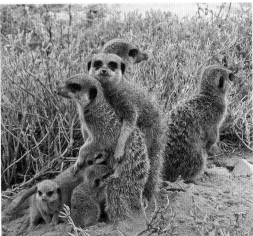

Mating

Pairing is quick and lasts around five minutes. Frequently pairing takes place within the security of the burrow system or burrow entrances, but it does occasionally occur on the surface, often close to the cover of vegetation. The male will hold onto the female and she will reach back her head and they will often bite and paw at each other's faces. Often the male will bite the female's nose and hold onto it when she turns back her head to him.

Play mating

Even baby Meerkats are involved in play mating. This behaviour continues throughout the Meerkats' lives and demonstrates the strong survival instinct from the first few weeks of age to reproduce.

Occasionally three or more Meerkats may play mate, forming a train of bodies.

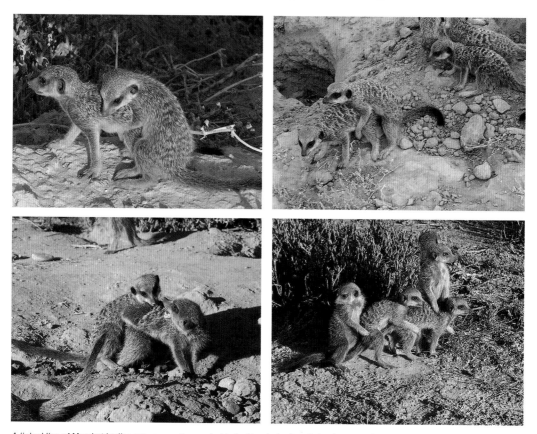

A linked line of Meerkat bodies may seem strange, but baby Meerkats already begin to practice their survival instincts and playing often results in play mating behaviour.

Mate guarding

In an attempt to prevent migrant males from mating with the dominant female, the dominant male will aggressively chase away other males that are within viewing distance. However this chasing occasionally leaves the female vulnerable to the relentless pursuit of these prospective suitors, and they sometimes manage to mate with her, despite all the energy intensive efforts of the dominant male to keep them away.

Gestation

Gestation lasts approximately 11 weeks. The eager-to-be-born foetuses actively kick and wriggle a few days prior to birth and often very large expectant mothers will lie on their backs and the kicking of the unborn Meerkat pups is clearly visible.

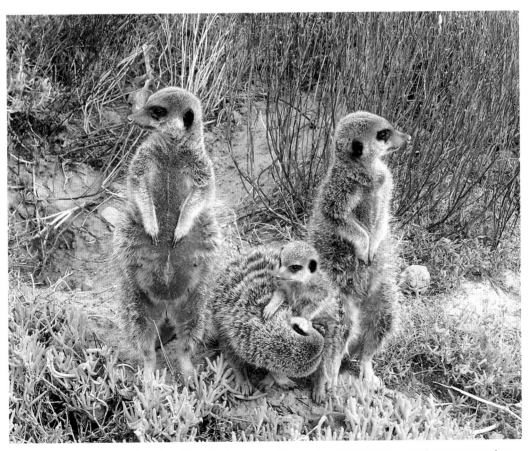

It was believed that Meerkats only had one litter of babies in a year. However, three litters in a single year is not uncommon from one female when conditions are suitable. A pup from a previous litter is groomed while standing next to another generation of soon-to-arrive siblings.

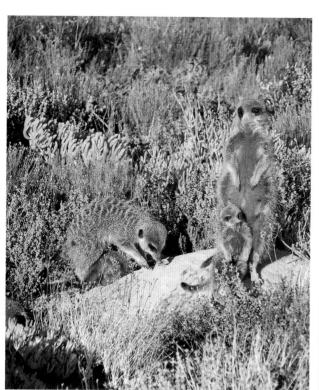

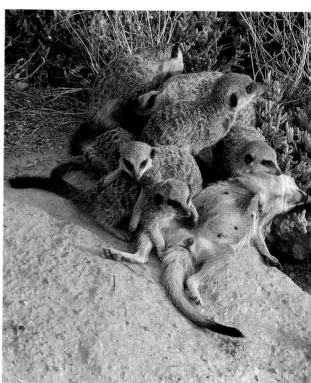

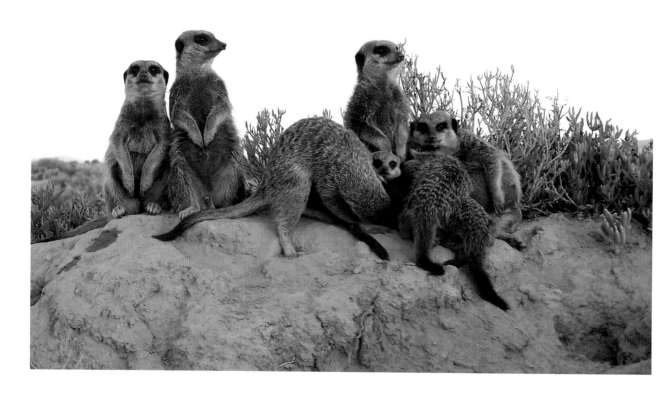

Abortions can occur through stress and have been witnessed in evicted females who will remove the foetuses and eat them. These females have the ability to lactate and if they survive and are accepted back into their natal group they will often allolactate for the dominant female's babies.

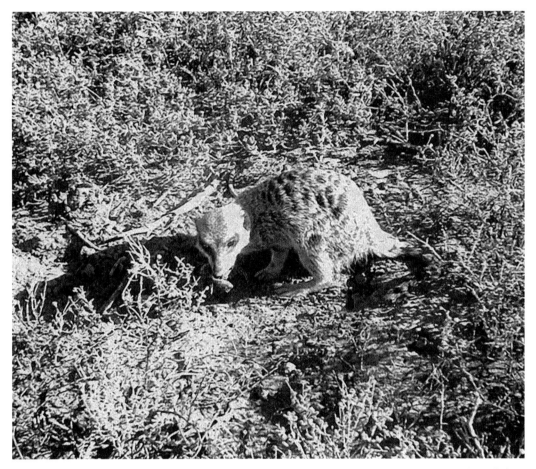

OPPOSITE: *After being pregnant for almost 11 weeks, females will collapse onto their backs and find it difficult to stand or walk due to being so heavy. The babies kick and squirm increasingly shortly before birth.*

ABOVE: *Evicted females will commonly abort their babies due to being stressed. They will still continue to produce milk and may lactate for a dominant female's babies.*

Birth

This is a dangerous time for the mother and she may be attacked by rival females when she is in a weakened and vulnerable state, and even have her babies killed through infanticide. Babies are usually born inside the safety of an enlarged breeding burrow, however birthing does sometimes happen between burrows and then the newly born babies are picked up by the scruff of their necks by the mother and helpers.

The babies are then carried to the nearest burrow. Even older exhausted babies who have begun moving burrows with the group will be carried on occasion to prevent them from being left behind.

Babies may be moved several times until the mother reaches a burrow that she is comfortable with, usually an enlarged breeding burrow that has been prepared over many generations of raising young.

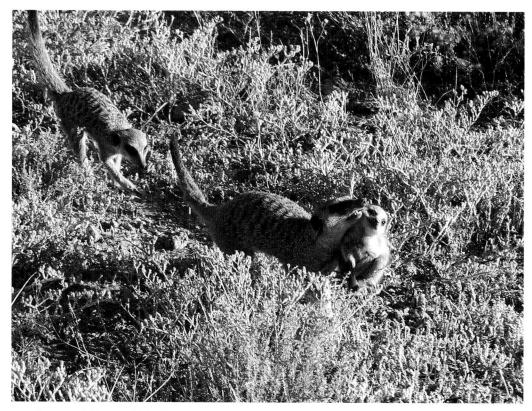

ABOVE: *Newly born babies and slightly older babies are often carried to safety if threatened or if they are in an unsuitable burrow. Pups do not protest at being picked up and carried away, which is a good survival instinct.*

OPPOSITE: *The first evidence of Meerkat babies is easily seen on any greatly reduced in size females who also have clear suckle marks from babies around their nipples.*

Post-partum oestrus

Conception may occur again within a week of giving birth provided that food availability is high, offering a better survival opportunity for the investment in additional litters.

Pups

Even before babies emerge it is possible to know that they have been born due to the dried circular patches of milk on the lactating female's hair around their mammae, where the babies have been drinking.

It is also possible to get a good estimate of the number of babies present by the number of suckle marks.

Babies weigh less than 20g (0.7oz) at birth and their eyes and ears are sealed shut.

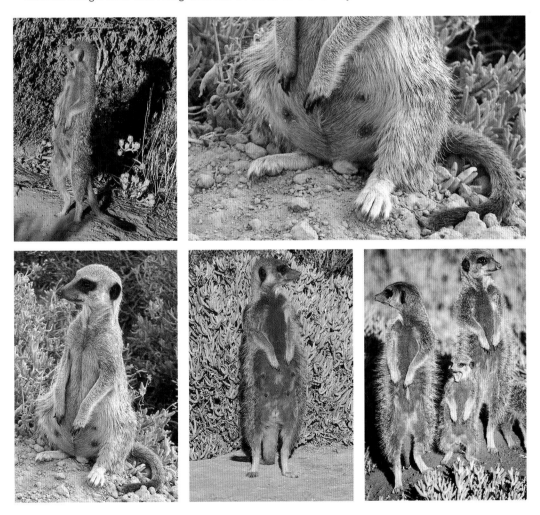

ABOVE, CLOCKWISE FROM TOP: *Newly emerged babies from the Little Karoo Meerkat subspecies are much darker than those in the Kalahari; seven-day-old pups whose eyes have barely opened venture to the surface in the Kalahari; the Kalahari Meerkat subspecies is well adapted to its sandy environment, but these babies are very weak and tired after only a few short steps outside of their burrow.*

OPPOSITE: *Babies suckle from any lactating females and spend a great deal of their day sleeping and then playing with litter mates.*

They have very short hair all over their bodies and the genetic freckle patterns on their camouflaged backs can easily be seen.

Their heads are very round with short compacted noses allowing them to suckle easily without the need for a long 'foraging nose' at this stage of their lives. Their eyes will begin to open at around seven days old.

Even at such a young age, with their eyes only starting to open fully, Meerkat pups explore the bright sunny world outside the burrow chamber of their birth.

The baby Meerkats make some excited foraging calls as they discover 'snacks' in the sand and also warn their brothers and sisters to stay away from their discovered food.

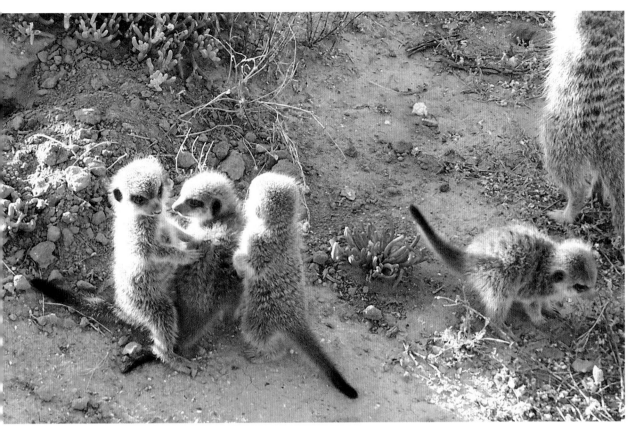

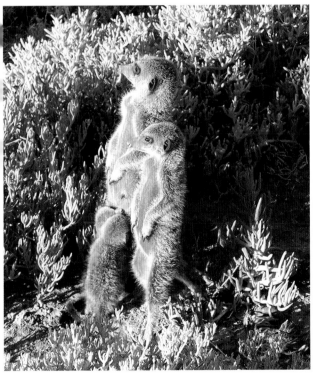

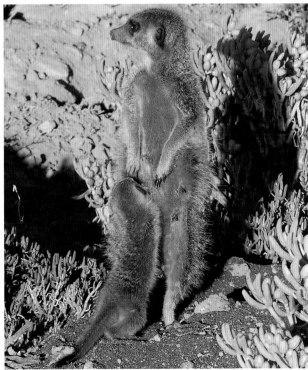

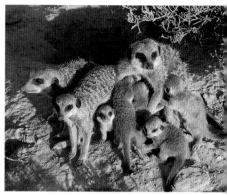

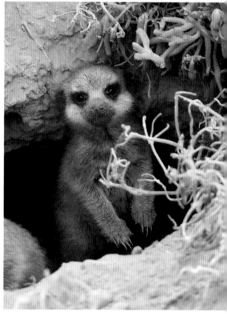

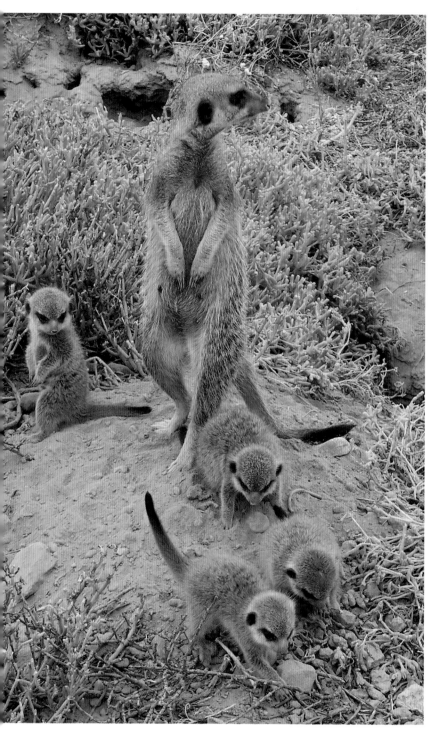

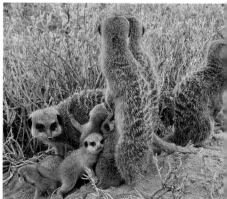

They will continue to suckle from their mother when she returns each day for around two to three months depending on food availability, before they are fully weaned from her milk supplement onto solid food.

A babysitter is highly vigilant and guards the babies for the entire day while the mother of the baby Meerkats has departed so that she can forage for enough food to produce milk and lactate for her pups when she returns to them at the end of the day.

Without the help of fellow group members the mother would not easily raise a litter of Meerkat pups as she would need to find food and babysit. Co-operative breeding such as this is essential for the Meerkats' survival.

The babysitter forgoes essential food and water to guard the pups and is caring for babies that are not even its own, but may be related.

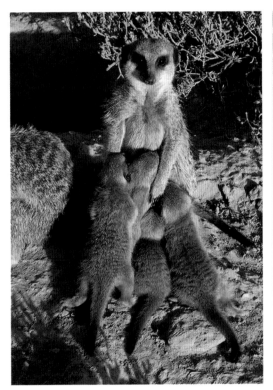 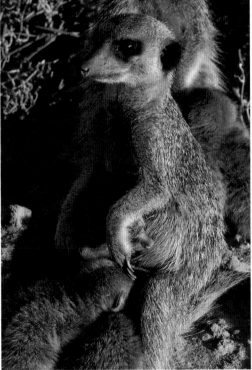

OPPOSITE: *Pups are cared for by babysitters during the day while their mother forages for food to obtain sufficient energy for milk production. When she returns they will hungrily greet her and suckle. Shortly after suckling babies have their wet faces coated in burrow dust.*

ABOVE: *Due to the high energy demands, lactating females need to forage for food and leave their babies in safety or the young would not survive. Cooperative breeding means that females who have lost their own litters can still produce milk. This benefits the group's survival and reduces the individual energy demands to care for the young.*

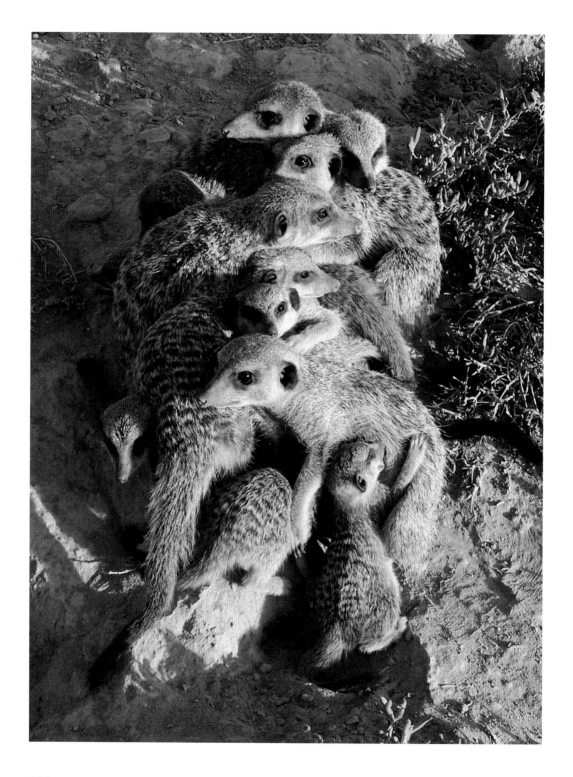

Number of litters

Breeding females may have three litters in an exceptionally good rainfall year when there is an abundance of resources, breeding repeatedly after each gestation. However these opportunities are very rare in the harsh ecosystems that Meerkats frequent. Instead of attempting to raise many litters unsuccessfully with too few resources, it is beneficial to raise fewer litters with greater care and higher survival results.

Natality is primarily determined by the climatic conditions over the breeding year. Meerkats attempting to raise a litter when there is an insufficient supply of resources will be severely penalised by nature, resulting in very high mortality rates and a waste of limited energy reserves.

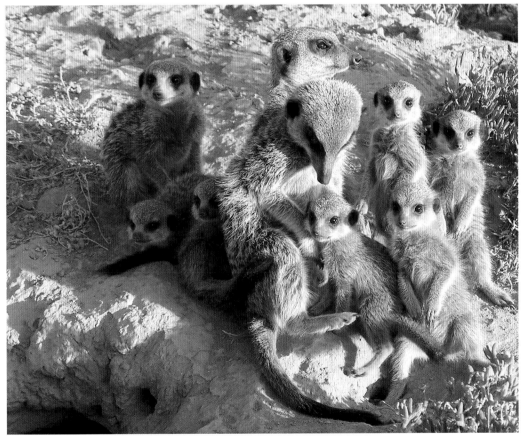

OPPOSITE: *Many Meerkats helping to raise young results in efficient breeding which will benefit all the members within a group as more Meerkats are able to share vigilance and be cooperative.*

ABOVE: *Rather then have limited resource availability for the babies of multiple breeding females, the dominant female usually has the highest chances to raise her own litter. She may have two or three litters over a year and raise many young.*

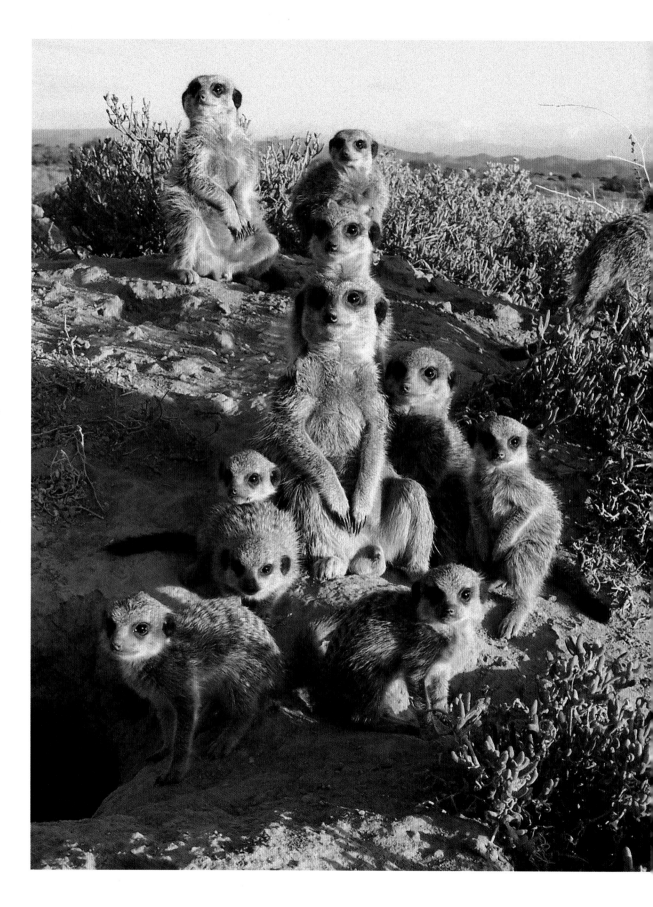

Number of pups born in a litter

Frequently four to six babies are born, but very rarely litter sizes of eight have been recorded. It had been believed that all the babies emerging from a burrow would be from a single litter, resulting in an apparent litter of more than eight pups on one occasion. These incorrect observations were due to an assumption that only the dominant female would have babies.

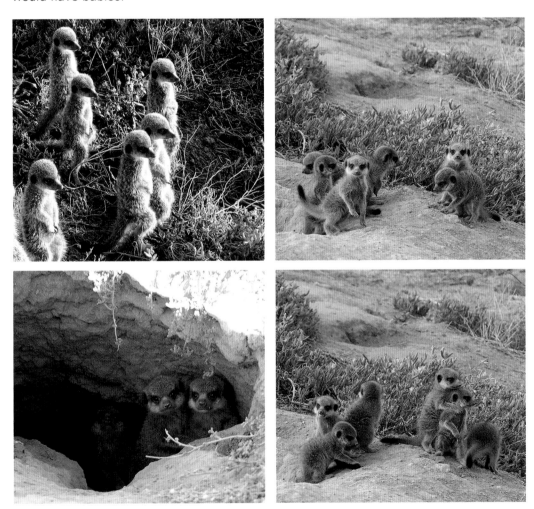

OPPOSITE: *It is very uncommon for there to be more then six babies from the same litter present within a group. Usually litter sizes consist of four to five pups.*

ABOVE: *Large litters of six babies place a huge burden on a group and very few survive their first year. It is a precarious balance for cooperative breeding between having too few young or too many depending on a great variety of factors influencing survival rates beyond their home burrows.*

Multiple pregnant females

Occasionally multiple Meerkat females will get pregnant at the same time. These large combined litters are a very rare event in a stable group structure within the confines of available resources. These multiple litters of three or four breeding females with 14 or more young do occur, and usually this is when there is no clearly defined dominance within the female hierarchy.

They usually coincide with the death of a dominant female or male, or the arrival of unrelated migrant males who impregnate all possible breeding females simultaneously.

These breeding conditions may also occur when sisters outlive their mother and have not yet established a breeding hierarchy. They may then all become pregnant without any reproductive suppression evictions. In an uncommon situation such as this, multiple litters may survive. Multiple females will then also lactate for the large litters.

The following breeding cycle usually has an established dominance hierarchy. The new dominant female will then normally be the only one who manages to get pregnant first and raise her young successfully. Her subordinate sisters would then be evicted.

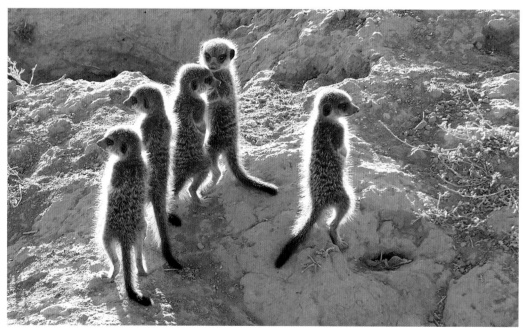

ABOVE: *A litter of five pups has a good chance of survival within a large Meerkat group. They are already very alert and will react to almost anything and treat it as dangerous as they guard, learning to differentiate over time.*

OPPOSITE: *Witnessing more then one pregnant female within a group is rare. Two is exceptional. To document three preganant females together without any aggression between them is extraordinary! Combined litters born simultaneously are very unusual and mark a significant environmental or group event.*

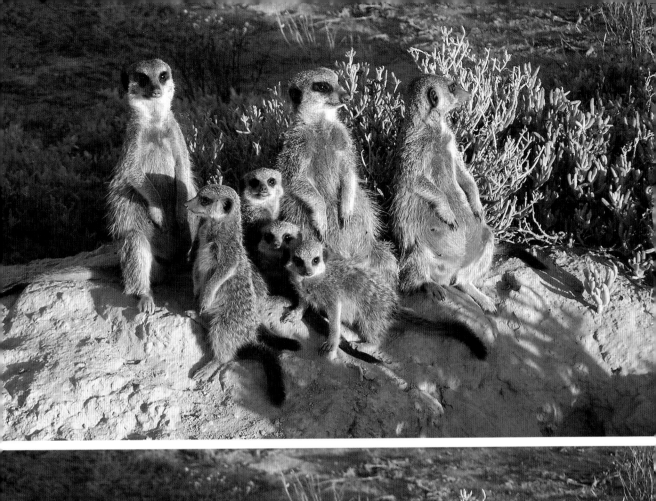
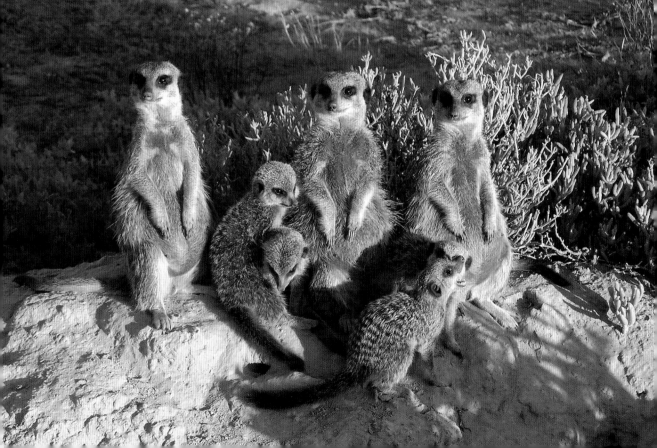

Multiple allolactating females and combined litters

The suckle marks are easily seen on multiple females who are allolactating, compared to the more common sighting of only one lactating breeding female.

After giving birth these females may attack and kill each other's babies and establish a dominance hierarchy, or very rarely they may raise a very large combined litter of babies. This may also occur when there is a great abundance of food resources after floods or an exceptionally high rainfall season resulting in the absence of breeding competition.

It is also possible that these mixed litters occur when populations are very low and are an attempt to rapidly increase a group's size even with the presence of an established breeding hierarchy and a dominant breeding pair. The dominant female appears to then allow subordinate females to breed without the associated eviction aggression.

If a dominant female risks potential dominance challenges to her in her weakened post-birth state, she can benefit from subordinate females allolactating for her babies. This allows her to lactate less as her babies will not be as hungry when they receive milk from multiple carers. Lower-ranking females will then also receive less energy than the dominant female, who can regain her strength more quickly with their assistance.

These females will then allolactate to all the young present, greatly increasing their combined survival.

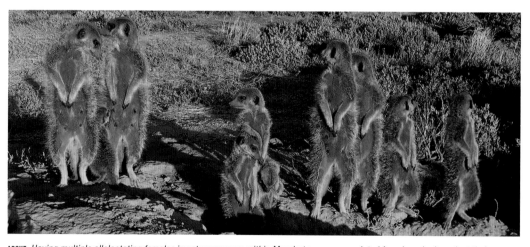

ABOVE: *Having multiple allolactating females is not uncommon within Meerkat groups, as evicted females who have lost their young may return and lactate for the dominant female's babies. To document three litters of babies born simultaneously who survive and then all suckle on three females is truly remarkable. Large combined litters may have a good survival chance when they are born together if there are sufficient individuals to care for them all.*

OPPOSITE: *The 'drinking patches' of dried hair on multiple lactating females can clearly be seen when Meerkats warm themselves in the early morning sunlight. With many Meerkats feeding babies the mothers have less of an energy drain on themselves and can provide additional milk for babies after a day's foraging.*

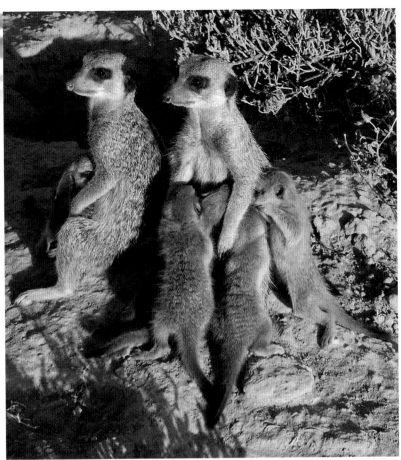
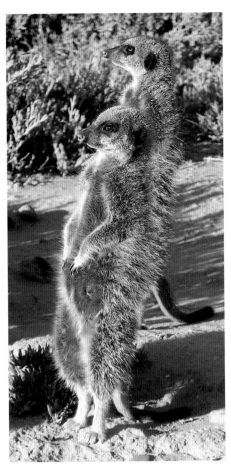
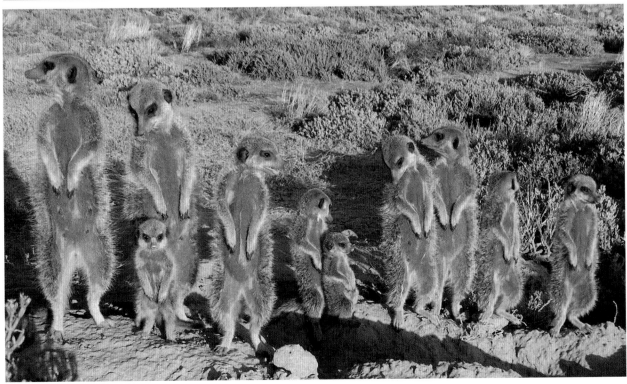

LEFT: *When there is a change in dominance, there is a temporary period of chaos as established hierarchies collapse and migrant males may arrive to take over a group as the new breeders and kill any babies that they encounter.*

OPPOSITE: *These babies from the Kalahari subspecies were from a subordinate female who gave birth outside of her group's protection and away from the dominant female. With no help available for feeding herself and her two babies she had to choose between abandoning her litter to return to the safety of her home group and raise her mother's babies, or try to raise her babies with very little help.*

Infanticidal males

Migrant males may become infanticidal and kill any previous litters they encounter on their arrival. This would ensure that they did not have any genetic competition from former unrelated males, and that their own litters would have sufficient resources and better survival rates.

Reproductive suppression and eviction

Although Meerkats are highly co-operative when helping to raise their young, they are not tolerant of possible competition over limited food resources for babies. This usually results in the dominant breeding female aggressively chasing all other possible breeding females away from her group. This is an attempt to get pregnant first and prevent lower-ranking females from having babies at the same time as her litter.

Any females that could then get pregnant subsequent to the dominant female would have their babies at a significant developmental disadvantage at birth due to their smaller sizes.

Occasionally, evicted subordinate females who manage to survive and return to the safety of their natal groups may give birth at the same burrow as the dominant female. The dominant female will usually kill and eat any babies that are not hers.

In the unusual situation where these babies from subordinate females are not killed at birth, they will inevitably be left behind at the burrow. They are unable to maintain the pace set by the burrow changing group with the older babies from the dominant female. The younger and less well-developed babies, who were born after the dominant female's litter, are unable to keep up with the older and stronger babies and will ultimately be exposed to abandonment and predation.

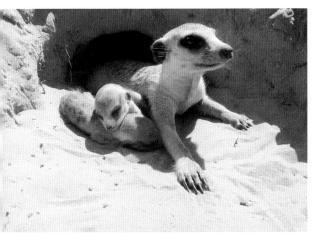

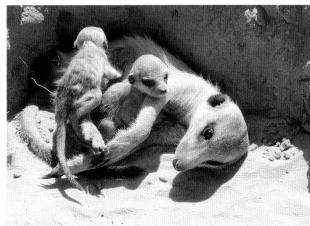

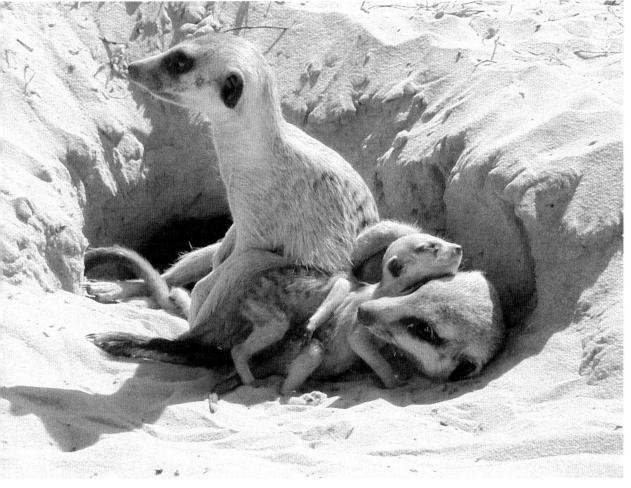

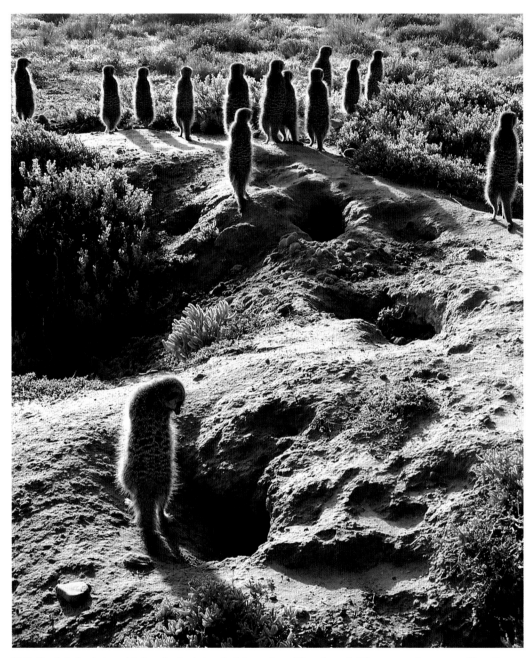

ABOVE: *Shortly before being evicted a subordinate female distances herself from the rest of the group as they emerge. She will soon be aggressively attacked and chased by the dominant female.*

OPPOSITE: *As the aggression levels increase from the dominant female towards lower ranking females, the measure of intolerance towards them can actually be seen by the ever increasing distances that they stand away from her at the sleeping burrow.*

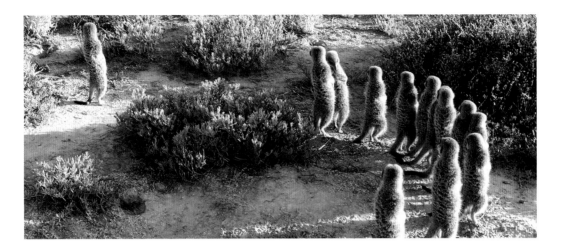

Pre-eviction behaviour

Previously it was believed that subordinate females voluntarily left the safety of their natal group to start a new group. This was a misinterpretation of the aggressive eviction and very high reluctance of these females to leave.

Prior to being evicted the subordinate females will increasingly approach the dominant female and initiate allogrooming, which she will reciprocate less often and then stop prior to an eviction. She will instead attack and bite the subordinate females. The dominant female will also lie flat on the ground and actively stare at any subordinate females. They will often approach her in a cowering stance while making a very specific grooming approach call, as the equivalent of an appeasement. This call is absent when approaching members of the same rank in the hierarchy.

The pre-evicted females will also begin to distance themselves from the rest of the group starting at the morning sleeping burrow. Often they will be the very first to emerge, which is the only time the 'weather forecaster' can be easily predicted to be one of the subordinate females.

The subordinate females will move further away from the main sleeping entrance before the rest of the group emerges. They will commonly sun themselves away from all the other sunning Meerkats.

Often the subordinate females will move to a safer distance from the increasingly aggressive dominant female when the group moves off to forage.

Prior to eviction, the dominant female will be very aggressive and body slam and scent mark and even bite any subordinate females. The subordinate females will usually turn onto their backs and paw the dominant female's face. The dominant female will then pursue the subordinate females and bite their backs and tails until they run away, resulting in them being actively evicted from the group.

The dangerous isolation of being evicted

The evicted females initially follow as close to their family as the dominant female will allow, but she will frequently chase them away if they get close enough to her.

This reluctance to be evicted and alone is also illustrated by the subordinate females returning to the sleeping area of the dominant female once she has gone below ground for the night. It has been suggested that subordinate females simply leave and form new groups.

Subordinate females do not simply decide to wander off into the unknown to maybe start their own group without any members or territory ... that would be suicide. There are seldom open unused territories available unless there has been an extinction event. These areas would soon be consolidated into the territories of old existing stable groups.

Burrow usage by evicted females is similar to pre-eviction over the first few days of being evicted. However they may sleep at the same sleeping burrow but not use the same sleeping entrance or chamber as the intolerant dominant female.

And as before being evicted they are predictably the very first individuals to emerge ahead of the other Meerkats in the morning, but will usually quickly move away from the main burrow rather than just further away from the sleeping burrow entrance.

There are numerous associated energy costs to being evicted. Any evicted female will be waking up earlier to get away from the dominant female before she emerges and chases them. There will not be time to relax and have parasites removed while being groomed, or to conserve energy by warming up or cooling down effectively. The reduced opportunities to forage between being chased and escaping will also considerably deplete energy reserves.

Being outside the protection of their group is often fatal. As they continually lose condition, they will become increasingly less vigilant and spend longer digging for food when they can, increasing their risk of predation by not being able to guard. Evicted females are very easy targets for hungry predators.

Being evicted results in the systematic attrition of condition, and should any evicted Meerkats survive their ordeal, they are much less likely to pose a threat to a stronger dominant female receiving all the benefits of being in a co-operative stable group.

Evicted females may not always return to the same sleeping burrow as their main group and they routinely become increasingly isolated. They are seldom able to follow the main group as they get weaker each day and fall further behind.

OPPOSITE TOP: *The dominant female will repeatedly chase and attack any subordinate female that attempts to return to the group when she has evicted them. She and other group members will treat them as if they are intruders.*

OPPOSITE BOTTOM RIGHT: *Evicted females have a high mortality rate, as being outside the protection of their group is very dangerous. They will often curl up in exhaustion after not being able to eat or rest from being frequently chased by their own group.*

OPPOSITE BOTTOM LEFT: *Evicted females frequently meet migrant males who get them pregnant and then leave to return to their own groups. They may give birth but the dominant female will usually kill the subordinate female's babies.*

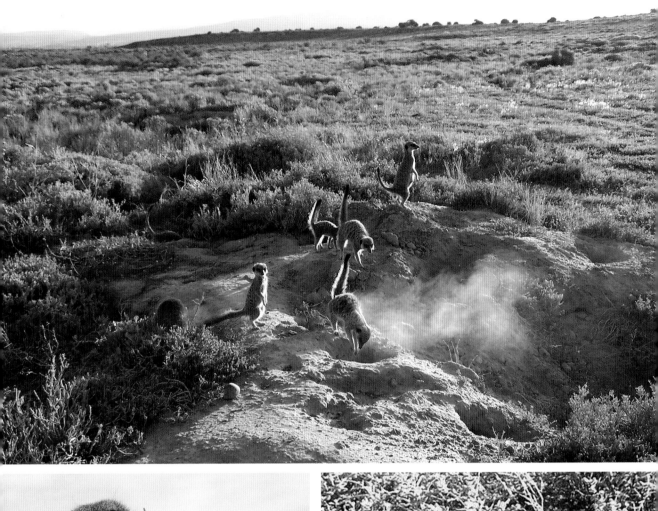

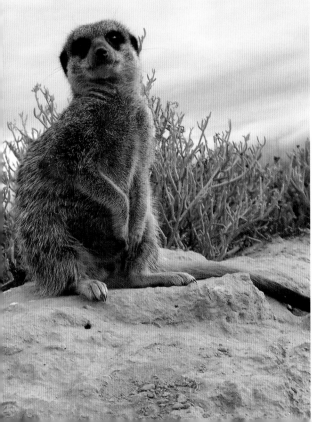

Evictions often occur before subordinate females may conceive, allowing the dominant female to gain an advantage where her foetuses will develop first.

There are no vacant territories for a new group to simply form. However, evicted females will commonly get impregnated by migrant males who do actually leave their own territories and may also return without being chased away or being evicted. These temporary displaced coalitions are where the confusion about new groups forming has originated from.

There is an insufficient quantity of resources available between stable breeding Meerkat territories which overlap snugly for a new group to be viable. These groupings may last for a few hours or even weeks, but the evicted subordinate females inevitably attempt to return to their natal family.

This is also an ethical conservation consideration for not introducing captive Meerkats into wild populations, as these would cause an artificial displacement of naturally occurring groups and impact on available resources.

These temporary groupings are also unable to care for any young born as they lack sufficient numbers to do so effectively. Even in the very rare situation of a vacant territory being available due to an extinction of a former group, larger surrounding groups will move in and kill or displace any intruder Meerkats that they find, and consolidate the territory with their own. These displaced Meerkats are under serious threat from all the usual survival challenges and any surrounding Meerkat groups. It is much safer for them to disperse and return to their respective natal groups.

If new groups were commonly forming and viable, larger Meerkat groups would not even exist or need to be co-operative – another clear indication that simply forming a new group is impractical and very dangerous.

Surviving being evicted and returning to the natal group

Impregnated evicted subordinates will often spontaneously abort their young and eat them. These females still produce milk and are able to lactate even without their own babies. Once the dominant female has given birth, these allolactating females will often manage to return to the family and the dominant females babies will benefit from their milk.

Survival rates for the babies of subordinate females are low. Although multiple evicted females frequently get pregnant, usually only the dominant female manages to raise her young.

Migrant male coalitions and displacement

From the age of nine months to around two years, male Meerkats commonly leave their natal territories in search of breeding opportunities or 'vacancies' in neighbouring territories. These wandering missions coincide with the eviction of subordinate females and the onset of the breeding season.

Travelling into unknown territory without experience of the network of safety burrows or possible localised threats is very dangerous. Males often meet up with other migrant males, but they lose condition and face danger in a very similar way to evicted females. The main difference between their losses is that they are self-imposed, as they choose to leave their groups and are not chased out as subordinate breeding females are.

Migrant males follow 'scent adverts' for when a 'breeding vacancy' occurs. These openings for opportunists may also occur when a resident breeding male has died, or has left due to the death of a dominant breeding female partner. He will not breed with his own daughters. The dominant male may also be displaced by migrant subordinate males.

After the breeding season ends, if no viable group openings were discovered, and commonly after a temporary grouping with evicted females and impregnating them, the males will return to their home territories.

Female Meerkats may in time inherit the territory from their mothers. If the dominant female dies, the father and dominant male will not breed with his daughters and will commonly leave the group in search of another 'vacancy' with unrelated females. Any subordinate males from a former coalition with the dominant male may then have an opportunity to become the new dominant male since they are not the father of the new dominant female.

Dominance displacement

When a dominant female dies, migrant males will move into the territory and cause a displacement where the dominant male who may not yet have left will be chased away. Subordinate males in these newly formed breeding structures may in time become the dominant male. They will also aggressively chase any other potential intruder males to ensure their own chances of being the dominant male are higher with fewer competitors. The dominant male benefits from this alliance but is also at risk from the subordinate males potentially attempting a dominance takeover, which can also happen.

There is a high mortality rate for migrant males and evicted females. They are also unable to forage or groom and remove parasites effectively and lose condition rapidly, which is a high cost for being away from their home groups.

Conserving breeding corridors between suitable Meerkat habitats is essential in order to allow for migrant male genetic dispersal to occur. Meerkat populations that become isolated due to land usage practices will ultimately go extinct.

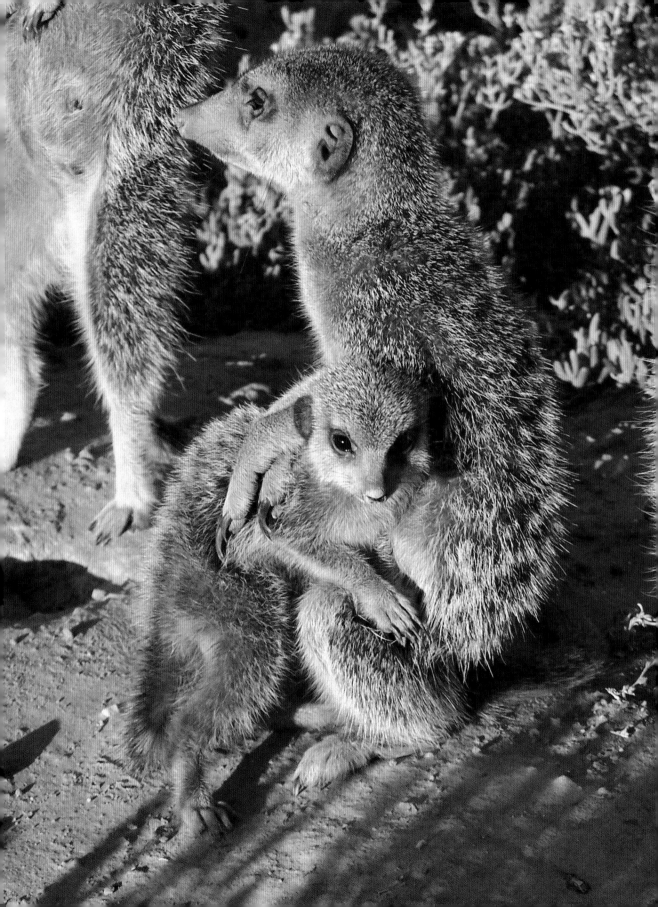

BABYSITTING

MEERKATS ARE HIGHLY GREGARIOUS and are an excellent example of co-operative breeding mammals that collectively assist in rearing babies together to improve the group's survival rate.

The dominant female is usually the breeding female within a group. After giving birth she must leave her young in order to acquire sufficient nutrients from foraging for food in order to lactate for her babies.

Due to the many threats her babies could encounter if left alone in a burrow, the group uses babysitters.

These are individuals who may remain behind at the burrow with the young for a few minutes to an entire day without any food or water for themselves. They decide to do this individually.

Similar to guarding, it is believed by some that babysitting is an appointed duty and reserved only for females or certain specialist individuals taking turns.

Again as is the case with guarding, this is not correct nor is it a turn system.

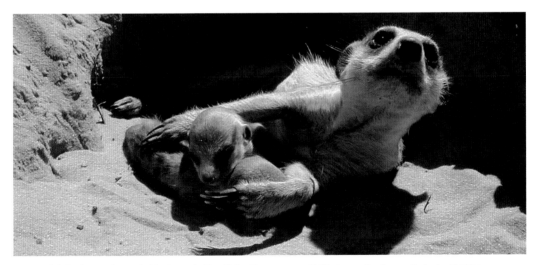

OPPOSITE: *A babysitter and a pup hold onto each other. Babysitters are essential for increasing the survival rate of babies.*

ABOVE: *Babysitters choose to go without food in order to protect babies. As is the case with elevated guarding, it is often the more well fed individuals which are able to perform this task.*

Condition and hierarchy play a very important selective role in who may babysit on any given occasion. Condition is not determined by the Meerkat's sex. Male and female Meerkats babysit.

It is very uncommon for the same babysitter to babysit daily as its condition will seldom allow for such an extended period of energy loss.

Sometimes the last to emerge and leave the burrow are the babysitters, as others rush off to get food. This is a case of 'if you snooze you will lose' – being a late sleeper really does cost in this case, the loss being in condition.

The hungrier individuals, especially the previous day's malnourished babysitters, seldom spend more than a day at a time babysitting due to the high energy costs involved. If this was a set role or determined by sex, the same individuals could be expected to babysit predictably, which does not occur.

A babysitter also benefits from the relative security of the burrow system and is not exposed to the same danger levels as it would be during active foraging for food.

Allolactation may also occur from babysitting females who have lost their own litters and are still able to produce milk. This further benefits the survival of the babies being cared for.

RIGHT: *Meerkats who voluntarily remain with the babies without any food are excellent examples of how good self-care can dramatically benefit others in a Meerkat team. It will also increase its own future survival chances by raising additional guards.*

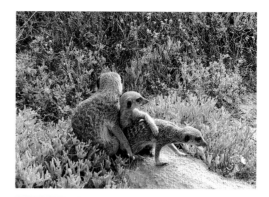
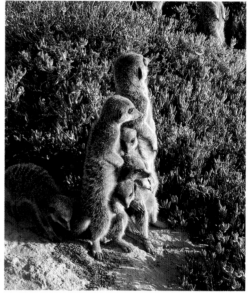
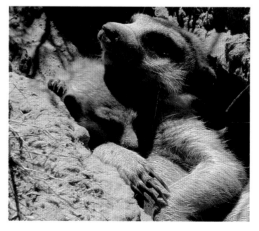

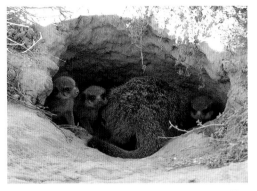

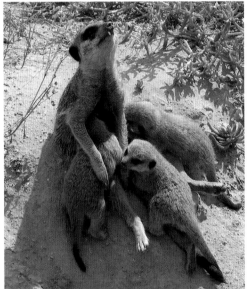

By assisting in the care of the babies, each Meerkat is in turn investing in their own survival through genetic preservation of their siblings.

Ultimately the babysitters will in turn be protected by additional group members who are then able to babysit for the following litter of young.

A larger group with an increased number of potential babysitters allows each individual to forage for food for longer and be in better condition.

This can greatly reduce the babysitting duration and associated energy costs, resulting in more frequent changes in babysitters.

Hungrier babysitters will then have an opportunity to forage and replenish their condition as they are replaced by returning Meerkats who are in good condition.

Although quite uncommon, even the dominant male or female may babysit if their condition allows this or if the group size is too small to allow for additional babysitters.

LEFT: *Meerkats who voluntarily remain with the babies without any food are excellent examples of how good self-care can dramatically benefit others in a Meerkat team. It will also increase its own future survival chances by raising additional guards.*

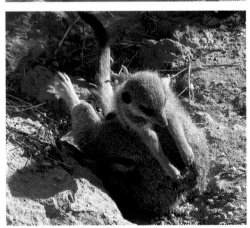

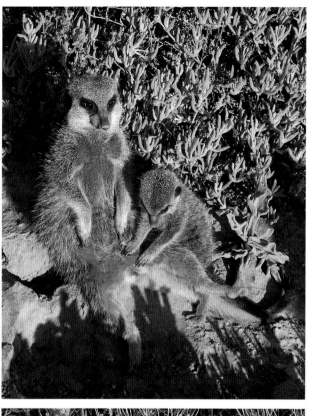

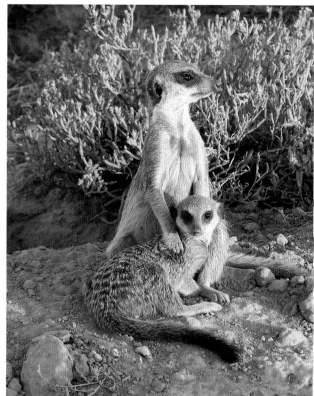

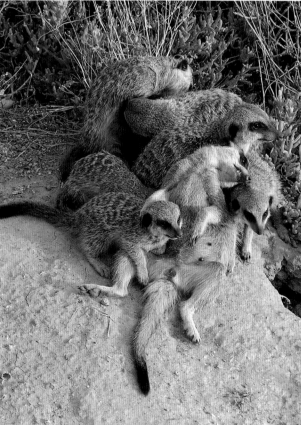

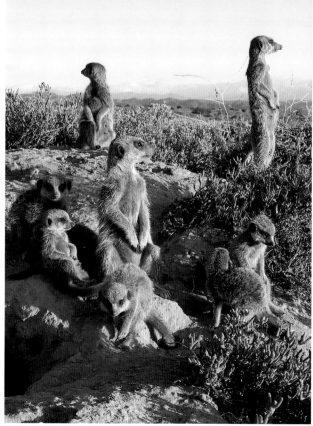

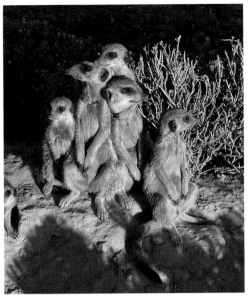

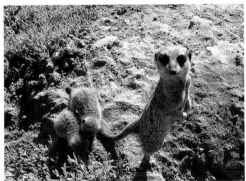

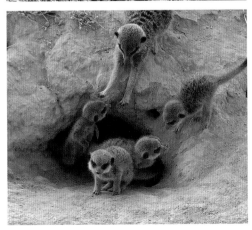

There is a severe condition cost involved to any dominant lactating female who is unable to leave her babies and forage for food which will directly impact on her ability to lactate for her babies and their survival.

When babies initially move to a new burrow from their natal burrow, they are often escorted by many Meerkats grouping around them for protection. This also happens if predators are encountered by the group.

When potential danger is sighted baby Meerkats are rushed to a nearby burrow, where they are actively sniffed and groomed and marked and the burrow is furiously excavated and maintained.

This is clearly imprinting the associated anti-predator behaviours with the burrow safety lesson being actively taught.

OPPOSITE: *Babysitting is usually much safer then being exposed to the dangers beyond the burrow. Being able to afford to remain at a burrow which will have the group return to it are quite beneficial even with the associated loss in condition.*

LEFT: *Larger groups may have more individuals who can assist in babysitting, allowing for lower energy losses due to greater rotation. Smaller Meerkat groups have very high energy losses due to more frequent and prolonged energy-depleting babysitting per individual.*

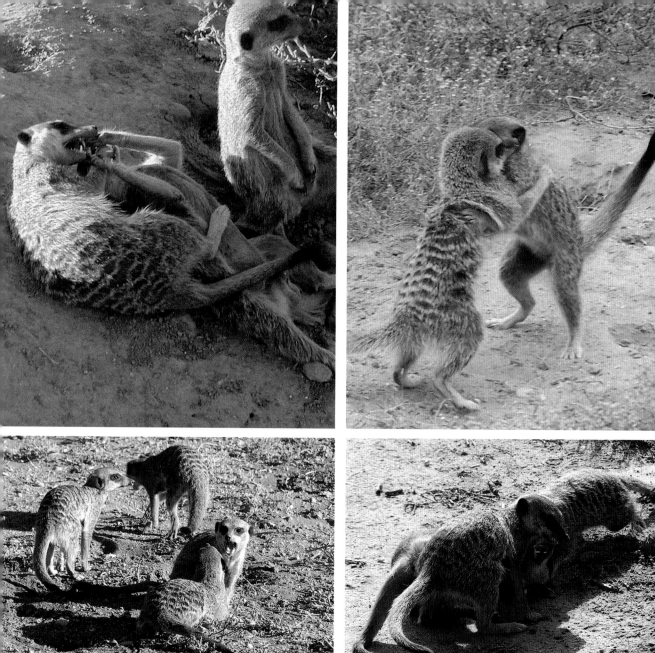
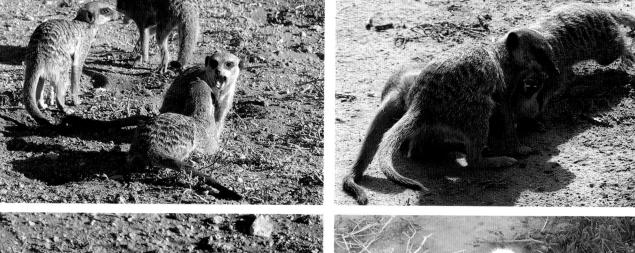
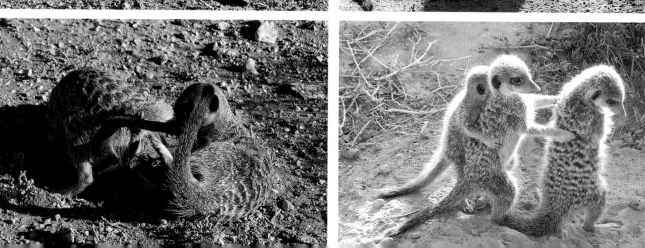

PLAY FIGHTING

PLAY FIGHTING CAN HELP to prevent serious aggression occurring in Meerkat groups and it is ritualised fighting from a very young age throughout the Meerkat's life.

Play fighting is a good indicator of a Meerkat's condition, as it has excess energy to use for playing.

This activity can include numerous Meerkats simultaneously and helps to establish and maintain hierarchy and strengthen intragroup relationships.

Playing often occurs during the breeding season which coincides with higher food availability and more time for play with better condition.

From as young as a few weeks of age, baby Meerkats often play and establish their own strengths and weaknesses within their litter and this also helps them to develop survival skills.

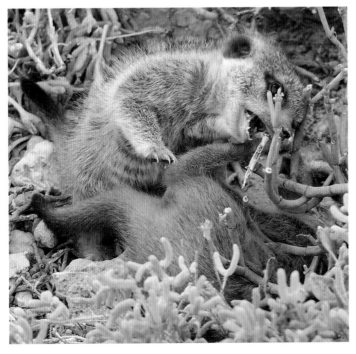

OPPOSITE: *Playing between litter mates begins immediately and can continue throughout their lives. Even very old Meerkats will play on occasion. Playing is a celebration of excess energy when food is more abundant. It can test the strength of participants and alleviate possible future conflicts through ritualised acceptance of positions within an established hierarchy.*

ABOVE: *Baby Meerkats practice their hunting skills on each other and will often bite each other very hard. As they get older they learn to be less aggressive when playing. A rapid series of agitated calls will be made to announce if any playing is considered to be 'unappreciated' or too 'rough' and if this warning is ignored real fighting may break out. Babies frequently test the tolerance levels of each other and do not simply stop when they are given a warning to do so!*

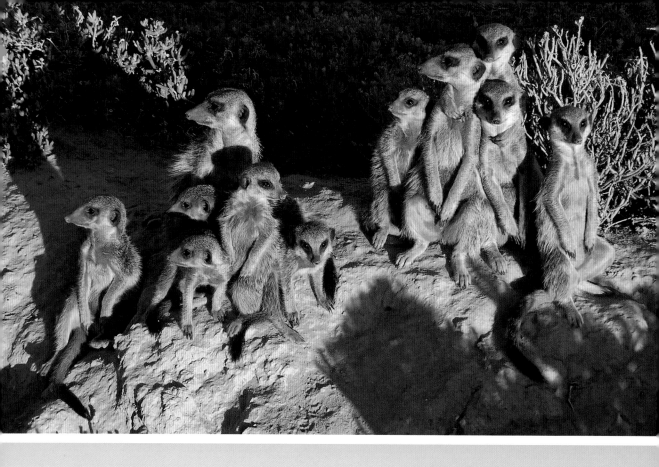
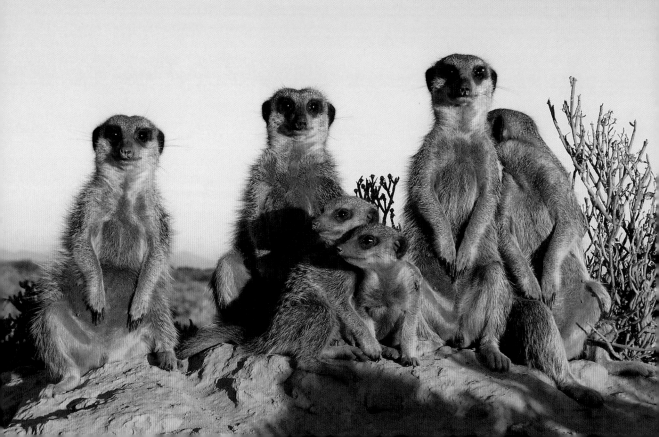

POETRY INSPIRED BY MEERKATS

I HAVE OFTEN FELT inspired by wild Meerkats to try and capture the essence of what I have experienced with them by painting images in words. The following two poems are from my experiences of watching Meerkats emerge in the morning and following them over the entire day to their sleeping burrows at night.

From dawn to dusk with the Ungulungu Meerkats

ALONE I SIT,
DARKNESS SHIFTS,
FIERY THREADS WEAVE
A GOLDEN TAPESTRY
FROM THE INKY BLACKNESS
INTO COBALT BLUE.

NOT MUCH LONGER I THINK,
SOON I WILL BEGIN TO SEE,
THAT CAUTIOUS BLINK,
THAT TWITCHING NOSE,
COVERED IN SAND.

THAT MEERKAT MAGICAL
 MOMENT,
WHEN THE SECRETIVE
SOLAR SOAKING SURICATES
EMERGE FROM THE LAND.

LIKE DOMED MUSHROOMS,
HEADS BEGIN TO APPEAR
SLOWLY, TENTATIVELY
I SENSE THEIR FEAR.

A CHIRPING SOUND IS HEARD,
BUT NOT FROM A BIRD,
IT RESONATES NEAR MY FEET,
HIGH PITCHED
WITH A RAPID BEAT.

ANOTHER CALL
MERELY ONE,
OF OVER THIRTY-FOUR,
ECHOED BY OTHER
WAKING VOICES.

ALL AROUND THEY APPEAR,
WITH DUSTY FACES,
FROM BENEATH
THE BREEDING MOUND.

A GOLDEN SHROUD
OF SILKY BROWN HAIR,
GLOWS,
WHILE MASKED FACES STARE.

MANY HAZEL BROWN
EYES SHINE,
SQUEEZING SHUT,
BLINK, BLINKING
SLEEPY SANDY TEARS.

THEY HAVE ACCUMULATED
THESE OVERNIGHT,
IN HUDDLED WARMTH
BELOW THE GROUND,
TRICKLING TRAILS
DOWN VELVET MASKS,
SHINY AND WET.

WHAT DREAMS
I WONDER ARE THESE
LITTLE
ERDMANNE ANIMALITIES
SLOW TO FORGET?

OPPOSITE: After decades of observing wild Meerkats I find them to be truly magical mammals to conserve and I deeply appreciate their species for the incredible opportunities I have enjoyed around them in their habitats. The Ungulungu group has become a very special family that has tolerated my presence for many years of shared experiences between our two species.

SNOOZING,
HEADS NODDING,
GREY SOLAR PANEL
TUMMIES STRETCHED,
TRIPOD TAILS ETCH,
THE SAND,
WHERE THEY STAND.

THE FACES GLANCE,
CURIOUS
AS IF IN A
SLEEPY TRANCE,
AT ME,
THE MEERKAT MAN,
SITTING PATIENTLY HERE,
THERE IS NO NEED
TO FEAR!

BOTTLE BRUSH
BODIES SPREAD OUT,
AND GATHER NEAR,
SLENDER BACKS
ARCH AND STRETCH,
TAILS BEGIN TO
CURVE OVER AND BEND.

IN ANTICIPATION
OF YET ANOTHER
CELEBRATION OF
A BANQUET
LYING IN WAIT.

BENEATH A MYRIAD OF FEET,
SOME INVERTEBRATE SNACKS
WILL HAVE AN
UNFORTUNATE
FATE.

A SUDDEN SHRIEK,
A GROWLING BARK,
AND LITTLE EARTHLINGS LEAVE
PUFFS OF SAND,
AS THEY DESCEND BELOW
INTO THE DARK.

A PALE CHANTING GOSHAWK
TRACES FEATHERY CIRCLES
HIGH ABOVE,
IN THE DOME BEYOND
MEERKAT REACH.

ANOTHER MOMENT REVEALS
AN EMPTY SLEEPING BURROW
LIKE A DESOLATE BEACH.

THE SUNBATHERS
HAVE GONE,
THERE IS NO MORE
TWITTERING SONG.

THE PREDATOR LOSES INTEREST,
AND DISAPPEARS,
TRANSFORMED INTO A TINY
 SPECK
BEFORE MY EYES,
DISTANT WING BEATS
FADE RAPIDLY
FROM MY EARS.

CAUTIOUSLY,
BOBBING UP AND DOWN,
FROM THE EARTHY BROWN,
LOOKING LEFT AND RIGHT,
AND ALL AROUND,
FOR ANY SIGN
OF DANGER PAST.

THE WILD
UNGULUNGU MEERKAT GROUP,
SOON RETURNS TO BAKE,
BEFORE THEIR IDOL
OF SEARING WARMTH
IT SOARS HIGHER,
THEY WATCH IT GO,
MESMERISED LIKE MINDLESS
 ZOMBIES,
BEFORE SOL'S
BURNING MIGHT.

SLOW HEARTBEATS PASS,
WARM AND SATISFIED,
THEY BEGIN TO YEARN,
TORMENTING HUNGER
BEGINS TO BURN.

SHARP NAILS
SCRABBLE AND SCRATCH,
IN UNISON CONTENTED BODIES
 TURN,
WITH PRACTICED PRECISION,
ACCEPTING THEIR DAILY
 OFFERING
OF SOLAR FLARE.

THE EQUIVALENT OF
A HUMAN CAFFEINE FIX,
NOW THEY ARE READY,
FOR MORE
CRUNCHY FARE.

THE PULSATING ORB,
CLIMBS HYPNOTICALLY HIGHER,
LEAVING A SHIMMERING HAZE.

A MYRIAD OF FLOWERS
SLOWLY STRETCH,
WITH THEIR
PHOTOTROPICALLY
BRIGHT PETALS,
THEY SEEM TO GAZE,
SEARCHING TIRELESSLY
FOR THE IMMENSELY
POWERFUL LIFE GIVING
BEAMS FROM ABOVE.

THE IMPATIENT ORB IS
SKATING ON THE RIM
OF THE SURROUNDING
GREAT BLACK MOUNTAINS,
SEARING THE GROUND,
RADIATION BEATING
RELENTLESSLY
AND HARSHLY DOWN.

NOSES TWITCH,
TWITCH,
DISRUPTIVELY CRYPTIC
BACK PATTERNS
BRISTLE,
NAILS SCRATCH AND ITCH.

LITTLE IVORY NEEDLE
TEETH NIBBLE.
YOUNG WHINING PUP VOICES
QUIBBLE,
CLICKETY,
CLACK,
THEY BEGIN TO GROOM.

A FEW START TO AEROBICALLY
SWEEP OUT THEIR
SANDY ROOM.

LIKE A LARGE HOTEL,
THIS REAL ESTATE,
MUST NEVER BE ALLOWED
TO DEGENERATE.

MORE BODIES JOIN IN,
BURROW CLEANING FIRST,
BEFORE BREAKFAST
CAN BEGIN.

THIS IS NOT
A SCENE FROM A ZOO,
NOR A SURREAL DREAM,
BUT EXISTS AND IS TRUE.

EACH DAY
IS UNIQUELY SPECIAL
UNLIKE ANY OTHER
THAT HAS GONE BEFORE.
TIMELESSNESS TRANSCENDING
BOTH ME AND YOU.

THE DAY'S JOURNEY
HAS ONLY JUST BEGUN,
FOLLOWING WILDLIFE
INVISIBLY
AND UNOBTRUSIVELY,
IS TREMENDOUSLY
REWARDING FUN.

HOUSE CLEANING
AND ROMPING PLAY CEASE,
THE 'LET'S GO GET FOOD' CALL,
BEGINS TO INCREASE,
REVERBERATING FROM
MANY THROATS
AS IF WITHOUT END.

AND THEN,
FURIOUS SCRATCHING,
SCORPION CATCHING,
LARVAE ARE REVEALED,
GECKOS REMAIN
CONCEALED.

AN ANT BITES HARD,
IT WILL NOT LET GO,
A YOUNG PUP'S NOSE,
IS NOW ADORNED,
WITH REMAINING JAWS.
THIS LOOKS REALLY SORE!

THE YOUNG ARE
A TEACHER'S MAIN CONCERN,
THEY MUST TRY AND AVOID,
THE SEARING BURN,
FROM THE ANT'S BITE,
AND HOW TO WAIT
THEIR TURN.

NOW IS THE AGE
TO
LEARN, LEARN, LEARN.

GRAB AND SNATCH,
BITE OFF THE TAIL FIRST
TO DISPATCH,
THAT VENOMOUS NEUROTOXIC
 STING,
AROUND A MEERKAT
THE SCORPION IS
NO LONGER KING.

RAPIDLY EATEN
TOXINS ARE BEATEN,
LIKE A TASTY DESSERT,
OR A POTENTIALLY
LETHAL FLIRT.

A VENOMOUS SNAKE HISSES,
PUFFED UP TAILS,
RISE FROM ONE AND ALL,
A WAILING SOUND IS HEARD
FROM A PUP,
A DISTRESS CALL.

RELENTLESS MOBBING,
HEADS AND TAILS BOBBING,
A NIPPED SNAKE'S TAIL,
HERE AND THERE,
AND OFF IT GLIDES,
TO FIND A MORE PEACEFUL,
UNINTERRUPTED-BY-MEERKATS
REPOSE,
TO CONTINUE ITS DOZE.

LYING IN WAIT,
A JACKAL TRIES TO POUNCE,
THE MEERKATS ALARMED,
RAPIDLY BOUNCE.

ALL TOGETHER,
AN INVINCIBLE TEAM,
CRYPTIC BACK PATTERNS
TEASE AND CONFUSE,
THE HAPLESS PREDATOR,
IS SURE TO LOSE.

SWAYING AND DANCING
LIKE A MYTHICAL MULTI-HEADED
 HYDRA
WITH MANY EYES, TEETH AND
 TAILS
WHEN ONE HEAD IS DOWN
ANOTHER APPEARS.

THE SURVIVAL TECHNIQUE
IS IN PLACE,
EACH MEERKAT WILL
STAND BY AND FACE,
A LESSER DANGER
LIKE THIS.

BUT SHOULD A LARGE
EAGLE APPEAR,
ALL THESE WARM BODIES,
WILL DISAPPEAR,
INTO THE SAFETY
OF A NEARBY BOLT HOLE,
BENEATH THE GROUND,
TEASINGLY CLOSE,
YET SAFE AND SOUND.

UP, UP RAFIKI
THE WILD MEERKAT GOES,
CLIMBING STEADILY,
SNIFFING WITH
HIS LONG NOSE.

HE NOW STANDS
AND GUARDS,
UP IN A DEAD TREE,
ALL OTHERS ARE SAFE,
HE WILL REMAIN AT HIS POST,
FAR LONGER THEN MOST.

WITHOUT EVEN
A BITE OF FOOD TO EAT,
WHILE THE
UNGULUNGU MEERKAT GROUP
FORAGES CONTENTEDLY
IN TRANQUIL HARMONY,
FOR BREAKFAST
BELOW HIS FEET.

RAFIKI WILL PRIMARILY,
LOOK AFTER HIMSELF,
THOUGH,
IF DANGER APPROACHES,
HE WILL BE
THE FIRST TO GO,
INTO THE BOLT HOLE,
CLOSE TO THE TREE.

WE CAN OBSERVE FROM
THIS NATURAL LESSON
OF HOW BY PRESERVING,
OUR OWN WELL BEING
WE ARE ABLE
TO GIVE TO OTHERS
BENEVOLENTLY
IT WOULD SEEM.

AN INDIVIDUAL'S SURVIVAL
IS PRIORITISED FIRST,
AND THEN OTHERS
MAY BENEFIT,
WHO ARE LESS WELL VERSED,
IN GUARDING,
FORAGING,
SCENT MARKING TOO.

IN WILD MEERKATS,
DOMINANCE IS
EXPERIENCED BASED,
AND NOT DETERMINED
BY SIZE OR WEIGHT,
EXPERIENCE DECIDES
A MEERKAT'S FATE.

FINALLY HUNGRY MOUTHS
ARE FED,
A SLEEPING BURROW
IS APPROACHED,
IT IS ALMOST TIME
FOR BED.

EXHAUSTED BODIES
NOW HUDDLE AND BUNCH,
THEY ONLY HAD A SHORT
SIESTA AFTER
BREAKFAST
AND LUNCH.

THE LAST WINKS OF
LIGHT RAPIDLY FADE
INTO SECRETIVE
MURKY DEPTHS.

SOFTLY CONTENTED
HUMMING SOUNDS,
GROOMING,
HUGGING AND YAWNS.

THEN
ONE BY ONE,
THE WILD
UNGULUNGU MEERKAT GROUP
DISAPPEAR
INTO
THE SAFETY OF THE GROUND
UNTIL DAWN.

I BLINK ONCE,
TWICE,
WAS TODAY JUST A DREAM?

DARK MEERKAT-FILLED HOLES
IN THE SLEEPING BURROW
 SYSTEM
MOCK ME,
THIS IS AS CLOSE
AS I WILL BE,
TO THE SECRETIVE
UNDERGROUND
LIVES OF THE MAGICAL,
MYTHICAL,
MEERKATS.

LIKE A FANTASY,
THEY SEEM UNREAL,
I BREATHE DEEPLY,
ENJOYING THE FEEL,
THAT THESE ANIMALS
ARE WILD AND FREE.

In the Little Karoo a distant Meerkat protects fellow team mates in a dangerous neighbourhood full of surprises. Every day is a survival challenge shared by all the Ungulungu Meerkats, and every day that they awake provides another opportunity to live wild and free in harmony with nature.

Sleepy sunset with the Ungulungu Meerkats

FLOWING ENERGY
LIFE PROFOUND
SYNCHRONISTIC MOVEMENTS
ALL AROUND

HUNGER SATIATED
GRUBBY CLAWS
DUSTY NOSES
SHINY EYES
OPEN MAWS

CONTENT
HUDDLING
SOOTHING SOUNDS
SOCIAL BONDING
BEFORE A NIGHT
UNDERGROUND

CURLED UP
WARM
SLEEPY BREATHING

THE EARTH
AN INNER SANCTUM
TRUSTED
REJUVENATING
HEALING

SADDENED
TO SEE THEM GO
WISHING I
COULD JOIN
THEM
IN SECURITY
BELOW

DARKNESS
RUSHES IN
BURROWS FADE
SWALLOWED
BY NIGHT

HAPPY MEMORIES
STILL BURN
MY SIGHT

GOOD NIGHT
MYTHICAL
EARTH PEOPLE
'ERDMANNE'
GOOD NIGHT.

CONSERVATION AND ECOLOGICAL IMPORTANCE

THE MEERKAT SPECIES may not appear to be in any danger of going extinct in the wild. However, this cursory and incorrect assumption is not based on adequate accurate local habitat surveys. Individual subspecies populations are facing different threat levels relative to their distribution.

The Kalahari Desert Meerkat subspecies is often used as a generalised site-specific conservation status for the entire Meerkat species, including all the known subspecies, which is grossly inaccurate and non-representative. Classifying a species as not under threat or endangered is not accurate without a comprehensive assessment of its entire habitat range.

The very nature of the Meerkat species does not allow for accurate comprehensive population counts throughout its distribution, and these can only be guessed at. However, the negative impacts on the habitats of the Meerkats can be accurately determined.

The Kalahari Desert Meerkat subspecies is an example of this inaccurate generalised assumption, and is not under threat from habitat loss caused by ploughing of its burrows to plant large areas for crops. There is also little threat from the usage of crop pesticides or even from human developments encroaching on their vast habitat, as it is not a densely populated area.

In contrast the Little Karoo Meerkat subspecies is indeed under severe threat from massive loss of suitable habitat. I have been researching the conservation impacts on the species and subspecies since 1993.

Conservation challenges for the Little Karoo Meerkat subspecies

The Little Karoo Meerkat subspecies occurs in a highly populated part of South Africa which has been settled and farmed intensively for hundreds of years. With an exponential increase in stock farming for profit, huge areas of previously fertile and indigenous vegetation, and the remaining suitable Meerkat habitat, was destroyed and desertified through overstocking and ploughing for food crops.

OPPOSITE: *Trampled and compacted barren soil with the vegetation stripped away through intensive and unsustainable land usage practices results in severe erosion and environmental degradation. With ever-increasing demands for food the few remaining wilderness areas in the Little Karoo are under constant threat.*

The resultant soil compaction through stock trampling and large-scale erosion due to unsustainable land-usage practices has had a severely detrimental effect on Meerkat populations.

This resulted in very few areas with suitable habitat remaining and these became increasingly isolated from each other. When Meerkat populations get isolated they no longer have overlapping territories or corridors of adequate habitat including sheltering burrows that migrant males can move through to ensure the continued genetic dispersal and viability of these populations.

Meerkats have a very specific preference for alluvial compacted calcrete soils in the Little Karoo ecology. This geology usually occurs in the ancient river bed systems. Very sandy or rocky ground is avoided due to burrow instability which would result in burrows collapsing if building was attempted in unsuitable crumbling soil types.

When formerly suitable Meerkat habitat areas had been desertified, trampled and compacted, to satisfy the increased dietary demands of the burgeoning stock population, new agricultural areas were developed for the planting of crops.

The indigenous Little Karoo succulent plants are very fragile and are quickly trampled and destroyed by livestock. It is a difficult challenge to return these to an area that is not actively managed by conservation.

Alien plant invaders

With the removal of indigenous plants by over usage from stock and ploughing, they no longer prevented competition towards exotic species, which began to colonise the previously fertile and balanced ecosystems.

The spread of these invasive plants has been largely facilitated by crop-planting with their seeds mixed in with the food crop. Irrigation networks help to rapidly spread these aliens to large areas. Human transport networks and additional stock food containing these seeds have greatly increased the spread of invasive plants.

Many of the invasive plant species outcompete the indigenous vegetation which is unable to establish. The fast-growing alien plants have no natural enemies in the area since they are foreigners in the ecosystem.

The impact that invasive plants have on Meerkats

Invasive alien plant species frequently have dangerous phytochemicals that can kill livestock and possibly Meerkats and their food.

Meerkats will abandon areas of territory that lack indigenous plants due to their reliance upon them for the provision of their main food resources. When the Meerkats leave an area it will further deteriorate and exotic plants will increase in number.

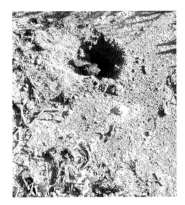 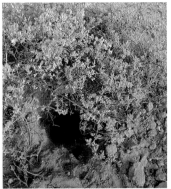

Through the daily cycle of soil-enriching dung and the reversal of sand-compaction by stock through intensive foraging digs, Meerkats' pioneering impacts can reverse serious erosion and revitalise an ecosystem.

Predators may also actively kill all the Meerkats that they can easily see in exotic vegetation since the Meerkats are not camouflaged amongst the alien plant species. Meerkats have adapted very specifically to certain habitats, and when these are artificially changed, the Meerkat loses its ability to hide effectively in these areas.

Meerkats are pioneer mammals and can help restore indigenous vegetation

When an area in which Meerkats occur naturally is damaged by poor land-usage practices and exotic plant species begin to increase in number, these plants will not support the indigenous food items that the Meerkat requires.

The encroachment of alien vegetation in an area can be limited by Meerkats favouring the plants that are indigenous to their territory, and that they have developed a relationship with. It is essential that Meerkat burrows are protected and livestock must be removed from the area before all the indigenous vegetation is gone, in order for this process to succeed.

Meerkats are the equivalent of rotational crop farmers and are the gardeners of nature. The indigenous plants grow even better since the invertebrates that were eating their leaves and roots were removed and converted into Meerkat dung and plant food as compost. Foraging Meerkats frequently leave dung in the holes that they dig around plant roots, rather than digging a separate hole for their dung.

Additionally the compacted soil around the plant is loosened and aerated, and has a better chance to trap rainfall in the depression which will channel the water directly into the plant's roots. This symbiosis benefits the plants and the Meerkats, who are the plants' custodians. The active digging from the Meerkat directly reverses soil compaction caused by livestock.

With increased aeration and water infiltration from the holes dug around their roots, and the presence of Meerkat dung compost, created from the invertebrates that were eating the plant, the vegetation grows even better. The flourishing plant will then attract more food, which the Meerkats will harvest on a subsequent visit which may be a few weeks later as the Meerkats travel around their territory.

The Meerkat's territoriality ensures that it does not stay in one area for an extended time, allowing food populations to recover from foraging. This is like a rotational crop management system.

These indigenous plants will benefit more than intruder species which are not a natural part of the Meerkats' foraging cycle. Over time the intruder species will be outcompeted by the Meerkat-enhanced survival rates of the indigenous plants.

Meerkat digging can help prevent desertification

Areas that have had their indigenous vegetation removed are exposed and susceptible to severe soil erosion through wind and water. The harsh incoming solar radiation is then no longer broken up and absorbed by plant cover, and results in the ground becoming much too hot. The high clay content in the ancient water systems that Meerkats often colonise can bake solid when exposed to sunlight without the protection of topsoil and surface vegetation.

These highly compacted and almost sterilised soils then crack and expose vulnerable root systems in fissures causing further erosion and moisture loss in deeper soil. The revealed roots also die, and the soil is no longer effectively anchored.

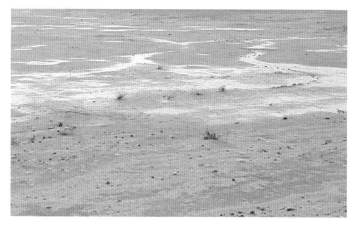

Water is unable to penetrate clay soil compacted by domestic stock and this commonly results in soil erosion through water such as rill and then disastrous donga formation. Exposed cracks in the drying soil that shrinks results in further moisture loss and additional exposure to wind erosion. Once pioneer plants are removed and the nutritious top soil has been eroded away, these once fertile habitats are barren and desertified areas largely devoid of any life.

Crater ploughing is sometimes used by conservationists to break the surface of compacted and eroded soils to create crater-like basins that allow for better water infiltration and seed entrapment. These excavations then form micro niches for pioneer plant species to establish themselves in a more sheltered environment.

Pioneer diggers such as the Meerkat already do this on a daily basis, at no charge to a landowner who could pay large sums of money in labour and machinery costs for the equivalent anti-erosion methods to be implemented.

Meerkats break up hard compacted soil by their constant digging using their sharp claws. This digging helps to prevent soil erosion, by allowing rainfall to infiltrate the soil easily. This prevents what is known as the run-off effect, where water cannot sink into the soil and washes most of the topsoil away, which is so critical for plant growth.

This wash away effect quickly leads to a more severe form of erosion like rill and donga erosion. But due to the Meerkats' digging habits, and thousands of daily digs, this soil erosion process is greatly reduced.

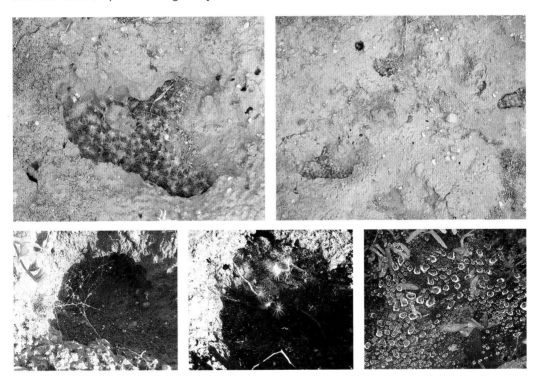

Meerkats plough up compacted soil, fertilise it with their dung and maintain a balance between the species that eat the plants. Plant species flourish when they have their attackers eaten by Meerkats, which are effectively grooming the plants. Plant roots are aerated and have water gutters directly around them through Meerkat digging which prevents soil erosion and enhances effective water infiltration. The pock-marked surfaces left behind by a foraging group of Meerkats rapidly trap plant seeds and other top soil. They also attract spiders which create water-trapping webs to further facilitate seed germination.

Meerkats help seeds to have a better chance of germinating

The process of seeds accumulating in holes dug by Meerkats, and then trapping water which easily infiltrates the digging depressions, prevents top soil erosion and greatly improves the chances of seed germination.

Spider webs are often constructed in the depressions created by Meerkat digging. These spider webs commonly trap seeds and water, which will then positively help seedlings to grow.

The Meerkat digging sites also create a multitude of micro-habitats and niches for other species. These may also include species that the Meerkat will eat when it returns to the same foraging area again in the future.

Bare soil which has previously been eroded can recover more quickly when Meerkats occur in the area. These diggings from the Meerkats will promote pioneer indigenous plants that can rapidly grow and stabilise the soil from further erosion.

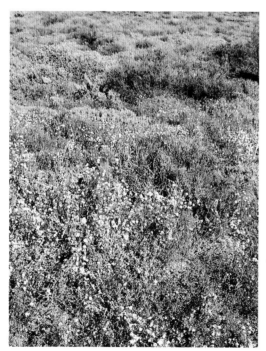 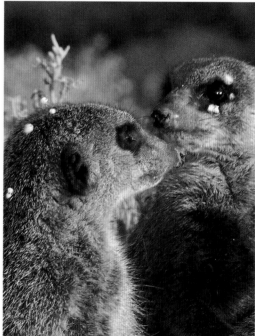

ABOVE LEFT: *Meerkats are difficult to see as they become covered in seeds in the Little Karoo succulent vegetation. They actively disperse plant seeds which adhere to them and also act as pollinating agents as they move around various plants in search of food which favours particular plant species.*

ABOVE RIGHT: *Seeds which do not fall off during transport will often be groomed off. As this happens they will receive moisture from the Meerkats mouths and have an additional opportunity to germinate more effectively. Some seeds may even be ingested and transported much further away from their host plant, resulting in internal as well as external seed dispersal by Meerkats.*

Meerkats are seed-dispersal agents

Meerkats often disperse indigenous plant seeds on their bodies, and this is known as epizoochory. This specialised dispersal of plant seeds greatly facilitates indigenous plant conservation. Occasionally ingested small fruits have their seeds dispersed through endozoochory, and when Meerkats groom some seeds will be swallowed in the process.

Because Meerkats are frequently digging around flowering plants, they also get covered in pollen and act as pollinating agents for many of the flowering plants in their habitats.

The use of pesticides on crops

The fossilised river bed systems were targeted to plant stock food due to their very rich alluvial top-soil deposits. This resulted in destructive ploughing of inherited Meerkat burrow systems, followed by the planting of non-indigenous plants in those areas and the use of pesticides.

When the food that Meerkats eat has been poisoned by pesticides, this could have a negative impact on their survival as toxins build up in their bodies when they eat poisoned food. By not using chemicals on crops and protecting Meerkats on properties landowners could save money. The Meerkats would actively control plague outbreaks and swarms of crop-eating insects, literally grooming the crops and promoting profitable organic farming rather than destructive and expensive chemical farming practices.

Meerkats actively hunt termite, locust, cricket and grasshopper swarms, which will directly benefit a landowner.

These fragmented, unploughed Meerkat habitats are amongst the last remaining river bed valleys left. Unless more suitable habitat is actively protected, this Little Karoo Meerkat subspecies is heading for extinction.

I would like to reemphasise that the Meerkat species is not in the same endangered position as certain subspecies populations are, and to generalise about a species conservation status whose exact numbers can never be known is dangerous and irresponsible. The remaining suitable habitat and its loss can be calculated however.

The Meerkat Magic Valley Reserve is a conservation initiative for Meerkats and their habitat which aims to continue to purchase additional land to enlarge and consolidate the fragmented suitable habitat for the protection of the subspecies and their entire ecology of fauna and flora.

Burrow destruction through livestock, ploughing and buildings

Burrow systems are essential for the Meerkats' survival. If these are not protected, the safety networks that Meerkats rely on will fail. The abundance of food, group size and territory are all irrelevant when facing a collapsed burrow.

Burrow-dwellers will rush to the apparent safety of their burrow systems when alarmed, and tragically end up being entombed and killed in their underground homes.

Stock trampling of burrows by cattle and other domestic animals is a severe threat which can collapse a burrow with the Meerkats being trapped within. I have noticed that many stock animals have a preference for the mineral-rich soils that have been excavated from deep beneath the ground and raised to the burrow surfaces.

The domestic stock habitually walks onto and often lies down on the burrows to rest while eating these dug up mineral salts, unlike wild animals that move around these burrows and avoid breaking them. When a herd of cattle, sheep or goats lie on a Meerkat burrow it is destroyed along with all the other wildlife hotel residents that make the burrow system their home.

Ploughing areas to plant crops or clearing areas to create buildings using heavy machinery or soil-disturbing equipment is also disastrous for burrows. An entire underground ecosystem which could be dozens of years old is destroyed within minutes.

It is not known exactly how old these burrows may be, but in over two decades of research I have not seen new burrow systems develop. What is certain, however, is the impact that the destruction of a burrow has on a Meerkat population and the large diversity of other burrowing species.

When Meerkats are not trapped within their collapsing burrows and killed, destroyed burrows can still result in Meerkat deaths when the Meerkats run to a former burrow system to escape from predators, only to discover too late that the burrow is no longer there.

They do not have time to simply dig a new burrow when being attacked by predators. Meerkats rely on maintaining an inherited network of very old and established burrows throughout their territory.

The Meerkats' survival depends on them knowing the whereabouts of these escape burrows. Even when they are unable to see these due to dense vegetation, they will follow their scent trails and memory of these locations. If they arrive at a collapsed, ploughed or built over burrow, it would be too late for them to escape from a pursuing predator.

Many predators that hunt the Meerkats are very fast and can cover distances rapidly. They will not hesitate to attack Meerkats, and will not wait for them to run to another burrow. Meerkats escaping into a known burrow system may only have a few seconds to avoid a predator's attack.

Eco-friendly landowners and active burrow conservation

If these vulnerable burrow systems were protected from livestock through camp fence systems being implemented, it would prevent burrow trampling and collapsing, which is also dangerous to stock as they may injure themselves. Wildlife has often grown up around these burrows and knows of their location and avoids injury by not walking onto them.

Burrow inhabitants move easily under, through or over stock fences, but domestic animals will not be able to destroy these protected fenced off burrows. The same fencing methods could be used to cordon off and protect burrows in fields that are being ploughed or from building developments. The small areas that these burrows require will have a minimal impact on crop farming or developments in the area.

Conservation friendly landowners, who protect burrows on their properties, would be promoting eco-friendly farming and development practices forming a sustainable balance between humans and nature.

Burrow systems are natures storm water gutters

One important benefit to the landowner who actively protects burrows is that these underground tunnels are the equivalent of nature's storm water gutter systems. These burrows prevent damage from large quantities of soil eroding water by channelling it safely and directly into the ground. This will benefit any surrounding crops, and food for livestock from the increased water in the soil and protection of top soil from erosion. The burrows' anti-erosion architecture has been perfected by burrow inhabitants over generations.

Meerkats are often falsely accused

Sadly Meerkat tracks may be found around dead animals, since Meerkats are curious and investigate everything they encounter in their territory. But they are not the cause of the animal dying.

Meerkats are even blamed for eating ostrich eggs! They cannot possibly break the eggs, and only if the egg is already broken by a larger mongoose or jackal will the Meerkat sometimes drink the yolk from the broken egg. They are not the cause for the losses of chicks or eggs, however. Many other mongooses' tracks are also often confused with the Meerkats' tracks.

Meerkats are often wrongly accused of eating ostrich chicks or other farm animals, when they are innocent. Many other larger mongooses tend to eat larger prey items like these birds, and have cutting teeth, but these mongooses also control rodent plagues that destroy vegetation and crops and are really beneficial to have on properties.

Unfortunately Meerkats in captivity do not have a natural diet and can learn to eat anything introduced to them by humans. This artificial diet results in many believing that Meerkats will eat food that they would not in nature. Wild Meerkats have a natural diet. Tame Meerkats are not comparable to wild Meerkats in behaviour and diet.

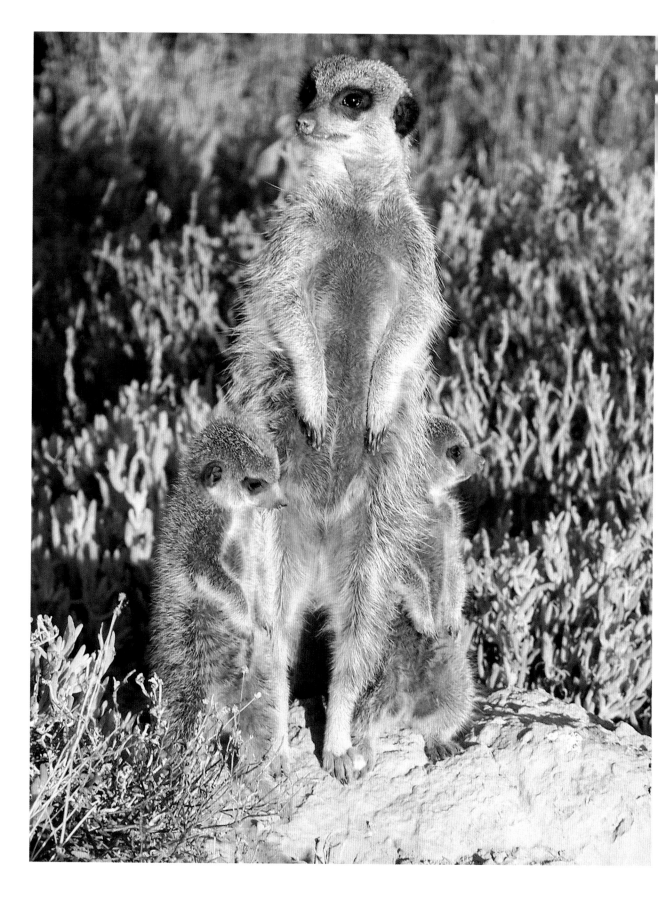

THE MEERKAT PET TRADE AND REHABILITATION CONCERNS

DUE TO THE MEERKAT'S sociable and entertaining mannerisms, many humans have related to them, to the point where they are even called 'Earth Men' from the Afrikaans 'Erdman'. Tragically this popularity has led to an exponential and unsustainable explosion in the Meerkat pet trade and is amongst the numerous threats facing the wild Meerkats' chances of survival.

When people see the 'cute, cuddly' Meerkat in the media, without all the appropriate conservation facts, they often want a Meerkat as a pet. The internet is full of such media which does not explain the tragic life of a pet Meerkat. If the demand for Meerkats as pets goes away, so too will the supply.

I hope that the information provided will encourage any potential Meerkat pet owners to reconsider for the sake of the Meerkat species.

Anybody who may see a 'wild' or captive Meerkat being touched and handled may in turn wish to do this, without understanding the implications of their unsustainable desires. Simply touching and handling Meerkats to attract viewer ratings is very irresponsible and heightens the Meerkat pet trade.

The media's often biased and non-conservation friendly focus has directly resulted in the increased demand for Meerkats as pets.

Presenters should take note of their impact on Meerkat conservation in this regard in the media. A simple media promotion of not having Meerkats as pets would be greatly beneficial from presenters. If viewers do not receive any information about why certain animals in research may be handled, they could simply assume that touching wildlife is acceptable even if not for research. Often researchers spend many years observing and

OPPOSITE: *Meerkats are best left in the wild where they belong. Babies need the support and constant care of their teachers to acquire their complex life skills. Meerkats are highly sociable with huge territories and should not be subjected to a life of imprisonment by humans.*

working with study species and may handle them in order to research specific aspects. This is done in a controlled manner, and not for attracting the pet trade or specifically for the media. This is not the same as media promoting handling of animals without an explanation as to why this may be required in certain research. This then later results in further unwanted captive Meerkats and the cycle continues.

I have been campaigning against the international Meerkat pet trade since 1993. I strongly believe the solution to this corrosive pet Meerkat industry is to simply share the conservation information with anybody who is 'Meerkat friendly'.

Anybody can help to conserve wild Meerkats simply by sharing the information about not supporting the Meerkat pet trade and conserving the Meerkat in its natural habitat.

Meerkats do not make good pets and should be protected in the wild. They become very aggressive in captivity as they imprint on the people who they live with, and instinctively consider anybody visiting their 'territory' as a rival Meerkat to be attacked.

Captive Meerkats are unable to migrate or be evicted, resulting in terrible intragroup fights between individuals.

The incessant digging of Meerkats is highly destructive in a captive environment. When Meerkats reach sexual maturity they will start to scent mark everything in their territory, which is often unwanted and unhygienic for people.

Tragically most captive Meerkats are not given the social interaction that they are adapted to with groups of fellow Meerkats. They usually become very 'depressed' and will commonly self-mutilate, biting off their tails and limbs due to the equivalent of stress or frustration or simple boredom from their small cages or shelters. They often receive friction scars on their bodies from repetitive motion injuries in captive environments.

Due to the incredibly demanding sociable adaptations of a Meerkat, they require constant attention and vocal assurances over the day. Initially this may seem endearing to a captive Meerkat's owner. However, a Meerkat is far more demanding than a domesticated cat or dog.

Meerkats are active from sunrise to sunset, resulting in many a Meerkat pet owner not wanting the constant very loud barking and numerous calls and demands for their undivided attention. The captive Meerkat is then a tragically unwanted burden, and is often given to a zoo or sentenced to death in the highly dangerous and unfamiliar wilderness.

Captive Meerkats may live for as long as a domesticated cat or dog in captivity. The unhappy result of this longevity is that captive Meerkats are often left in a small cage for most of the day, to prevent their marking and digging while their owners are busy. Some Meerkat owners even have their Meerkats' teeth and nails removed, and scent glands too.

True Meerkat friends do not want to subject sociable Meerkats to a life sentence of being kept apart from other members of their own species in an unsuitable environment that is not large enough for them. Captive environments can never compare to the great open spaces of wild Meerkat territories.

Captive Meerkats are usually very unhealthy as they lack the adequate diet and the daily exercise they would receive over many kilometres of their home territories.

The sad reality is that many captive Meerkat owners who claim to really appreciate Meerkats are doing the greatest harm to the species.

Please protect Meerkats in nature where they belong.

Rehabilitation is not the solution to the Meerkat pet trade

Releasing Meerkats back into nature may seem like a noble and an easy solution for the large numbers of unwanted captive Meerkats. Although this idea is intended to be beneficial to Meerkats it actually has the opposite effect. It is not a solution that encourages people to not want Meerkats as pets to start with. The root of the desire needs to be addressed, then captive Meerkats will not end up being subjected to rehabilitation attempts or a life in captivity.

The best form of conservation for the Meerkat is not removing it from the wild in the first place. This goal can be achieved with conservation through education, creating an increased awareness about wild Meerkat conservation. This is a promising start to an active permanent solution.

This understanding of the importance of wild Meerkats in their natural habitats can actively lead to self-motivated conservation and the resultant lack of desire to keep Meerkats as pets.

Many who claim to be rehabilitating Meerkats for conservation are doing this for publicity and are working with released tamed Meerkats without regard to the impact they are having on wildlife populations in an area.

International zoos are often saturated with Meerkat populations and can't release them for reasons I will mention.

Wild Meerkats adapt to their home ranges from birth throughout their lives, and have a highly complex social structure and interspecies reliance. Tame or so called rehabilitated Meerkats have no chance of survival as they do not have the skills and knowledge taught to them from other Meerkats in a given area.

I refer to Meerkats as indicator species and examples of self-regulating naturally occurring wildlife. They are the true wild animals who have not been introduced to an area. If Meerkats are not in a specific area, there is always a good reason for this absence. Either they cannot survive in that given habitat for a variety of reasons, or there are already Meerkats there that have saturated all the usable territorial spaces.

Fences are also not barriers to Meerkats and they will regulate their own numbers and carrying capacity. They are not like larger game species which can be introduced and managed in an area.

It is believed to be unethical and illegal to reintroduce any Meerkats back into the wild for a variety of conservation reasons. Releasing captive Meerkats could lead to the introduction of diseases and pathogens into existing wild populations, even currently unknown viral strains. Genetic pollutants between subspecies that are from different areas and have unique adaptations to specific habitat types could be introduced. Subspecies are specialised into certain distribution areas and will not survive in areas that they would not be camouflaged in.

The Meerkat species actively learns about territorial information in an area from birth and individuals acquire this specialised knowledge over their lives growing up in an area. Their survival depends on an extensive repertoire of localised experience.

Existing wild populations of Meerkats will saturate any available niche areas in an ecosystem. Introducing Meerkats from captivity into an area would place a severe strain on wild Meerkat populations. There is a limited balance of food resources which are usually seasonal and fluctuating in harmony with the supported carrying capacity of wild populations.

If there are no Meerkats in an area, they simply do not occur there or they are unable to survive in that area due to various factors. These include: interspecies competition from mongooses with similar dietary requirements; predation pressure; unsuitable geology which does not allow for a certain burrow structure, being too rocky or too sandy; habitat unsuitability due to encroaching human settlements or the ploughing of burrows and pesticides being used on Meerkats' food; and alien vegetation impacting on indigenous fauna and flora, resulting in the absence of species specific indigenous food supplies even when habitat and climate are suitable for populations.

A detailed understanding acquired over years investigating an area's specific diet, climate, geology, social structure, range overlaps, intergroup aggression, intragroup aggression with regards to migrant and evicted individuals and their locations, habitat saturation, local weather patterns and their history in an area, including fires and floods, would need to be understood as to why rehabilitation of Meerkats is not a viable or responsible solution for the reduction in the population of captive Meerkats.

I believe that without this comprehensive research data, any release of Meerkats into the wilderness is completely unethical. This is not a solution to the unsustainable removal of the species from the wild for the unsuitable pet trade.

It is unfortunate that attempted rehabilitation of Meerkats is often from well-intentioned initiatives that do not fully understand the potential impact that their actions can have on wild Meerkat populations.

Without the staggering variety of site-specific research information, any attempts to release captive Meerkats should be seriously reviewed by conservation officials.

Very few people in the world have first-hand experience about where wild Meerkat populations even occur due to the highly secretive and burrowing nature of the species. Few Meerkats are ever seen in the wild by casual observers, even when looking directly at them.

This has further contributed to a lack of correct distributional data and to release Meerkats would require this at the very least, even without any of the many other factors mentioned that need to be considered.

Captive Meerkat populations and their exhibits could directly benefit wild Meerkat populations and their habitat by actively promoting awareness about their conservation and not keeping Meerkats as pets.

The fact that my Meerkat conservation work exists in an area in the Little Karoo which was never thought to have naturally occurring Meerkat populations is another example of why attempted introductions of Meerkats are unethical. Even with decades of research into the Meerkat species, there is much more to learn about them.

It is my sincerest hope that people around the world will protect the wild Meerkat as one of their favourite animal species, and do not end up only watching them through the media or in captivity while Meerkats go extinct in the wild.

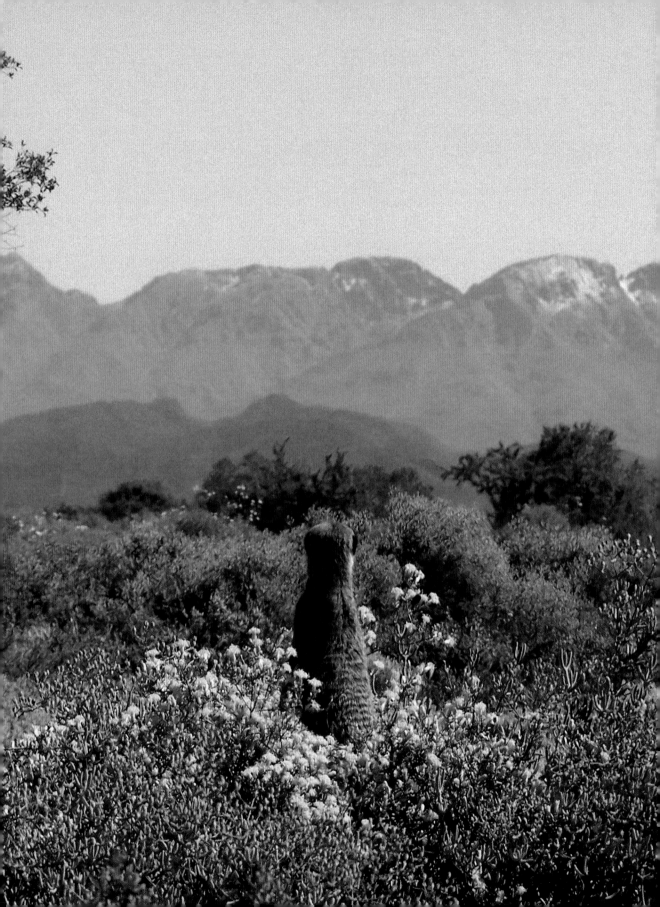

INDEX

OPPOSITE: *Wild Meerkats are actively protected in The Meerkat Magic Valley Reserve by The Meerkat Magic Conservation Project ensuring future generations of Meerkats grow up wild and free in nature.*

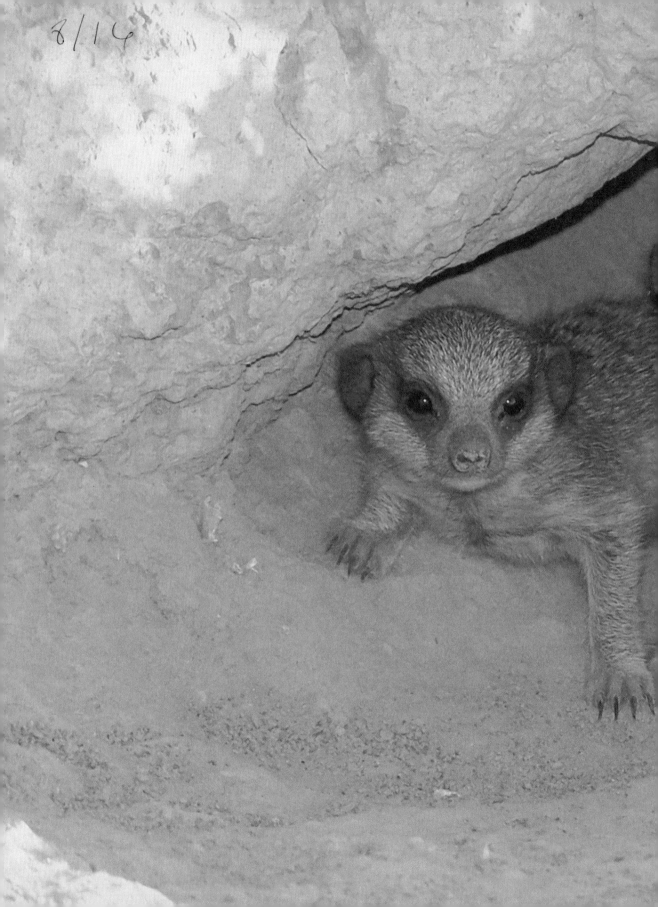